HAREWOOD
HOUSE
One of The Treasure Houses of Britain

HAREWOOD HOUSE

One of The Treasure Houses of Britain

Mary Mauchline

MPC

Illustrations:
Figs 4, 12, 14, 15, 19, 21 and plates 1-17 are published by permission of the
Harewood Trust; figs 3, 9, 10. 11, 20 and 22 from the Harewood Archive by
courtesy of the West Yorkshire Archive Service, Leeds; figs 5, 6, 16-18 and
plate 19 by the courtesy of the Trustees of Sir John Soane's Museum, London;
plate 19 by courtesy of Alec Cobbe.

ISBN 0 86190 366 8

1st edition published 1974
Revised 2nd edition published 1992

British Library Cataloguing in Publication Data.
A catalogueM PC record for this book is available from the British Library.

Printed in the UK by:
The Cromwell Press Ltd
Broughton Gifford, Wiltshire

For the Publishers:
Moorland Publishing Co Ltd
Moor Farm Road West, Ashbourne, Derbyshire, DE6 1HD

Contents

Illustrations

1
The New House at Gawthorpe

Today, Harewood House lies well within commuter country. Traffic streams past the main entrance gates through the village of Harewood, along one of the main arteries of Yorkshire which links the industrial areas round the city of Leeds with the market towns of the Yorkshire Dales and the Great North Road, the A1 from London to Edinburgh.

Yet the idyllic setting of the house remains unaffected. The bold outlines of the building stand in sharp relief against the sheltering background of a well-timbered park, medieval in origin. Vistas open westwards over sweeps of meadow to the farmlands and moors of Wharfedale, with Almscliffe Crag silhouetted against the horizon.

To the south, the less extensive view over the Victorian terrace garden to the rising ground beyond the lake has an undeniable perfection: a casual glance does not reveal the ravages of the gale of 1962 which destroyed about 10,000 mature trees. If the work of 'Capability' Brown at Harewood did not satisfy his employer, others have found little fault in so captivating an example of the art of painting in landscape.

Harewood House was essentially the creation of Edwin Lascelles. From 1759 onwards he devoted much of his very considerable ability and his remarkable energy to the supervision of its construction and furnishing. Every detail of its workmanship and each item of expenditure came under his close and efficient scrutiny. At Harewood he knew what he wanted, a fine, new country seat to enhance his standing in politics and society, and

7

display without undue ostentation his vast inherited wealth (see plates 4, 6).

To build in the classical manner was often the main preoccupation of many of the landed interest in the middle years of the century.[1] In Yorkshire, as at Harewood, a distinctively Palladian style still remained the usual choice after 1750, a second phase of the earlier Palladian school associated with Lord Burlington, which had influenced the city of York itself a generation before.[2] This English adaptation of the Italianate inspiration of the sixteenth-century Venetian, Andrea Palladio, owed much to the work of Inigo Jones, who introduced the full discipline of the Classical Orders into English domestic architecture in the early Stuart period. The style and the philosophy of life behind it suited the English, especially the Augustan world of Georgian England. Palladio's country villas were designed for a class of noble capitalists, who had retired to farm their estates on the mainland between Venice and Vicenza. This pattern of commercial success, cultivated leisure and economic security was well understood by their eighteenth-century counterparts in the Protestant north of whom Edwin Lascelles was an admirable example.[3]

In the middle decades of the century the increasingly professional status of the architect was not yet recognised.[4] It was still customary to give the credit for 'improving one's place' to the gifted amateur owner, who directed the building of a great country mansion or made extensive alterations to an existing house. During the years when Harewood House was being built, from 1759 until 1771, the fever for improvement and the first flush of enthusiasm for Neo-classical ornament were at their height. Yet more than ambition, a cultivated taste and a dilettante interest in architecture were necessary for the successful outcome of a major building project. Wealth, sound business sense, some knowledge of the organisation of the building industry and the ability to handle men and marshal materials were, in some degree, prerequisites, and all these Edwin Lascelles possessed. Ill-considered schemes could undoubtedly impoverish unwary landlords, whose resources proved unequal to their ambitions, but no such inadequacy was likely to affect Edwin Lascelles. His was a fortune 'not easily hurt' as a fellow Member of Parliament wrote sourly.[5]

This inheritance Lascelles owed to his father, Henry Lascelles, the founder and senior partner of the London West India merchant

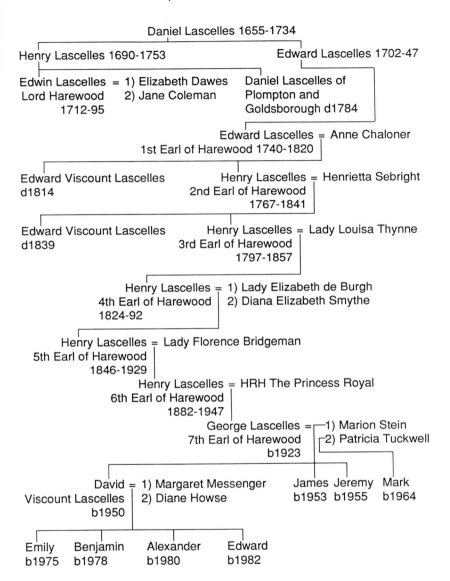

Fig 1 The Lascelles of Harewood

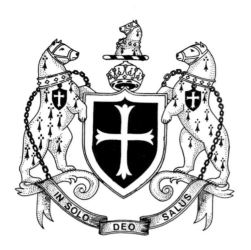

Fig 2 Arms of the Lascelles of Harewood
Arms — Sable, a cross patonce within a bordure Or
Crest — A bear's head couped at the neck ermine, muzzled gules, buckled or, collared of the second, rimmed and studded gold
Supporters — Two bears ermine, muzzled and collared gules, buckled and chained, the chain reflexed over the back, or, the collar studded and rimmed, gold, and pendant therefrom an escutcheon sable charged with a cross patonce gold
Motto — 'Salvation in God alone'

house of Lascelles and Maxwell.[6] In his purchase of the adjoining estates of Gawthorpe and Harewood in West Yorkshire, the elder Lascelles had a stroke of immense good fortune. He bought the property in 1739 at a time when estates seldom changed hands, since land was the chief source of power, political, social and economic; prices were high and opportunities of acquiring suitable properties were few.[7] The Harewood estates, with their associated townships, formed a centralised, compact unit, and the deal included the purchase of the Old Hall at Gawthorpe, a medieval manor house which had belonged to the Gascoignes. It later came through marriage into the Wentworth family, who made substantial additions to the house in the early seventeenth century. The place was surrounded by the formal gardens and the deer park which had so delighted Thomas Wentworth, 1st Earl of Strafford, during his brief periods of withdrawal from the political arena. After his execution, his son was forced by debt to sell Gawthorpe in 1656 and the estate was similarly encumbered when Henry Lascelles made his offer.[8]

Only the Lascelles riches, however, were new. The family was of Norman descent, settled in Yorkshire from the time of the Conquest. The branch from which Henry Lascelles derived was already closely connected with the north, especially the market town of Northallerton. From the medieval period, the Lascelles had held office as justices, sheriffs and Members of Parliament.

Francis Lascelles, a reluctant member of the Commission to try Charles I, absented himself from its crucial sessions and, by his marriage to Frances St Quentin, allied the Lascelles with the Aldburgh and Gascoigne families who had once owned Harewood and Gawthorpe.[9]

By his purchase of these adjacent manors Henry Lascelles, therefore, established his descendants in an area with which they had inherited associations. The situation of the property was ideal, set between their family concerns in the north and the rapidly growing industrial town of Leeds only eight miles to the south of Harewood. To the east, some twenty miles away, lay York, the capital city of the north of England, with a Season not certainly comparable with London, but offering a sufficiency of provincial diversion, with its fashionable shops and luxury trades, new Assembly Rooms and racecourse. London itself was reasonably accessible by road, an important consideration.

The interest of the Lascelles family in West Indian affairs dated from the beginning of the century. Henry Lascelles had done well in Barbados from the profits of colonial administration, in Customs concessions and government contracts, and from his own commercial dealings with planters and the staple crop of sugar. In 1740 he set up his London West India merchant house to finance loans to planters, negotiate their commissions in England, sell their crops and later take over their mortgaged plantations.[10]

Involvement in politics was necessary for the survival and growth of any mercantile enterprise in an age when Crown patronage and government favour regulated the country's overseas policy. Only in parliamentary action could a merchant hope for protection of his interests, when legislation could at a stroke change the course of his fortunes by altering conditions of import or export.[11] The fall of Walpole in 1742 was a serious blow to Henry Lascelles since it deprived him of the Ministerial support he had so long enjoyed. In this situation, he bought for about £23,000 borough property voting rights in Northallerton and took his seat in the House of Commons as Member for Northallerton in 1745. On his death in 1753 he was succeeded by his eldest son, Edwin.

Edwin Lascelles was in politics, however, rather as a landowner than a merchant. He reached the height of his political career in the years between 1761 and 1780 when he represented the county of York. His support of the War of American Independence and his

refusal to be drawn into the strong Yorkshire Association move-
ment for administrative reform, despite his sympathetic leanings
to such a cause, lost him his once strong Yorkshire following. He
withdrew, and ended his long political life in the Commons as
Member again for Northallerton, the seat being vacated for him by
his brother, Daniel, in 1780.[12]

Any expectation that Edwin Lascelles would have an outstand-
ing career in politics was disappointed. His new Harewood House
did not become in his day one of the great houses where policy was
discussed and politicians made. He was matched by exceptionally
able politicians in his own county, where men like Lord
Rockingham were adepts in party management and adroit posi-
tioning for power. Lascelles, although nominally recorded as a
fellow commoner of Trinity College, Cambridge, and admitted to
the Inner Temple, was by birth and background a Barbadian,
whose wealth was based initially on trade rather than on land. A
generation later he would have found himself more at home: he
greatly admired the younger Pitt, a loyalty which possibly ac-
counted for Lascelles's peerage in 1790. It was, as his wife wrote to
Pitt, 'the only favour he ever in his life asked for himself '.[13]

This ennoblement accorded well with what Henry Lascelles
had planned for his eldest son. It seems that about 1740 he had
quite deliberately settled Edwin's future role. Daniel was estab-
lished in the London merchant house, but Edwin was put almost
at once in control of the estates of Harewood and Gawthorpe and
was the heir of an estimated £166,666 of his father's fortune of
some £284,000. About £53,000 of this was invested in real estate,
chiefly in Yorkshire.

The death of Henry Lascelles in the autumn of 1753 made little
difference to his son's authority at Harewood. The decision to
build a house to replace the Old Hall at Gawthorpe seems to have
been taken very soon after Lascelles found himself master of his
father's wealth, although he continued to live at Gawthorpe until
his new country seat was ready for occupation in 1771.

In the building of Harewood House, nearly every circumstance
seemed to be in his favour, and the nature of the site itself was
remarkably well suited to his purpose (see fig 3).

Above the Old Hall, Harewood Bank rose steeply to the north
giving a wide view over the fields already enclosed and pasture
land. Here on the southern slope, dipping more gently than the

northern escarpment, Lascelles sited his new house. Below, the Old Hall lay in a damp hollow, beside a tiny tributary of the River Wharfe, known as Stank beck. In the acid soil of this millstone grit zone, oak and ash trees flourished — a typical feature of medieval parkland in the area. To the east lay the arable lands of the Vale of York, to the west stretched Wharfedale and the uplands of the Yorkshire Dales. It was a countryside of considerable beauty and great variety.[14]

The immediate surroundings of Harewood House had both intense individuality and contemporary appeal. Within very small compass, the changing emphasis of the landscape was quite dramatic. No situation could have more eloquently expressed the literary and romantic attitudes of the day towards Nature: rugged splendour and dark, shadowed seclusion contrasting with gentle pastures. In such a place, the emotions might with ease be stimulated or soothed, the intellect challenged to nobility of thought and heroic imagery, or the unquiet spirit hushed to contemplative reverie.[15]

All this sublimity and beauty were on a miniature scale, however, and the scenery was in fact very largely the result of prehistoric glaciation. The great glacier, which had covered Wharfedale, left in its wake deep channels, marked out by glacial melt water at some stage during its retreat. Hence, at Harewood, in the belt of level pastoral country beside the old manor house, the Stank beck plunged suddenly into the sharp little ravine running through a narrow, tree-clad gully.[16] The stream had sufficient force to turn the mill at the western side of the Old Hall. Equally suddenly, the beck emerged into placid, undulating country. Lascelles could appreciate his property in visual rather than in emotional terms and his reaction was entirely practical. He was concerned with problems of drainage and water supply, with gardening and planting, making a lake and generally redesigning the contours of the land around his house, busy at his place like any gentleman of the period hoping to fashion a north country Elysium (compare figs 3 and 20).

There were woods and water in abundance, springs, pools and the little stream. The final requirement for the creation of an eighteenth-century landscape was there, the enchantment of gothic fantasy[17]. On the northern boundary of the park, the fourteenth-century castle of Harewood provided Edwin Lascelles with a

spectacular and ready-made ruin, with two gaunt towers rising above the remains of the building (plate 2).

Edward III granted a licence to William de Aldburgh in 1366[18] to fortify his new castle on the escarpment of Harewood Bank, dominating the lower reaches of Wharfedale. The castle was therefore, four hundred years old when Harewood House was completed in 1771 and, as lord of the manor of Harewood, Lascelles inherited the vestiges of the feudal rights and privileges exercised by William de Aldburgh. He was a diplomat in the service of Edward Balliol, Edward III's puppet king of Scotland, 1332-9, and the Aldburgh and Balliol coats of arms appear over the entrance gateway and in the chapel above.

In the later medieval period, although considerations of defence remained important in the north of the country, castles were increasingly residential in character, concerned with convenience, comfort and a degree of privacy. In these respects Harewood Castle could be deemed the precursor of Lascelles's Harewood House as an assertion of personal achievement and political ambition.

Various features of Harewood Castle, especially its massive, compact construction and the sophisticated, intricate plan of the interior to meet both defensive and domestic needs, suggest that the architect may have been John Lewyn,[19] who worked from 1367 as master mason for the Cathedral and Priory of Durham.

William de Aldburgh was succeeded by his son. His two daughters married into the Redman and Ryther families and their descendants held the castle between them until the reign of Elizabeth. The Redmans intermarried with the Gascoignes of Gawthorpe and hence with the Wentworths. When the estate was sold in 1656, the castle was described as 'much decayed' and advertised as a useful source of dressed stone and timber to repair the houses of the little medieval market 'town' of Harewood, with its market cross, tolbooth and butchers' shambles.[20]

The castle remained isolated until it was taken into the North Pleasure Ground by Edwin Lascelles's heir, his cousin, Edward, 1st Earl of Harewood, about 1813. In the front of the castle an open space was cleared and turfed and the castle could be entered through a door made from a window behind the dais in the great chamber.

During these alterations, indications of previous gardens were

uncovered, showing that the castle area was from the beginning a planned layout. Gardens on the east and west sides of the walls descended in terraces down the steep slope to the river Wharfe and, on the level ground below, a large fish pond was located (plate 2). The Wharfe was well stocked with fish: 'the eel is incomparable' observed an early nineteenth-century writer.[21]

The complex has been further damaged by road construction. The making of the turnpike road in 1751-2 destroyed the approach to the main entrance of the castle and its successor, the A61, cuts through the site of the fish ponds along the foot of Harewood Bank. The woodland has been thinned, however, and the castle is again visible from the roadside.

A comprehensive landscape project involving the entire estate was begun tentatively in 1976 and is now fully established. The castle is well-documented and a programme of research and investigation ensures the preservation and conservation of the standing castle and its historic surroundings.[22]

Edwin Lascelles was much more interested in another feature of the medieval scene, the nearby fifteenth-century parish church of All Saints (plate 1).[23] It occupies an ancient site and, until the Reformation, was in the hands of the Augustinian priory of Bolton in Yorkshire and dedicated to the Holy Cross. Harewood village gradually ebbed away from this northern end of the 'town' and, by the close of the seventeenth century, the church was surrounded by fields.

Old Gawthorpe Hall had a fine chapel, but Lascelles can never have considered it adequate. As early as 1748, five years before his father's death, an entry in the Harewood parish registers refers to him as the Lord of the Manor of Harewood and gives him permission to pull down a pew and enlarge it 'for the better accommodation of the his servants for the hearing of Divine Service in the Said Parish Church.[24] There were abortive plans for a chapel in Harewood House, one by Adam and another by Carr, but All Saints became the family's place of worship and burial.

From the first, Lascelles apparently viewed the church as a romantic gothic eye-catcher. In 1759, the year in which the building of the house began, Robert Adam made drawings 'to add a finishing to the top of the steeple in the Gothick taste'.[25]

This remained unexecuted and it was not until 1793 that Lascelles had the east elevation decorated with gothic battlements, pinna-

cles and window tracery. Apart from its appeal as a handsome example of northern Perpendicular architecture, the associations of All Saints with Lascelles's predecessors as Lords of the Manor and owners of Harewood Castle may have influenced his decision to use the church as a family chapel. The Aldburghs, Redmans, Rythers and Gascoignes of the fifteenth century are commemorated there by a remarkable series of alabaster tombs, one of the largest and finest collections in a parish church in the county.[26]

These six monuments, each with two effigies, are survivals from the iconoclasm which received virtual licence by an Act of 1550 in the reign of Edward VI for 'the Abolishing and putting away of divers Books and Images'. On the sides of the tomb chests are hosts of angels, saints with their symbols and 'weepers' or mourners.

The earliest effigy is that of Lord Chief Justice, Sir William Gascoigne, who died in 1429. He is known chiefly for his dignified and apocryphal appearance in Shakespeare's *Henry IV* as the judge who committed the future Henry V to prison. Despite some injury to his nose, the unlined, composed face seems to present a portrait of Sir William, probably modelled from his death mask. So delicate is the carving that the outline of the ears is obvious beneath the tight-fitting coif. Traces of red can be seen on his robe with a hint of green on its underlining, for these monuments were bright with colour.

The monuments are a very valuable record of the costume, the armour and the art of carving in alabaster in the fifteenth century. It is indeed ironic that, when Edwin Lascelles was occupied in intensifying the medieval aspect of All Saints, the stained glass of the period should have been lost; only a few fragments have been recovered. Moreover, the medieval furnishings — the stalls for the priests, the seats and the screens of oak — were taken out in what a mid-nineteenth-century historian called 'a series of most barbarous alterations'.[27]

The present furnishings and stained glass date mainly from the restoration by Sir Giles Gilbert Scott, 1862-3.

In 1978, the church was declared redundant and the fabric vested in the Redundant Churches Fund. An extensive programme of conservation began and the six monuments, cleaned and restored, were returned as far as possible to their original positions. The work is regarded as a model of its kind.

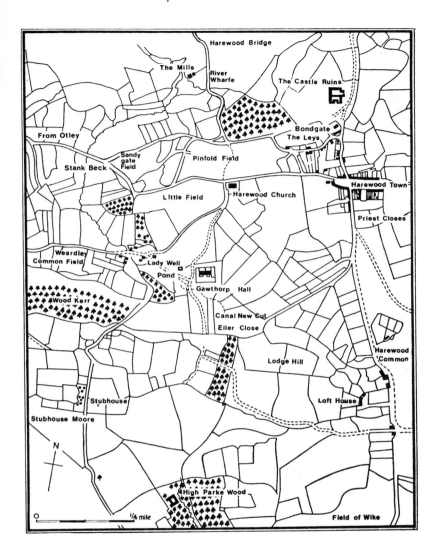

Fig 3 Gawthorpe Hall and the 'Township' of Harewood, from a map of the Manor of Harewood, 1698-9. Edwin Lascelles sited his new Harewood House between his manor house at Gawthorpe and Harewood Church. The 'New Cut' or Canal was an attempt at formal landscaping in an environment still essentially medieval. (HA Estate Maps, no 33)

The survival of the castle and church at Harewood enabled Lascelles to establish an appearance of historical continuity, indentifying himself and his family with an estate only recently acquired. When he was ennobled in 1790, he took as his title 'Baron Harewood of Harewood Castle'[28] and when he died, five years later, a family vault was constructed under the church.

It is significant that the avenue to the house was aligned so that visitors could appreciate first of all the markedly 'Gothick' character of the east end of the church, before the path curved away to the left to bring them within sight of the impressive, classical entrance front of the new house (fig 1, plate 4). It was a subtle and effective contrast, a manipulation of landscape to suggest ancient lineage and fashionable good taste, the fruit of wealth and success.

Harewood Bank provided the stone for building the castle and the church. Geologically it was part of the Yorkshire Millstone Grit series and composed of Upper Follifoot Gritstone, an extremely fine and durable stone.[29] Lascelles thus had close at hand building stone of sound quality, easily quarried from his own estates. This readily available supply saved him a great deal of expenditure and time, for the transport of stone was one of the most expensive and difficult features of any major building programme.

Lascelles's good fortune extended even further. To assemble materials for such a project as the building of Harewood House a good system of communication was vital and in the mid-eighteenth century such conditions seldom existed. Comparatively, Harewood was well served by road and even by water transport. A northbound turnpike ran through Harewood village from Leeds. Older routes nearby were the road between York and Lancaster and the road from Wetherby to Otley. The junction of these roads can still be seen clearly marked on the ground on the north side of Harewood Bank. To the east there was the Great North Road from London to York and Scotland, with its coaching centres at Ferrybridge, Tadcaster and Wetherby. This last was the postal town for Harewood, but Tadcaster was the most important for carriage of goods to the new house.[30] The poor conditions of these roads, however, often hampered the transport of building materials.

Despite this, passenger travel was becoming easier; the introduction of a coach on springs in 1754 benefited Lascelles and his family. In June 1756, he allowed two days for himself and his

family to reach Gawthorpe from London. This was a journey made in summer and at a speed not reached by public 'Flying Machines on Steel Springs' for several years.[31] The servants, leaving London two days previously, arrived some hours after the family was in residence. In Lascelles's lifetime, the conditions and speed of road travel improved very considerably; in 1786, mails were transferred to coaches. In the same year his steward was much astonished by the sight of Mr Lunardi in his balloon soaring over the Harewood area for twenty minutes.[32]

The chief advantage for the construction of the house was the navigation of the Wharfe. Hull was the leading port for supplies of timber from the Baltic and North European countries and for coastal trade with London. Goods could be shipped in flat-bottomed boats by river as far as Tadcaster. This meant a journey by water of about a hundred miles along the Humber, the Ouse and the Wharfe. There were considerable difficulties, for the navigation was tidal and the draught uncertain.[33]

From Tadcaster, the journey to Harewood was made by road, using the estate horses to draw carriages or waggons. It was a distance of eleven miles and work on the house was often held up while supplies forced their way through Customs formalities at the port of Hull. The examination and checking of goods and materials, and adverse weather conditions were all responsible for constant delay. Lascelles's steward, Samuel Popplewell, wrote of snow 'drifted up to the Horses midsides' and of 'waters so high & Weather & Roads so bad' that it was impossible to get to Tadcaster.

A worse hazard than the weather were the uncertainties of deliveries and the rising costs during the Seven Years' War from 1756 to 1763.

When building began on the stables in 1755, isolated incidents were already occurring between the British and French in their colonial outposts in India and Canada. War broke out in 1756 and the foundations of Harewood House were laid in 1759, the famous year when English victories on land and at sea secured a colonial empire and perfect summer weather enhanced these triumphant reversals of previous incompetence and defeat.[34]

At first Lascelles did not take seriously warnings that freight charges would increase and that wood must be bought from any merchant who would sell at a fair price 'both goodness of wood and fine lengths'. He complained repeatedly about the high cost of

imported wood until he was effectively silenced by one of his timber merchants, who told Popplewell that a 'fine parcel' of wood had come into Hull but the price could not be stated. If war broke out the price would go up and, even if preparations for war were in vain, 'this Equipment of Ships of War has augmented the Seamen's wages very much and consequently Freights'.

Lascelles accepted the situation, and the delay caused by the necessity of English ships travelling under the protection of Admiralty convoys did not in the end impede his plans. As late as 1762, Samuel Popplewell could write to a Hull dealer in timber that both Edwin and Daniel Lascelles 'are fitted for deals this season & Timber. I believe they are determined to buy none until we have a peace'.

The period during which Harewood House was being erected was characterised by optimism. The decade, 1760-70, was one of success in war, confidence in the nation's economy and prosperity in agriculture. It saw the initiation of extensive building projects like the urban development of London, Edinburgh and Bath. The implementation of the Turnpike Acts added further to the numbers engaged in constructional work. An indication of the general growth of the building industry is the increased output of stained (wall) paper and glass and the rise in timber imports.[35] Although the carcase of Harewood was completed before the demand for building labour and materials reached its height, Lascelles had to face an increasingly competitive market in wages and prices.

As far as wages were concerned, Harewood lay within the district affected by the West Yorkshire textile towns, where Leeds was especially important as a marketing centre for woollen broad cloth.[36] The village of Harewood and the hamlet of Stank beside Gawthorpe Hall were both engaged in spinning and weaving on a domestic scale. To the north of Harewood there was a tradition of a low wage structure for masons and craftsmen, once most notable around Ripon but, by 1760, this district was catching up with the normal rates of payment in the area.[37] The statutory regulations of the West Riding justices had ceased in the case of the building trades to bear any relation to the realities of supply and demand, and these trades commanded comparatively high rates of payment in the northern textile and manufacturing districts.[38]

Apparently Lascelles relied on the income from his rents to pay for his building programme, for he wrote in this context in the

spring of 1756: 'I am every year playing at Ducks and Drakes with the income of my estate and spending half the rents before they become due.' But rents were rising during the 1760s and the only real incubus on wealthy landowners such as Lascelles was the Land Tax. It fell more lightly on the northern counties and, despite its increase to pay for the wars of the period, the Land Tax represented possibly about five per cent of Lascelles's rent roll.[39]

It was a good time to build. Of the material he used at Harewood only wallpaper and glass were subject to excise duty. The window tax, although increasing, did not become a major element in fiscal policy until the end of Lascelles's lifetime.[40] Fire insurance duty was not introduced until 1782. His house was up before the Act of 1776, which regulated dimensions of bricks throughout the country.[41] Few building regulations applied to country districts until that date, although chimneys had to be plastered or pargetted inside and no timber was permitted within five inches of a fireplace.[42]

By the time Harewood House was first occupied in 1771, the bubble of inflation had burst. Hard times, depression, even emigration followed. Catherine Ibbetson of Harewood, who had 'put out worsted to spin for several gentlemen in Leeds for nearly forty years', said that in 1771 and 1772 she had paid seven pence for spinning a pound of wool into thirteen hanks, whereas in 1774 she paid only $4^1/_2$d.[43]

To a prudent manager such as Edwin Lascelles, the possibility of such crises was always taken into account. His policy in building was consistent — to get the best as cheaply as possible: 'He who wil do it most reasonably & at the same time well, shal alwaies be imployd by me'.

The stable block immediately to the west of the Old Hall was begun on 3 April 1755.[44] Correspondence between Richard Sykes and Lascelles confirms the intention of the latter to initiate a major building programme in that year. The Sykes family, too, had made a fortune as merchants in Leeds and in Hull, and Richard Sykes had, like Lascelles, inherited an old-fashioned manor house. His diary records the laying of 'the first stone of the new house at Sledmere' in East Yorkshire in July 1751.[45]

Lascelles wrote to him on 21 April 1755: 'I am going into Mortar Pevmel [Pelmel?] & shall stand much in need of the experience & assistance of such Adepts as you. The first step, I am told, is to

provide the main materials; & wood & Iron being of the number, I flatter myself I shall learn from you, the Lowest price of the latter'[46]

Richard Sykes replied promptly on 27 April, recommending Lascelles to have an ample supply of timber and iron ready to hand in view of the possibility of war with France and to acquire 'another Quality ... to fortifie your self with a Multitude of Patience'.[47]

Only the day before, Popplewell had written to one of the staff thrusting the whole matter aside as a mere gentleman's whim: 'I have no News to send you ... Mrs. Stables having got a fine Boy, Mrs. Midgley near her time, turning the road by [the] church, building a Square of Stables, a New House at [the] Top of the Hill and the like.'

Therefore, from the spring of 1755, the construction of his 'New House at Gawthorpe' was much in Lascelles's mind. The stables situated down beside the Old Hall were never intended to be an addition to the older house; their construction served as an exercise for Lascelles in building. Four years later, when he set to work on Harewood House itself, he had all the necessary experience to enable him to commit himself to the building of one of the Georgian domestic palaces which so much influenced the eighteenth-century social scene and the English landscape itself that they have become the epitome of the period.

There seems no available evidence to support the contention that Sir William Chambers was the architect of the stables at Harewood. Certainly in 1755-6, Lascelles was considering Chambers's drawings for the house itself and a proposed elevation for the stable block to accompany these survives, which has been identified as Chambers's work.[48] This heavily rusticated, over-elaborate design was never executed and a much less conspicuous stable block was erected.

The responsibility for the construction of the square of stables was certainly John Carr's. The simple clear-cut elevations of the Harewood block and the paired Tuscan pillars round three sides of the colonnaded court are well suited to the low-lying, peaceful setting, and Carr was in effect the architect. He was himself in practice in York and his father, Robert Carr of Horbury, acted as Clerk of the Works to Lascelles. Both the Carrs were highly esteemed as masons trained, unlike the cosmopolitan and erudite

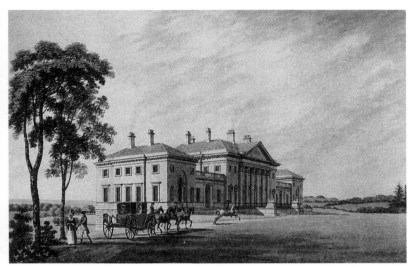

Fig 4 The North Front from a watercolour by Thomas Malton Jr 1778; sphinxes guard the shallow flight of steps to the entrance and the base storey is clearly visible

Chambers, as practical craftsmen, learning their trade locally, acting as building contractors and using the growing number of publications on classical architecture to inform their designs. The younger Carr, now with an established reputation, had half a century of first-class practice ahead of him.[49]

Daniel Lascelles, however, had his reservations about Carr's work at his Plompton stables. He exploded in a crescendo of unwonted fury about the expensive turret, a characteristic feature of Carr's stables and one lacking at Harewood. Daniel found such an addition 'fitter for a Church or Royall Mews' and wished that 'Mr Carr would have shown his more humble style of Architecture'. The two enormous stones for the cupola, 5ft 3in sq and 10in thick, he declared an extravagant absurdity: 'for Godsake what are these for ye Dial plates? does he intend them as big as those at York Minster? ... All I wish is that Mr Carr was less an Architect for me or would Exercise these sublime parts of ye Art upon a Noble Subject'.

At Harewood, the construction of the stables went well. Beginning in April 1755, local masons worked through the summer and by November the 'Great Arches' were both turned and, despite changeable weather, 'the hewen work has gone on pretty Briskly'.

Lascelles was vitally concerned with every aspect of the building: for instance, he insisted that there should be only two ornamental balls at each end of the centre of the east front, 'more wou'd be too crowded'. In February 1756, the roof was up and he allowed the workmen the traditional guinea to drink for the rearing of the roof. By January 1758, the Carrs had received their last payment and a month later the scaffolding was out of the yard.

Richard Sykes had stressed the importance of the work of an overseer and a carpenter or 'head joiner'. The estate carpenter, James Sanderson, proved himself during these four years well able to undertake the arduous and exacting work of choosing, measuring and assembling the timber required. Even more important was the master mason and here Lascelles's choice was the Muschamp family, resident in Harewood and well known for their skill, which won both the older Muschamp and his son, John, the appreciation and respect of the two Carrs. The Muschamps contracted at cut-price rates, but even so Lascelles wrote to his steward: 'You will find Muschamp makes ... 12d p[e]r day clear out of the Labor of all his Men who work Cornice, Back and Front Work. I don't doubt making a much better Bargain for my house.'

Apart from stone and wood, lead was an important commodity and a good plumber an essential part of the team. In this capacity Mr Rhodes fulfilled his work on the stables expertly, casting the lead himself. The price worried Lascelles, who insisted that each consignment should be carefully weighed before delivery to Rhodes and that there should be no waste in casting.

All these men were immensely capable, but Samuel Popplewell found himself bewildered by the multiplicity of duties expected of him. To his usual varied and demanding estate and legal work there was added the general responsibility for the number of men employed on the stables, the payment of their wages, the checking and payment of materials and the daily supervision of the building; it all proved too demanding. Lascelles became irate. Popplewell's accounting was 'very ridiculous like many Others very falacious'. There was, for instance, the supply of coals: 'I suppose you will say it is for Coals used in burning Bricks.' He told his steward that the bill should be in the Building and not the Household Account: the bricks must be counted and only the sound bricks paid for, not an enviable task, for in the summer of 1757 alone, 152,500 common stock bricks were fired for Gawthorpe,

apart from about 45,000 other types. The tenants still owed the feudal duty of 'coal boons', the service of carting coal, so Lascelles ordered 'That the Tenants instead of bringing a Wheelbarrow load, bring a Cart Load'.

Thus Lascelles impressed on his steward the watchwords of economy and efficiency. Popplewell sent his cash book up to London in a basket, along with a turkey and a hare, a partridge, a snipe and three woodcock, and declared he felt his death warrant had been signed. Somehow he was made to understand the intricacies of book-keeping and the necessity of discharging current expenses from annual income (see figs 10, 11).

After the years of work on the stables, he grew accustomed to Lascelles's tirades, reproaches and implicit apologies, supported his own poor health with patience — boils, chills, 'gout in the head' and a general tendency to be 'not very stout' — and was able, with the help of his son, to see to its completion the building of Harewood House.

Lascelles came to know the men who were to form the core of his workers on the house very well.[50] He was pleased, moreover, with the quality of the local stone for, though he complained it cost as much as Portland, he admitted that it 'cuts so kindly'. He realised the advantage of contract work as opposed to piece work, especially in an era of inflationary prices, but he was disappointed that cash payments apparently brought relatively little benefit: 'I find I pay for Everything Equal with the person who demands credit, & that I am not the better Served for being a good Pay master.' In short, the building of the stables brought home to him a simple truth: 'I must pay for my Experience.'

He learned also from the renovations being made at the same time to his brother's new house at Plompton, near Harewood. Daniel built up his Yorkshire estates around Plompton with his purchases of Goldsborough and Ribston, properties which Edwin was later to inherit along with his brother's West Indian concerns.[51] The two brothers were close friends, constantly together, more so perhaps because Daniel was divorced and childless. They shared an interest in 'improvement', but Daniel's tiresome letters, full of confusing repetitions and verbose explanations, are in marked contrast to his brother's crisp, forthright directions and terse language. Even the arrival of a turtle could throw Daniel into a minor panic; he despatched this culinary embarrassment, alive,

by carrier from London to Gawthorpe: 'I have nobody here to dress it, nor should I know what to do with it.'

Hence Edwin Lascelles's advice on the alterations at Plompton was frequently sought. John Carr produced two schemes. Although the less ambitious of these was accepted — and mislaid — by Daniel, Popplewell complained that 'so much pulling down & making up ... in Old Houses are monstrous tedious'. The interior work at Plompton is interesting, since it is clear that the fashion for wainscotted rooms had not yet been superseded. A bedroom so decorated was to be left and wainscott put up in the Dining Room, but for the Drawing Room a Wilton carpet was ordered 'which as ye may know is sold in pieces ... so as to fitt the room exactly'. Edwin Lascelles chose the Drawing Room paper from a selection sent out from York. The paper was to be stretched on canvas, since wallpaper was still thought of as a removable fitment. The base and surbase below the paper were not to be wainscotted, but plastered, with a rough-textured finish. Edwin also 'pitcht upon a Common paper at 5d a yard' for his brother's own room.

Apart from the Gawthorpe stables and his interest in Plompton, it is likely that Lascelles carried out some minor alterations to the Old Hall at Gawthorpe itself. John Carr seems to have designed a Garden House and done some work on the doorway of the Hall, where a portico, executed by Muschamp, was measured off by Carr, the usual check made by an architect or superintendent of the work before payment was made to a mason. One of the lessons of experience was the painting of the best staircase at Gawthorpe, for the paint especially sent down from London by Edwin Lascelles turned yellow. But Daniel thought everything at Gawthorpe quite perfect — from the laundry mangle to the 'mortiss' locks on doors, which he considered just the right height and width to give warmth and comfort to the rooms.

Yet his brother did not delay his decision to replace the house by a new structure. Apart from the references made by Richard Sykes and Popplewell to the project, there is the evidence of a letter dated July 1755 from James Norris, who had worked for the architect James Paine at Doncaster Mansion House. Norris wrote in a small, clear hand: 'As I understand you Intend to build a new house and has already begun you Offices and am Informed you are not Engaged with a Joyner, I shall take it as a Singular favour if you would Imploy me.'[52] Certainly the site itself was fixed from

the beginning of 1756, for in February of that year Popplewell wrote of the high wind, 'which has torn down all the scaffold where the new house is intended to stand'.

Even at that time, however, Lascelles had not entirely made up his mind whom to commission as his architect. He was a desirable patron and in no hurry to bestow his favour. The stables were an essay in Palladian style, a harmonious and admirably proportioned composition, but the well-tried Anglo-Palladian model might prove too conservative a choice for the architecture of his new country seat.

Lascelles must have known Palladian domestic architecture at first hand in his mid-twenties, for in 1738 he was in Padua in the heartland of Palladianism. In that year, he signed the register of English and Scottish visitors kept by the University of Padua,[53] the only indication so far that Lascelles undertook a Grand Tour. By then the University had lost its high reputation as one of the earliest centres of humanist studies in Europe and the town was reported to be in decay. English tourists usually failed to appreciate the medieval and Renaissance treasures of the place and escaped to Venice, sailing along the Brenta Canal in a kind of waterbus past the Palladian palaces and villas situated among the willows in the watery terrain. Canaletto recorded the appearance of Padua and the Brenta in these years in a series of drawings, later worked up into etchings and paintings.[54]

The most characteristic feature of a Palladian villa was the dominating central block, given importance by its pedimented and columned portico. This dramatised entrance to the house was set high on a flight of steps, like a temple. Wings on either side ran out either as straight corridor links or as curving quadrants to terminate in pavilions at either end of the elevation. Three storeys were customary: a rusticated basement, a principal storey, which contained the state and family apartments, and an attic floor of less spacious accommodation. Built in stone, Anglo-Palladian palaces and villas were more impressive in appearance, if less superficially attractive, than Palladio's own masterpieces of brick and stucco. The whole effect was one of balance and dignity for the house was essentially an articulated structure, the climax being the central member on which the more ornamental features of the stonework were concentrated.[55]

To 'improve one's place' implied also the landscaping of parks

and gardens in conformity with the accepted view of Nature as the
perfectable expression of the laws of the Universe and with the
best agricultural practice of the day. Lascelles regarded the plans
for landscaping Harewood and building a model village at the
gates as an integral part of the whole conception.[56]
He was much impressed by the sophistication and elegance of
contemporary French society. He thoroughly enjoyed being a
fashionable figure, very much *à la mode*. His London house-keeper
warned the staff at Gawthorpe to prepare 'for A Great Dell of
graindeur & yr Stommaks and Pallets for all frinsh Dishes for we
air all a Modaparre' (*à la mode de Paris*). The house steward, Fleet,
complained he was 'thote nothing of I am an Inglishman thats my
Misfortune and without a French Tung there is nothing to be
done'. This admiration for mid-eighteenth-century French culture
probably induced Lascelles to search for an architect influenced by
the new attitude then inspiring the schools and salons of Paris.

Neo-classicism demanded essentially a clear vision of the natu-
ral simplicity and heroic qualities especially evident in republican
Rome, seen through direct observation of archaeological remains
and the artefacts of Mediterranean civilisation, as well as through
the splendid and scholarly vision of Renaissance Italy. The in-
formed study of literature and philosophy deepened understand-
ing and appreciation of Graeco-Roman culture, and architecture,
long influenced by the Classical Orders, was at the centre of this
reappraisal of classicism.[57]

It was a movement of European significance, given its remark-
able initial impetus by a brilliant avant-garde circle of French
architects in Rome, where there was a French Academy. By 1750
their brief return to Paris was influencing a gifted, but less hectic,
generation to engulf the city in the first wave of Neo-classicism,
and to discredit the fanciful, insubstantial charm of French rococo
by bringing to favour a style more noble, disciplined and precise.[58]

William Chambers had experienced both the refined perfec-
tionism of a Parisian architectural training and the vitality and
energy of the rediscovered world of antiquity in Rome itself. He
returned to England in 1755 fresh from six years of study in these
two forcing houses of Neo-classicism, deeply impressed by this
European re-interpretation but still aware of the merits of the older
Palladian school. His friend, John Hall Stevenson of Skelton in
Yorkshire, regarded him as a promising candidate to win the

commission for Lascelles's 'New House at Gawthorpe'. Chambers had the additional advantage of knowing the district well since he had spent his boyhood mainly in Ripon, only twenty miles north of Harewood.[59]

John Hall Stevenson was his earliest patron and the association between Hall Stevenson and Edwin Lascelles has fascinating implications.

Hall Stevenson was an eccentric in the grand gothic manner, whose ruinous and romantic medieval fortress near the north Yorkshire coast became the centre of his 'Crazy Castle' group of friends.[60] A connection with Cambridge University, Jacobite sympathies, a love of country sports and military matters, with a liking for literary efforts spiced with pornographic imagery and for 'hogsheads of Liquor and quantities of Tobacco' distinguished most of the members. How far Lascelles was involved with these rakish elements of the county squirearchy is uncertain, but he had a Cambridge background, was MP for the borough of Scarborough nearby and, later, for Northallerton and joined Hall Stevenson's troop, the Royal Hunters, to assist the Jacobite cause in 1745. Moreover, he can be identified with the subject of the *Privy Councillor's Tale*, published by the 'Crazy Castle' circle in 1762 as one of a series modelled on Chaucer's *Canterbury Tales*.

Colonel Hale, a Royal Hunter, married the daughter of Hall Stevenson's neighbour, Mary Chaloner, the sister-in-law of Lascelles's cousin and heir, Edward Lascelles. Her outstanding portrait by Reynolds, apparently commissioned by Edwin, hangs in the Music Room in Harewood House (plate 18).

Captain Robert Lascelles[61] of Mount Grace Priory, near Northallerton, was regarded as the jester at 'Crazy Castle'; he sold the Priory, took Holy Orders, became gamekeeper to Hall Stevenson and kept in touch with the branch of the Lascelles family at Harewood. He and Lawrence Sterne, the novelist, were Hall Stevenson's closest friends and supported his most esoteric venture, the society of 'Demoniacs', a watered-down version of Sir Francis Dashwood's Hell-Fire Club, lacking the macabre quality of the black rituals and atheism of the Medmenham monks. All this would be anathema to Edwin Lascelles and one cannot see him as a Demoniac.

Stevenson wrote from Yorkshire in November 1755 that he had prevailed upon Lascelles to wait for the submission of drawings

from Chambers: 'I beg you will prepare a plan for a house of thirty thousand pounds for Mr. Lascelles ... he has had plans from Every body in England.' He went on to point out the importance of the prize: 'This wd be a great stroke for you if yo[u] succeed, I don't hear of any undertaking of that consequence at present. As you will probably ha[ve] many criticks of all kinds and from all motives [I] need not advise you to be upon yr guard to [submit] as compleat a design as you are able. ... It is to be a country house.'[62]

Lascelles apparently did ask Chambers to produce a set of drawings for the house, but on receipt of them returned an equivocal reply, dated 20 June 1756: 'As I can not possibly call upon you today & you are to go out of Town tomorrow morning, I have inclosed a Bank Bill of £100 for the trouble I have given you in drawings Plans etc, which I hope you will think Sufficient. The Plans are at Lord Leicesters' who had not time to look them over when they were deliver'd to him.'[63]

The Earl of Leicester's vast early Palladian mansion, Holkham Hall in Norfolk, had been begun with William Kent as architect in 1734. It was, however, much influenced by his patron, Lord Burlington, who gave the interior grace and distinction: the Entrance Hall is one of the irreproachable achievements of English country house architecture showing the Italianate quality of movement superbly realised. The Earl was an eminent antiquarian and Lascelles could have been advised by no one more fitted to guide his ambition.[64]

Lascelles's letter to Chambers continued in more favourable terms. He informed the architect that the plans would be brought from Lord Leicester's and taken to Chambers's own house: '[I] hope you wil Perfect them & send them to my Brother's in Mark Lane who wil take care they are forward After me. The Ground Floor, the End Fronts & the attick are what is left unfinish'd.' Lascelles concluded with characteristic caution: 'Be pleased to acknowledge the Receipt of the Bank Bill for fear of accident.'[65]

Clearly Lascelles had been studying and perhaps altering the plans. This may very well have been the case for both his interest in Daniel's house at Plompton and his own relations with Carr make it clear that Lascelles was a patron who in architectural matters would over-ride expert opinion he had himself commissioned.

In the event, Chambers's design was not accepted. It is an

impressive piece of work. The focus of interest was on the first-floor portico, with its large pediment supported on Corinthian pillars dominating a rusticated basement. The terminal pavilions were graceful and in themselves well proportioned, but the entire structure was fitted rather for exhibition than for domesticity, a competition entry rather than a serious and attractive plan for the country seat of a Yorkshire gentleman, however wealthy and influential.[66]

Internally, dignity was given and space wasted by a central tribune separated by staircases from two courts, with the apartments spread around these three features. In the four terminal pavilions there was accommodation at basement level for boots, shoes and periwigs, for a dry larder, for laundry premises, and on the south-west corner a room 'For Flowers in Winter'. A considerable area was set aside for wine and ale cellars with a disproportionately large apartment labelled 'Empty Bottles'.[67] All over the house there was ample provision for purely domestic needs in the way of closets for mops and pails, for coals and brooms, larders and pantries, and one sadly unnecessary suite, nurseries on the principal floor of the North West pavilion next to the room intended as Mrs Lascelles's Dressing Room. Both children died in infancy; a son was born in February 1756 just about the time Chambers would be engrossed in these plans.

Chambers was deeply offended by their rejection. In the third edition of his *Treatise on the Decorative Part of Civil Architecture*, published in 1791, he added a note to the plates of the elevations and the plans of the Casino at Marino near Dublin he had built ten years after the Harewood fiasco:

'This design was originally one of the end pavillions of a considerable composition made soon after my return from Italy ... which among many others his Lordship procured for Harewood House.'[68]

Another competitor may have been Lancelot 'Capability' Brown, whose accounts refer to two general plans for the house.[69] Nothing further is known of these, but Brown was certainly at Harewood as early as the spring of 1758, almost a year before the foundations were laid. A letter written in March by Robert Teesdale, the head gardener at Castle Howard, to Popplewell confirms this. Teesdale had asked the Harewood gardener for 'a few random Pencil Strokes of Mr. Browns Designs for your Place'. They were not

forthcoming, so Teesdale repeated his request to the steward himself for they were regularly in touch, drawn by a common interest in gardening and in the building schemes of their respective masters: '... it would give me some Satisfaction to see any thoughts that has Drop'd from that Great Man'.

Since the drawings were in the hands of the gardener, they possibly were concerned only with the landscaping of the grounds at Harewood, but it is clear that Brown was involved with Lascelles's plans from the very outset.

Despite all this laborious and self-important search for a suitable architect for the new house, John Carr's architectural association with Edwin Lascelles had begun by 1754, and Lascelles was assured in December that 'Mr Carr presents his services and when Ever yo've occasion for him upon the least notice he'll be ready to wait upon you'.

From 1755 until 1758 while the two Carrs were supervising the building of the Harewood stables and the Plompton alterations, John Carr was also building for Lord Rockingham. Lascelles had strong political affiliations in that quarter and architecture, like many aspects of eighteenth-century England, was enmeshed in politics and patronage. This was heightened by Carr's first important work being for the pioneer of Palladianism, Lord Burlington himself. Under his direction, he was engaged on Kirby Hall, a manor-house west of York. The City of York had acknowledged Carr's arrival as an architect by giving him a minor commission and the offer of admittance as a Freeman of York. He had done a town house in Leeds for the merchant Jeremiah Dixon,[70] and a country mansion, Arncliffe Hall, in North Yorkshire for a member of a notable county family, Thomas Mauleverer. Carr's associations and his experience made him highly acceptable to Lascelles. His buildings were soundly constructed, his workmanship impeccable and his patrons distinguished.[71]

From 1755, Lascelles's new house had been occupying John Carr's attention. To this year there can be ascribed with certainty a letter from Carr to Samuel Popplewell which indicates how advanced architecturally Carr's ideas for Harewood House were: 'The Dimensions of the rooms are all figured & an easy access to every room ... I get into the Gallery, Bed Chamber and Dressing Room without going thro any other Room, which seldom can be in such a large house & have two spacious Back Stairs of 10 feet Diamr.'

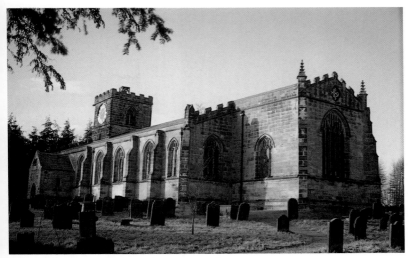

Plate 1 All Saints Church, Harewood

Plate 2 Harewood Castle from the north, from a watercolour by
 J. M. W. Turner, 1798

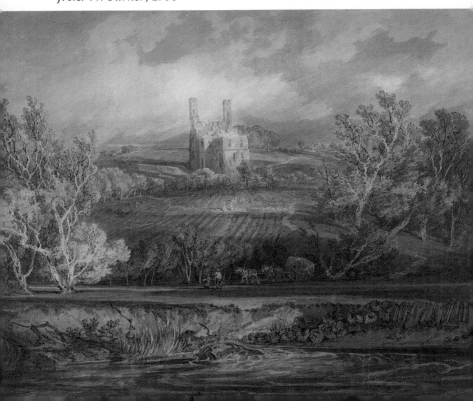

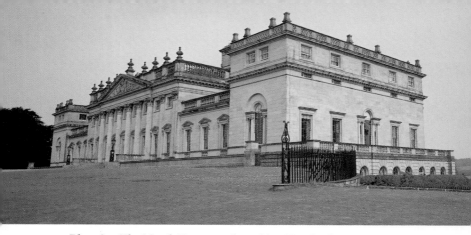

Plate 3 The North Front as altered by Sir Charles Barry in the mid-nineteenth century

Plate 4 Harewood House from the north-east, from a watercolour by J. M. W. Turner, 1797

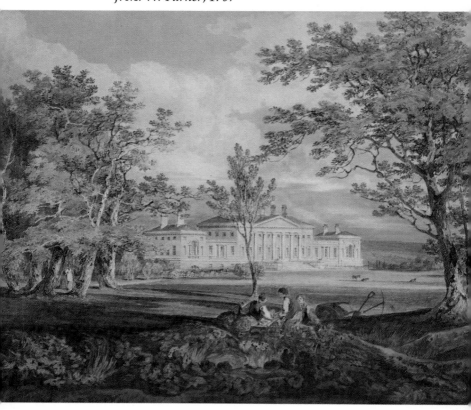

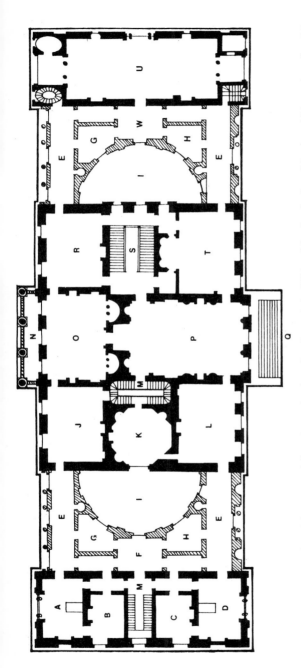

Fig 5 Robert Adam's plan of the principal floor shows the alterations he made in 1758 to John Carr's plan. Adam's ambition to introduce Neo-classical features and to design each room in terms of its specific function is illustrated by his device 'for additional amusement' in the Gallery, two closets set within classical, pillared niches, the oval to display china, the square for miniatures. (SC vol 35, no 8)

A Bedroom: 19ft by 24ft. B Dressing Room. C Wardrobe:12¹/₂ft by 17ft. D Mr Lascelles's Bedchamber: 19ft by 24ft. E Passages. F Lobby. G and H Servant's Rooms. I Semi-circular Courts, diameter: 49ft. J Parlour: 30¹/₂ft by 22¹/₂ft . K Mr Lascelles's Dressing Room, octagaonal diamet: 23ft. L Library: 33ft by 22¹/₂ft M Staircase. N Portico, South Front. O Great Saloon: 36ft by 25ft (22ft high, whereas J and R are only 20ft high). P Great Hall: 30¹/₂ft by 34ft. Q Steps to Entrance, North Front. R Drawing Room: 30¹/₂ft by 22¹/₂ft. S Great Staircase. T Great Dining Room: 33ft by 22¹/₂ft. U The Great Gallery: 24ft by 60ft. W Ante-chamber

John Carr had drawn the plan a month before, but had not meant to show it to Lascelles until several improvements had been made. However, 'Mr. Lascelles hinted to know something of the shape of Mr. Jones' plan upon the Scaffold this forenoon', so Carr produced his rough sketch, which apparently bore some resemblance to Jones's and must have interested Lascelles, for certain drawings were despatched to him by Carr in February 1756, the month the scaffolding collapsed in a storm.[72]

Then Lascelles may have put forward his own or another's suggestions, because in the same month old Robert Carr, cautious and courteous, wrote that what Lascelles asked for would require a good deal of time and that 'everything will be to draw out at large upon large papers', and hinted that it might be difficult to settle on a price. Lascelles expressed surprise 'there Shoud be so much difficulty to Settle Prices required in the Plan sent you. I shoud think that People so well versed as Messieurs Carrs in Building woud be able readily to give a Satisfactory Answer to Every question'.

Matters slowly progressed. In March 1758, Lascelles was enquiring when John Carr would be visiting London on his return from seeing Lord Leicester, who would most probably at least make a cursory examination of Carr's plans for Harewood House. Lascelles suggested he should meet Carr in Town, where they could settle things as well 'if not better than in the Country'.

In June, however, Lady Lindores introduced to Lascelles the Scottish architect, Robert Adam, newly returned from an extended period of study in Italy — like Chambers in 1755 — and setting up practice in London. His interest had been mainly concentrated on the domestic rather than the civic buildings of the classical sites of Italy, and he was determined to introduce into English domestic architecture his own distillation of the Neoclassical style — lighter, more delicate and more suited to both town and country houses than the more sombre background provided by the Palladians. He lacked neither talent, poise nor ambition and influential patrons were soon to endow him with an impressive list of clients. One of the earliest of these was Edwin Lascelles, who showed Carr's latest design for Harewood to Adam.[73]

He found Carr's Palladian elevations ill-suited to any major alterations but he suggested certain changes which he described to

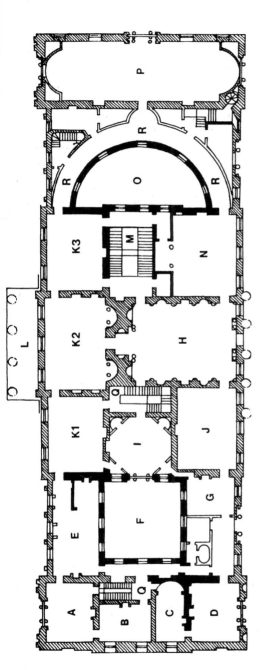

Fig 6 Carr's signed, undated plan for the principal floor of Harewood House represents the compromise between his more conservative, Palladian model on the west and Adam's advanced Neo-classical style for the east of the house, which was built to this joint plan 1759–62. Structural failure resulted in the demolition of Adam's work and Carr was commissioned to rebuild the east side in conformity with his own plan for the west.

A Bedroom: 24ft by 19ft. B Lady's Dressing Room: 29ft by 15.6ft. C Lady's Dressing Room (apse): 18ft by 12ft. D Bedchamber: 24ft by 19ft. E Gentleman's Dressing Room: 27ft by 19ft; servant's room adjoining. F Square Court. G As E; 18ft by 25ft servant's room and closet adjoining. H Entrance Hall, not named as such: 31.6ft by 44.4ft. I Octagonal or Circular Room, named 'Common Dining Room or Supping Room'. J Common Parlour: 33ft by 22.6ft. K1, K2, K3 Gallery extending through three apartments, 30.6ft by 22.6ft, 36.6ft by 24.6ft, 30.6ft by 22.6ft. L Portico. M Grand Staircase. N Dining Room, not named. O Semi-circular Court, Ante-room opening off. P Gallery (unnamed) apsed feature either end: 77ft by 24.6ft. Q Stairs. R Semi-circular passage opening into Ante-room.

his brother James in a letter of 17 June 1758: 'Lascelles's house is now well advanced. I have made some Alterations on it; But as the plan did not admitt of a great many that has prevented the fronts from being much Changed likewise: The portico I make projecting, & bold dressings round the windows, the pavilion fronts are quite different & the Collonades also & look well; Statues etc. adorn the whole, an enriched frieze, & being done to a large Scale, it is magnificent. I have wrote to him & told him my progress, & hope soon for an Answer.'[74]

The most important part of the letter is Adam's postscript which indicated alterations far more significant than the details already so confidently described: 'I have thrown in Large Semi-circular Back Courts with columns betwixt the House & Wings,' wrote Adam with unwitting nonchalance (see fig 5).

His brother replied from Edinburgh on 25 June: 'It affords me the greatest pleasure, to think that you have got Lascelles's plan improv'd to your mind, & that you have tickled it up so as to dazzle the Eyes of the Squire. I hope in the holy Trinity it will satisfy him thoroughly, & that He will bestow a Consultation upon You that will bring it to £700 for advice.'[75]

But, as with Chambers, Lascelles was reluctant to commit himself to acceptance of these changes, which were, despite Adam's protestations, radical in character. The two semicircular courts would give him a house spacious and elegant in its Neo-classical conception of colonnaded interior courts, but it was in the prevailing Palladian climate an affront to long-accepted principles and a denial of Carr's professional ability.

By September, Lascelles had still not sent any answer. Robert Adam referred to his dilatory patron when he wrote to James on 5 September 1758: 'While Lascelles is silent I shall be so But Lady Lindores & all the people there think him prodigiously to blame & declare if he does not write They will never see his face again. I have enough ado to keep them in Temper they are in such a passion For as they say if the Man likes it, It is very Cruel not to say so, & if he does not why wou'd he keep one in Suspence or propose his Alterations, or a new Plan.'[76]

The commission was especially important to Adam since he regarded Chambers as his keenest competitor in architectural practice and to succeed where Chambers had so dismally failed was a triumph not to be missed. He underrated both the acumen

and the ambition of the Yorkshire squire in as great a degree as James Adam misread Lascelles's readiness to hand over a fee of £700 for the expert advice of a newcomer to the London world of the cognoscenti.

During these months, from June until at least September, Lascelles was attempting to make the best of both antique worlds. Carr offered probably the traditional Palladian disposition of the principal apartments, a symmetrical arrangement of rooms grouped round an east and a west inner court with a central axis of an entrance hall and a saloon or general meeting place beyond. Adam's lunette-shaped courts with their curving pillared passages were the essence of Neo-classicism, graceful and restrained, but draughty. To implement this adaptation of classical architecture would certainly be a startling and impressive departure for an English north-country seat; it would also deprive Lascelles's new house of several rooms both at base storey level and on the principal floor.

The solution was in the event an unusual compromise (see fig 6). Carr's plan was chosen for the family apartments on the east side of the house with his Circular or Octagonal Room overlooking the square inner court, Adam's for the State Apartments on the west. Dividing these two differing conceptions of a classically designed interior were the Main Entrance Hall and the Saloon, aligned as customary on the north-south axis.

In the three plans which show clearly attempts to reconcile the ideas of Carr and Adam, it is the more advanced adaptation which was preferred by Lascelles, where the arc of the western courtyard corridors sweep out to the very walls of the house and leave no room for connecting passages between the main body of the building and the wings (see fig 6).[77] Apses at either end of the Gallery, which occupies, as now, the whole length of the west wing, and the entrance to it through a round Ante-room are other notable differences from Adam's extant drawing. Moreover, in the Dining Room a square recess replaces his deep apse (see figs 5 and 6).[78] Adam seems to have assisted with the revision, but it was Carr who drew the final plan as executed between 1759 and 1762.

Harewood House was, therefore, the earliest of Adam's buildings in the pure form of Neo-classicism in domestic architecture. Lascelles's audacity in agreeing to a plan totally asymmetrical in

Fig 7 John Carr's plan of the Principal Floor as published in Vitruvius Britannicus *1771 a comparison with figs 5 and 6 shows the increased accommodation this plan provided*

Fig 8 The North Front, as published in Vitruvius Britannicus *1771; Adam planned to give more 'movement' to this elevation and to add three statues to the pediment and four to each pavilion. His drawing in the Soane Collection (SC vol 35, no5) shows these with flat roofs.*

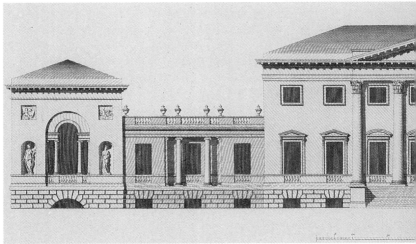

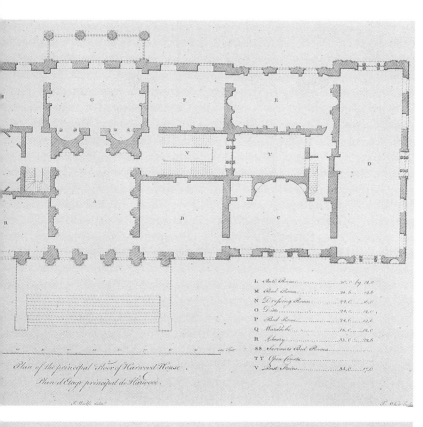

L Anti Rooms....................10. 0 by 13. 0
M Bed Room....................24. 6..........19. 6
N Dressing Room............22. 0........16. 0
O Ditto............................24. 0.......12. 0
P Bed Room....................24. 0......19. 6
Q Wardrobe....................18. 0......12. 0
R Library.........................33. 0......32. 6
SS Servants Bed Rooms.....................
TT Open closets..................
V Best Stairs....................33. 0........17. 0

Plan of the principal Floor of Harwood House.
Plan d'Etage principal de Harwood.

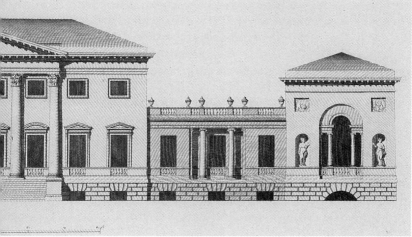

its internal arrangement and incorporating features as interesting in their spatial relationship as those found in early Anglo-Palladian building seems to indicate the influence of Lord Leicester and his own wish to be a patron of unusual prominence.

The consequence Adam and Lascelles evidently expected the new house at Gawthorpe to assume can be assessed by comparing Adam's proposals for Syon House on the banks of the Thames near Richmond. There he designed for the Duke of Northumberland a similar but a more ambitious feature, a great domed Rotunda within the central courtyard, a place intended for the more extravagant occasions of the Georgian social scene, a saloon for fireworks and illuminations. The Rotunda, unlike the semicircular court at Harewood House, was never built; but when a temporary structure was erected in 1768 for the visit of the King of Denmark, it was found that 'Nothing could be more suited to a royal entertainment.'[79]

At Harewood, the Adam court was removed after only three years in 1762, when the construction was barely complete, and the West Wing of the house was then brought into conformity with Carr's Palladian plan (fig 7). Yet some of the Adam work in the rooms themselves remained, notably in the Dining Room. To Adam this apartment was a focal point within households of the English nobility and gentry, where here conversation might circulate freely with the port after the ladies had withdrawn. Hence this room must assume a leading role in any parade of apartments, 'fitted up with elegance and splendour', but not with damask hangings lest it 'retain the smell of victuals'. Stucco decoration was the ideal choice.[80] The virtual loss of Adam's Dining Room at Harewood House during the nineteenth-century alterations is as distressing in it way as the failure to retain his Neo-classical courtyard (see figs 17, 18).

Preparation for building to the joint Adam-Carr plan began late in the winter of 1758. Carr and Popplewell were left to get down to practicalities, and their work is evidence both of the method of constructing a great house and the dominating influence exerted by a patron such as Lascelles. They set out the pattern lines on the slope of the hill overlooking Gawthorpe, where the site had been located since 1755. Carr wrote on 22 January 1759, sixteen days after the work on digging out the foundations had actually begun, that on redrawing the plans for execution he had found it neces-

sary to extend the wing walls and house 9 inches at each end. He therefore asked Popplewell to see to it that the labourers dug 20in beyond the old stakes on the west side and the same distance beyond the first stake at the East Wing. This must be done as a matter of urgency 'to prevent Mr. Lascelles finding fault if they do not dig far enough, which I beg you see is done before he comes back, if you can'. More important than an extension of a few inches on a frontage of about 250ft is Carr's remark that he was still making alterations to the plan of the house, changes which Lascelles had seen and approved of only the day before. The Circular Room was now extended in diameter to 30ft, 'without either enlarging the house or altering the size of any room but one which room is large enough to the full for its use'.

This almost impromptu attitude characterised much of the building of the period, so that considering the chaotic delay in the arrival of materials and habitual disorganisation in the building trades and the reconstruction of the house in 1762, the landscaped picture of imperturbable serenity which Harewood House presented within a comparatively few years of its completion was a remarkable achievement.

For notes on this chapter see pages 169-74.

2
Building the House

Work began early in 1759. On 6 January John Wood and his partner were paid £2 13s 0d for 213yd 'of diging at East End', the first payment by Popplewell for 'The New House at Gawthorp'. A note signed by Muschamp records that the foundation stone was laid on 23 March, a ceremony carried out by Edwin Lascelles himself.

The house was planned to take advantage of a site which sloped towards the south and the foundations on the north front ran into the hillside. This excavation created a basement area, as in a town house, with a vast range of cellars underneath the carriage drive. It was an appropriate feature for Harewood, since it was probably in origin a characteristic of merchants' houses, where from medieval times greater storage space was necessary than their narrow gabled tenements could offer. The idea of a vaulted cellar under the street was retained in eighteenth-century town-planning. In London, coal for the Lascelles's household might well have been delivered directly into the cellars through a circular coal trap set in the pavement above.[1] At Harewood House, an arcade of doorways in the retaining wall opposite the north front base storey gave at once easy access and a touch of Palladianism to their design.

During the early period of building, Popplewell was concerned with the foundations which were being dug out by contract labour; for instance, in August 1759 he noted a payment 'for cellar drain and Water closet Diging'. In smaller houses of the period, the drain simply ran directly under the house into a common sewer or a private cesspool. The stone-flagged drains at Harewood with

their brick arches overhead followed a more complicated pattern, but did not represent quite the latest development in sanitary construction. The system at William Kent's new Horse Guards building in Whitehall had inverted brick arches which joined the upper arches to form a brick tunnel, an innovation which reduced the chances of obstruction to a minimum and was thought to be the latest design in drainage.[2] By 1770 matters were advancing at Harewood, for in May the masons were 'sinking & laying down a concave Bottom in West drain'.

The problem of sewage remained acute where it could not be emptied conveniently into a river or the sea itself. At Harewood, neither the River Wharfe not the little Stank beck offered a suitable outlet. Each water-closet had its well leading to the main drain and there was a bog-house or cesspool at an agreeable distance from the house. One useful contemporary solution was the erection of chimneys to disperse the noisome vapours more effectively and safely, 'for pleasure can never be where there is not health'.[3] This device was incorporated in Harewood's plumbing and in December 1763 one of the masons and his labourer spent a day 'Raising Chimney to Drain at E. End of house'.

The assumption that the sanitation of the great houses of eighteenth-century England was totally at variance with the elegance of their interiors and distressingly inadequate for those who lived in them is certainly erroneous as far as Harewood House is concerned. The omission of any specific reference to water-closets, or to the only closet named as such on Chambers's plan of 1755 for the principal floor, does not reflect the actual situation.[4] There were, in fact, several. The family one was situated as recommended 'far removed and connected by a passage', leading from the suite of rooms it served, and it had a carpet fitted by Chippendale's firm.[5] There was also the luxury of a hot bath room in the basement, below the Drawing Room.

There is no doubt that at Harewood House the desired degree of efficiency and convenience was not always achieved. The flue of the brick-lined chimney in the hot bath room had to be altered before the plastering could be done, and in 1768 William Lofthouse, one of Muschamp's most experienced masons, spent three days 'Stopping Holes and Plaistering Walls in N. water Closet to prevent any air going up into the Rooms in the Principall Floor'. His wage of Is 6d a day was exactly the cost of casting one foot of

the large lead pipes used for a water-closet in the house.

The rain water, which ran off the widespread expanse of roof into lead gutters through spouts and down fall-pipes, had to be taken into account in planning the drainage system. Here again the prevailing approach to constructional problems tended to be pragmatic, a system of trial followed all too frequently by error. In the autumn of 1763 John Muschamp's work included the setting up of the East Wing cornice and 'making the gutter deeper for more fall'. Adam's portico leaked until alterations were made to allow the rain water to escape through more acceptable channels.

The main area of drainage was, of course, in the basement of the house, where at the cost of 4s 6d a rood, one hundred roods of small brick arches were built. The use of brickwork in the foundations themselves was extensive. A brick arch about 5ft long acted at the centre as the focal point for the distribution of the weight of the whole structure overhead and around the arch was built a great catcomb of brick compartments. Some of the bricks here seem re-used material, uneven, coarse and rough in texture. Bricks were necessary, too, as a precaution against fire in the interior of chimneys and underneath hearths. Moreover, most of the partition walls were of brick and the exterior walls were lined with the same material. These outer walls, having no cavity nor rubble infilling, are a solid composition of stone and brick. Although it is not obviously the case, much of the house was constructed in brick rather than stone.

This made it essential that Lascelles should overcome quickly the difficulties caused earlier by the expense, delayed delivery and uncertain quality of 'those damn bricks', which had so much annoyed him during the erection of the stable block. By the spring of 1758, he had apparently managed to begin a stock-pile of bricks of the standard he demanded for his new house and, in April, he ordered 'the hardest & best from those already made for the inner walls' of the stables to be picked out by John Dodgson, 'against the time they will be wanted'. Lascelles continued to employ Dodgson as his bricklayer. The agreed contract for the brick walling was by the rood. Dodgson charged for 1,110 roods in the principal storey and over half that length in the attic. His statement emphasises that the thickness of all these walls had been 'reduced by Contract to one and a half bricks', a momentous stipulation in the event.

Dodgson also made 882yd of chimney tunnels and set brick

arches over 362 doors and windows. These arches cost 1s each and his bricklayers earned 1s 8d a day. Over the period of five years, Dodgson's bill came to £680 10s 10d inclusive of alterations. He was paid eight times on account during this time and the balance of his bill, £119 12s 0d, at the end of January 1766 after John Carr had measured and checked the work (see fig 10).

The bricks of the house were made on the estate.[6] Local clay was good and a few square yards sufficed for a brick field. Kilns were cheap and easily constructed. Yet Lascelles was still faced with the comparatively high cost of coal to burn in the kilns and the supply of labour necessary to convey the finished bricks to the site. He could not rely solely on his feudal rights as Lord of the Manor to exact coal 'boons' from his tenants, for this was an occasional and rather inadequate form of service. Popplewell had to pay for coal to be brought to Harewood by 'sundry people', some of it from seams owned by the Gascoigne family to whom Old Gawthorpe Hall had once belonged. Bills for 'leading' or carting bricks were numerous and the job was done by various men, but always at the same contractual rate of 1s for one thousand bricks. Thus Lascelles profited in every way from organising his own suppply. He could control not only the quality, but the regularity of delivery, for bricks were made only during the summer months, and it was a branch of the building trade where quick profits could enrich the maker and supplier at the expense especially of those who needed, as Lascelles did, bricks in tens of thousands.

The architectural merit of the house depended on its masonry. External brickwork, so fashionable earlier in the century, had been replaced by stone, which the new generation of architects judged a more fitting medium to display their talents to advantage. The expense of conveying stone from the quarry face to the site induced those gentlemen who built their country seats during this period to use what was available on their own estates. The result was often a masterpiece superbly in harmony with 'the genius of the place' and the gritstone of the Harewood district was especially well attuned to its setting.[7] When John Wesley saw the house in April 1779, he wrote in his journal of the 'fine white stone, with two grand and beautiful fronts' (plates 4, 6).[8]

To get the stone from the quarries on the north of the estate simple equipment had already been installed during the building of the stables. In December 1759 John Sanderson was paid £2 5s 0d

'for an Engine making to draw stones out of the Quarry's'. Windlasses, pulleys, blocks, ropes, soap and oil were supplied. Ropes were sold by weight and delivered to the Harewood quarrywright, crane ropes costing $4\frac{1}{2}$d a pound. Traces for the masons to handle the stone were sold by the dozen, also by weight. The blocks could be rough hewn either at the quarries or the site, since transport was no problem over so short a distance; moreover, the stone could be cut before the sap had time to dry out.

John Carr and John Muschamp were possibly the most able partnership of architect and master mason in the north of England at this time. Under their direction a small team of about a dozen local masons worked regularly throughout the years of building, from 1759 until 1772, and were part of the establishment of the estate. William Burland, John Cryer, Jonathan Drake, Thomas Kendall, William Lofthouse, Thomas Muschamp, Robert Pullen and Richard Waters were all living within the bounds of Harewood parish and Cryers and Kendalls had lived there since the seventeenth century.[9]

These were craftsmen of skill and competence, working under expert guidance. In the rusticated basement, where the prominent, dressed stones or rusticks were set in recessed mortar courses, each rustick was carefully matched for colour. Thirty of them 'work'd for the outside not being a good colour' were set aside for the walls in Carr's inner court on the east side of the house, where the defect would not be so obvious as on an exterior elevation. Muschamp estimated in December 1760 that the labour of reducing the length of these stones from 15 to 13in for use in the court should employ only one of his men for no more than nine days at the usual wage of 1s 6d a day.

Every arris, the finely chamfered edge on rustics, is still sharp and clear, and the stones stand out in bold relief against the shadowed lines of the mortar. On the North Front the effect of this heavily rusticated base has to some extent been lost (see plates 3, 4 and fig 4). During the nineteenth-century alterations, the level of the carriage drive in front of the house was made up, and Carr's impressive flight of ten entrance steps reduced so that the lowest storey is scarcely visible on approaching the house. On the South Front the base storey, here at ground level, is not seen to full advantage, and the removal of Adam's portico has bereft this elevation, too, of much of that harmony and proportion which

originally distinguished the house (see plates 5, 6). The quality of 'movement' so prized by Adam is no longer there.

Above the rustication, the principal and attic storeys of Harewood House have a flat, plain surface, with the great ashlars, the blocks of dressed stone, set in mortar courses so thin that the joints are scarcely apparent. This monotony is relieved by Adam's striking window dressings and the balustrading below each window, with the Venetian windows accentuating the fenestration, the pattern of windows, on three elevations. The entrance front, traditionally on the north in houses of this period, is further enriched by the three Corinthian pillars on either side of the doorway, engaged (that is set against the wall) so that there is no sheltering portico on this front, a feature which Adam had suggested should be built only on the more exposed southern façade.

All the stone work was also undertaken by contract. John Muschamp agreed to build rustic work at 6s a foot and ashlar work at 5d. According to his 'note of all the particulars of the masonry inside and outside the house', the present exterior walls of Harewood House (apart from the nineteenth-century additions) were faced with stone at the prices quoted; in the base storey there were 11,740ft of rusticated work and, for the principal and attic storeys above, 56,488ft of ashlar, cut in the large blocks characteristic of north-country building.[10] Muschamp had also contracted for the three main staircases at 8d a foot, with a reduction of 1d for the 'plainer steps' of a fourth staircase situated in the West Wing, and for the erection of the chimney tops, with the great arches over the Gallery which supported them. The chimneys had the 'inside of the funnels work's circular'. His account came to £3,570 6s 6d. There was, however, an additional charge of £240 8s 10d for alterations.

A second and quite separate 'bill of particulars' gives details of the masonry in the foundations. Here stonework was less important than brick and the bill was correspondingly lower. Rough walling, in which the thickness varied from 1ft 6in to 5ft 6in and the prices accordingly from 5s to 11s 9d a rood, some stones dressed on one or both sides, the arches in the cellars and the flagging of drains at 3d a rood cost in all £137 12s 2d: the account included, in fact, 'everything but the hewn work' in the foundations.

Muschamp's charge for the masonry of the basic structure of the house amounted, therefore, to £4,238 10s 11d. John Carr approved

the work and set his neat, yet florid, signature to Muschamp's bill. Carr was paid his annual fee of £60 'for his drawings and attendance' and a further £2 14s 0d was given by Popplewell 'for his man's board when measuring off' (see fig 10). Lascelles must have considered his new house sufficiently advanced early in 1765 to warrant the customary present to the master mason 'at the rearing', for in the first week of February Popplewell paid 5 guineas to Muschamp 'allowed by Edwin Lascelles Esquire, when the House was roofed'. Muschamp himself noted three separate dates for the completion of the roof, June and October of 1763 for that over the east and west wings respectively, and September 1764 for the main body of the house.

The most significant item in these 'bills of particulars' submitted by Dodgson and Muschamp is the reference in both to alterations. These were occasioned by the crisis of 1762 when the brickwork and masonry of the square and semicircular courts had to be taken down so that all the structure might be strengthened. A major reconstruction of the plan of the house followed.

Dodgson's bill, while stating merely that the alterations are included, stresses throughout that the thickness of the foundations was everywhere 'reduced by contract to one and a half bricks'. Muschamp's bill is quite explicit; his rusticated and ashlar work in the courts was taken down; 134ft of the masonry was set up again at 2d a rood, but 6,602ft of 'ashlar work'd circular' was removed at an expense of $5^1/_2$d a ft and there is no mention that it was re-used. Adam's semi-circular court was not rebuilt.

The extent of the unforeseen labour involved is clear from the interim payments made to the two men during the years 1759-65. Dodgson's payment on account for the year ending November 1762 was conspicuously higher than any other of the annual disbursements noted by Popplewell. Muschamp received in June 1762, £240 10s 0d, a figure in excess of several sums paid over to him throughout the period.

The construction of Adam's western semi-circular court was in progress as late as May 1762 when the door into 'the Common Dining Room' from the court was altered. The lintels for the doors at the ends of the crescent-shaped passage, which encircled the arc of the open court in the west, were then already in place. In November 1761 Sanderson, the chief carpenter, had his men working at the casing of the dado there, for the passage presum-

ably had to be covered in to give comfortable and weather-proof access to the Gallery, reached through the round Ante-room (see fig 6).

Possibly there was a second covered way from the inner hall of the Main Staircase across the court to the Ante-room, and in June 1762 the men were taking down the floor over the semicircular court. By next month Adam's court had been obliterated; Dodgson refers to 'levelling for the masons where the circular court was'. A rough plan of the proposed reconstruction shows the west side of the house only, with the new plan clearly indicated; the staircase appears as two consecutive flights.[11] Lascelles's own handwriting is scrawled across the Gallery which he seems to have thought of dividing into a Lady's Dressing Room, a State Bedchamber and a Gentleman's Dressing Room, a clear indication that Lascelles was always the patron rather than the client of his architects.

The revised plan was implemented without any undue delay and there was no change in the disposition of the rooms round Carr's east court. Efforts were made to ensure more efficient drainage and the 'octangular room' was strengthened by the insertion of two beams. In 1767, iron reinforcements had to be 'let into the partitions of the Circular Room to stay them'. The new Billiard Room was situated in the basement under the Dining Room, a more suitable location socially for noise travelled less readily there, and the Coffee Room was next door.

On the Western side drastic reconstruction followed the demolition of the circular court and the Ante-room leading to the Gallery. A small square court was made, a rather cramped and utilitarian area, which allowed less light to penetrate the Venetian window on the half-landing of the Main Staircase. The door from the staircase into the circular court was walled up and the steps of the staircase altered. The walls of the Staircase Hall had to be partially rebuilt and the western wall in particular was 'thickened'. The inner Hall of Harewood House is therefore now disproportionately small, an unworthy setting for a fine staircase (see fig 7).[12]

The Gallery was naturally the room most affected by these changes. It lost much of Adam's Neo-classical character, but it became an integral part of the life of the house, no longer isolated from the apartments on the principal storey.

The only entrance through the Ante-room was removed to

make way for a single fireplace, probably on Carr's advice. The chimneys of the pair of fireplaces which had flanked this entrance were blocked up, and a doorway was cut at either end of the wall so that the situation was reversed; the eastern wall of the Gallery now had one fireplace set between two doors. Neither the plan of recesses supported on columns, nor the alternative scheme of semi-circular niches, was realised so that the room assumed an air of uncompromising severity, deprived of these devices used so successfully by Adam to give interest and variety (figs 5, 6, 16). The Gallery at Harewood presents today an unimpeded vista of enriched magnificence, flooded with light from the three great Venetian windows; a room indeed 'intended for grandeur', commanding attention, but devoid of any subtlety of architectural treatment[13] (fig 15).

The loss of Adam's court made it possible to have two more rooms opening from the Gallery. At the south end a second Drawing Room was created between the Gallery and the 1st Drawing Room, which then became the family's sitting-room. At the north end there was a new Dining Room, situated between the Gallery and the former Dining Room, now called the Music Room (fig 7). For this new Dining Room Adam's original design was accepted. The Main feature was the long, deep semi-circular recess on the south wall, with two niches set within the opening, a bolder and more complicated scheme than the square recess of the now abandoned plan (see figs 6. 7, 17). But the purpose differed from Adam's first intention; the apse held a fireplace and not a sideboard with its attendant wine cooler, urns and pedestals, thus completely destroying his conception of the space as a prominent setting for this important new group of furniture he sought to introduce into the range of English furniture design[14] (see plate 17). Conveniently, the staircase could, with only minor adaptations, be arranged to lead down to the wine cellars, which were reached just as easily from the new as from the old Dining Room. Late in June 1767 William Lofthouse spent five days 'Raising the Wall in West Court where the large pipes of wine go into the cellars'.

Work continued in connection with these major alterations beyond 1765, but the remodelling of the structure was considered to be complete in that year. Demolition had been swift; on 12 June 1762 Popplewell wrote to Lascelles: 'The Walls & rubbish in the

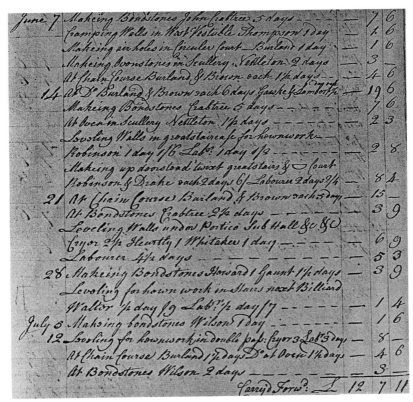

Fig 9 Details of work done by John Muschamp's masons at Harewood House in June and July 1760. The building of the house had been in progress since January 1759. The entries show Adam's semi-circular court — indicated by a \smile sign — under construction (14 June), and his portico already built (21 June). (HA Building Accounts 492)

New House will all be finished pulling down and removing today'.

The year 1762 was a difficult one in every respect. February brought 'a great storm of snow and wind', Carr was dilatory in going to Hull to purchase supplies of timber, glue, and Dutch lathes, and failed to buy iron when he got there. The severe frost damaged the fabric of the house, so that repairs were necessary in the East Wing, and a Venetian window in the Gallery suffered; earlier, flagstones in the kitchen had to be reset. Perhaps these circumstances helped to confirm Lascelles in his decision to re-

build his house on an entirely Palladian plan, a more utilitarian, a less expensive and certainly a less controversial model (fig 7).[15]

From 1762 until 1764, Muschamp's masons were exceptionally busy on the exterior of the house. They took the blocks of carefully selected stone — freestone, which could be cut in any direction -- into the carvers' shop to be formed into capitals and other decorative details, and they assisted the carvers to take the finished capitals off the stocks and hang them in position above the shafts of the columns.

Long bondstones were cut to go right through the fabric of the outer walls binding them together, and iron cramps were put in to act as staples so that the blocks of ashlar should remain firmly fixed in position. The masons were constantly required to help the carvers with the iron chain courses which tied the columns securely into the masonry of the outer elevations (see fig 9). One of Muschamp's labourers was paid sixpence for a half day's work 'clearing rubbish' out of the carver's shop, for his men had to turn their hands to any job on the building site.

Inside, the carpenters responsible for the timbers essential to the construction of the house were directed by James Sanderson. Oak was by far the most important wood for his purpose, but English oak was scarce and not suited to the construction of a great house like Harewood.

The curved members which developed were ideal for the framework and repair of small houses and farm buildings, but the boards were short and often the timber was knotted. Although some local oak was bought for Harewood House — a quantity came from Daniel Lascelles's estate at Plompton — the bulk of the wood was imported through Amsterdam. It came in a variety of girths and most commonly in lengths of 12 or 13ft or 14ft 4in. Yet the well-matched, finely-grained boards chosen for the Gallery floor were still not satisfactory and had to be relaid.

A canvas-backed drawing, which gives the specifications for the oak timbers of the roofs and ceilings, notes that the beams of the Sub Hall in the base storey are to be $10^1/_2$in by 12in, and the ceiling joists throughout 3in by $2^1/_2$in: for the roofing, 'Every 4th joist a deep one 3 inches thick & 11 inches deep'. The Westmorland slates of the roof hung on oak laths.

Deal, or fir timber, came from the Baltic countries into the port of Hull.[16] Great quantities of deal were brought to Harewood,

often as $2^1/_2$in or 3in battens and deals. In December 1763 the Hull merchants, Thorley and King, sold Lascelles 340 pieces containing 10,037ft of deal, one of many consignments. The use of such comparatively inexpensive wood was endless. It served for scaffolding, temporary floors, temporary window frames, where oiled paper kept out the weather and the light until the glazing could be done, for ladders, benches, trestles, planks and similar equipment used in building and in certain parts of the house itself, for instance, the architraves of some of the doors, where high-quality timber was not necessary.

Selecting, measuring and checking both local and imported timber was exacting and time-consuming with the added problem that only local timber could be chosen before felling. Nor were visits to Hull and inland navigation centres like Tadcaster the end of the matter, for discrepancies in the quantity of wood received at Harewood could occur despite previous careful investigation of short measure.

There was so much business to be negotiated that Lascelles was forced to submit to the expense of employing an agent, William Smith of Leeds, who was also expected to give assistance with the measuring and the arrangements for the transport of the timber to Harewood. Smith represented a growing sector of industry, buying and selling rather than handling or using the materials he dealt in. Normally Lascelles allowed no middle men to interfere with his building and improvement schemes at Harewood, and a man like Smith tended to be an anomaly, alien to an occupational structure made up of unskilled labourers, building craftsmen, decorative artists, firms and tradesmen supplying materials and goods directly to Popplewell.

Smith was astute and efficient and, because he was indispensable, his accounts seem to have been paid unchallenged. He took charge of all the routine of customs payments and duties at Hull, went to Scarborough to arrange for the charter of a ship, charged Lascelles for drink money for a crew and wages for his personal servant, for postage and for any loss he incurred through varying exchange rates. He travelled to Amsterdam and Norway, where English firms had representatives, taking £35 4s 4d as his premium in both countries. The commission on the wood he purchased for Lascelles could rise from 3 per cent to 10 per cent and he asked for a guinea for the timber merchants, Thorley and King, 'as a present

for their measurer'. His bill from June 1763 until April 1764 was £1,172 17s 8d; Sanderson's charge for roofing the main body of the house was £104 10s 1d.

All the timber was sawn, when necessary, in saw pits at Harewood, oak and deal, some sycamore and ash, and the mahogany for the doors. The job was exhausting, seasonal and thirsty; it also required, naturally, two men at the same time. These disadvantages meant that sawyers did not have a reputation for reliability. The men who sawed or slit the wood to be used in the house were possibly exceptional in the regularity of their employment and indeed in their skill; for the most part they were local men often accustomed to working in partnership. At first the sawyers were paid on piece work output, but later on contract by the length of wood sawn: 7s 6d a rood for deal, 10s 6d for oak and ash, and £1 0s 0d for mahogany, with 'finairs' for seasoning the wood at 1d a foot.

When the wood was considered to be sufficiently seasoned or 'fineaired', it was then brought to the site for the carpenters. Apart from the construction of the roof and floors, and the framework of doors and windows, Sanderson's recorded work between 1761 and 1768 was concerned with casing, or covering in wood, pilasters, doorways, pediments over windows and the lower section or dado of walls. He made wooden centres, on which to construct arches, and wedges for the staircase, which later he slackened according to the state of the fabric. He had his share of alterations in the west wing roof and in the floors of the servants' rooms over the Gallery, where in 1765 the trusses were forcing against the walls and bearing joists had to be put in.

The account for the initial period of his contract work was examined by Carr and receipted in February 1766, for a total of £610 18s $4^1/_2$d. If supplies of wood were difficult, the carpentry was relatively the least expensive item in the house. Sanderson constructed 225 centres for the doors and windows of the house for 1s 3d each, although those for the Venetian windows were 3s, and 1s each was charged for the lintels over the doors.

A second account was submitted in January 1769 for £266 18s 10d, which included £4 13s 6d omitted from the previous bill for work on the portico and 1s undercharged for work on the attic storey. A detailed statement is given of the carpentry in each room of the principal storey, dealing mainly with finishing the floors,

putting up brackets to hold the cornices in position for the plaster-
ers, and preparing the walls for them by fixing timber framing or
'stoothing the partitions', that is fixing in place the laths on to
which the plaster could later be keyed. The Circular Room had to
be fitted with 'circular framed stoothing' and both coved and
corniced brackets. Particulars of his work for the attic and base
storeys are not given and only a modest total is quoted. All prices
are said to be pre-fixed.

Sanderson — a name written by Lascelles as Saunderson, a nice
touch of distinction — died in 1768. Daniel Nunns, who had been
his chief assistant, took over as head carpenter in September of that
year. The previous month Sanderson's window was given £9 16s
6d in settlement of her late husband's work. A further examination
of his affairs revealed, however, that over a period of eight years
he had received about £40 in excess of his earnings, which amounted
in all to £877 7s $9^1/_2$d. Popplewell's ledger noted, therefore, that
Mary Sanderson had been 'overpaid for carpenter work at the new
house £39 7s $9^1/_2$d' (see fig 11). In October 1769, she repaid the
money, signing her name in an uncertain hand.

The incident illustrates that master craftsmen like Sanderson
had no need for any accumulation of capital when they were
employed on an establishment basis and a contract had been
agreed. Advances or 'payments in part' were not necessarily
retrospective payments. In this case the materials were supplied
by Lascelles, a precaution which obviated the growing tendency
for building craftsmen to engage in profitable sidelines.

One of Sanderson's last jobs was an alteration to a book-case in
the Study. Since this was a type of work associated with the
finishing of the interior and not with the actual carcase of the
house, it was the province of the joiners rather than the carpenters.
But there was no hard and fast line drawn between the different
crafts and their work usually overlapped. This was especially true
in estate building where the effort tended to be communal.

Riley and Walker, the joiners chosen, were a Harewood firm
and Riley seems also to have acted as Assistant Clerk of the Works.
They were responsible for the interior wood work, so that the
quality of their work was thus of primary importance and in the
principal storey especially the artist craftsmen enriched these
surfaces with carving and gilding.

The famous mahogany doors of Harewood House are perhaps

the best illustration of this dependence of the artist craftsmen on the skill of others working in the same medium. The wood from the West Indies was brought into Hull and taken, as was customary, by inland navigation to Tadcaster, freight duty being paid to the Tadcaster Navigation Company of which Lascelles was a trustee (fig 11).[17] The greater part of the sawing was done by Mawson and Senton, a local partnership (fig 10). Mawson could barely sign his name and spelt it Maoson. By contrast, Whitehead and Nicholson sent in a most efficient statement in fine copperplate handwriting. Only a few teams are on record as sawyers of the mahogany for the house. They all did their work well. The straight-cut grain of the great doors is as much part of their beauty as their carved enirchment.

The condition of the wood which enabled this crisp, clear-cut definition of Adam's classical motifs to be done with such perfection was due to the meticulous care with which Riley and Walker's men seasoned the timber. Benjamin Wade seems to have been responsible for this. He saw to it that the mahogany was carried to and removed from the pits. A stage was made so that it could be dried out and turned more easily; it was not kiln dried, like the wood for the columns in the Hall, at Arthington kiln a few miles away. The doors, when made by the joiners, were again 'fineaired' or seasoned on benches, and turned once every two weeks through the autumn months. They were then sorted out and brought into the house at the beginning of 1767, when the first reference to this occurs. Pieces were fixed on to the joints of the doors and then the joiners marked out the doors for the carvers to begin work. A note written upside down on a leaf of the last page of a Day Work Book for Saturday 28 February 1767 states that 'the rasings on the back of Pannells of mehogany Doors were smoothed of but not polished of & they were then sunk down for a cross band to be laid on'. The joiners also planed boards for the 'carvers to cut ornament on', worked pattern moulds for the carvers, set up benches so that they could sharpen their tools, and made a saddle upon which they cut out the bases for the columns of the Hall. Then they helped to remove the carvers' benches.

Their work as master joiners was equally varied. They put in and took out temporary windows, laid temporary floors, hung temporary doors and glued ornamental mouldings permanently on to the interior elevations, on the walls, door frames and shutters

in the principal storey. They altered some architraves, in one of which the deal was so bad it could not be carved, and, like Sanderson, they also altered bookcases in the Library and the Study. They 'fitted glass into the rabettes of the sash frames on the principal floor'. Rabettes, or 'rabbits', were the rebates or beds of wood prepared to receive the panes of glass. Rhodes and Tarboton, in partnership as plumbers and glaziers, soldered thin strips of lead, which, grooved on either side, held the panes firmly in place in the wooden frames.

Hung-sash windows had been known in the houses of well-to-do Yorkshiremen since the beginning of the century. Lascelles ordered them to be put into Popplewell's new house, but not others on the estate. Rhodes and Tarboton cast all the weights for the sash cords of Harewood House, using up 342 stones of lead in the process. Normally, the lower frame only was made to open and the upper remained fixed.

English Crown glass was the usual choice for windows since the import of glass was heavily taxed.[18] This was blown in the traditional manner into large circular panes, the thick bull's eye in the centre being regarded as 'waste', not fit for first-class work. The original panes can be recognised in Harewood House, especially on the North Front, because a blue-green sheen and the wavy effect of the curvature of the surface is apparent in certain lights. Some of the glass came from Newcastle and Tyneside was famous for its manufacture, but the handsomely produced bill-head of a glazier and glass cutter in 'Vere Street', Clare Murket' records the carriage from London by waggon of forty large squares, $130^1/_2$ft of glass packed in a box valued at 5s. Some plate glass was also used.

Glazing bars became narrower as domestic architecture reflected a more sophisticated style of living and, whereas Wren had popularised a 2in bar, those of the windows of the principal storey of Harewood House were reduced to $1^1/_2$in in thickness.[19] Edwin Lascelles could have a pleasure sought by most owners of a country seat in his day, that of gazing without undue architectural interruption upon 'a rich home view over fields and woods'.[20] From such acres came the income imperative for building on the scale envisaged and accomplished by him.

One of the most costy materials was lead. It rose from £13 10s 0d in 1755 to £15 15s 0d in 1758 and, despite Lascelles's hopes, the

increase continued. The Yorkshire Dales still had productive lead mines, worked since the Roman period, but to bring one ton of lead from Grassington, only thirty miles away up Wharfedale from Harewood, cost £1 and the charge increased as the decade advanced.

The lead arrived as 'pigs' and was cast into sheet lead at Harewood on a bed of sand by Rhodes. On average, 10lb of pig lead made 1sq ft of sheet lead suitable for roofing. Rhodes and his 'man' were each paid 2s 6d a day, the price of casting about 14lb of lead. They needed solder, a mixture of lead and tin, at 9d a lb, and numerous glue pots to heat it in.

To make pipes, molten lead could be poured into brass moulds which held iron cores of varying diameter, but Rhodes adopted the cheaper method of wrapping the metal round wooden cores made by Sanderson's men, and soldering the joints.[21] The largest bore of pipe made in this way cost 1s 6d a ft, but a more usual price was 6d a yd. Some of the lead piping on the outside of the house is thought to date from this period. Obtrusive, highly ornamental rainwater heads with the owner's crest cast in high relief were out of fashion. The muzzled head of the Lascelles bear makes only a modest appearance and the lead plates or 'ears' which hold the pipes against the wall are similarly inconspicuous[22] (see fig 2).

Unlike lead, iron was used as a decorative material. Its primary function in mid-eighteenth-century building was structural, however, since less massive masonry required iron cramps, rods and chain courses to hold the fabric securely at the right degree of tension. At Harewood House iron reinforced the walls of the Circular Room and Music Room and shored up the Great Staircase.

Iron was bought by the sheet from John Cockshutt's Works at Wortley in relatively small quantities to make parts of the quarry crane, the wheels of barrows, the fastenings of doors and gates, for shovels and for the plates of builders' hods. The works also supplied iron to the smith, George Shaw of Leeds, from whom nails of every length for every purpose were purchased in their thousands. Shaw also sold Holland twine, glue, resin, beeswax and hinges (see fig 10). His bill from February until December 1765 amounted in all to £119 17s 10d, but Riley deducted 2s 4d from his payment in January 1766, since the usual methodical checking of materials on arrival at the site had revealed 7lb short weight in a

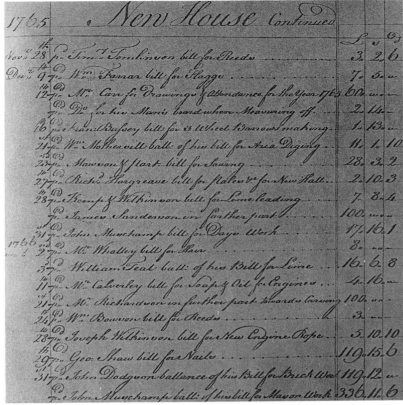

Fig 10 *An extract from Samuel Popplewell's Ledger, November 1765-January 1766, for the 'New House At Gawthorp'; the name Harewood House was not used until the late 1760s. Payments of the balance due to the mason, Muschamp, and to the brick-layer, Dodgson, show that their contract work has finished and that the shell or carcase of the house is virtually complete*

consignment of nails the previous day. Tradesmen's bills were promptly paid.

Following the customary pattern, another branch of the smith's craft was called in to do the more delicate work. The whitesmith who did the finer metal fittings at the house was Maurice Tobin of Leeds.[23]

Tobin's bill of November 1768 shows the range of a whitesmith's work. He supplied long hinges at 5s a pair for the window shutters of three rooms on the principal floor and charged for another

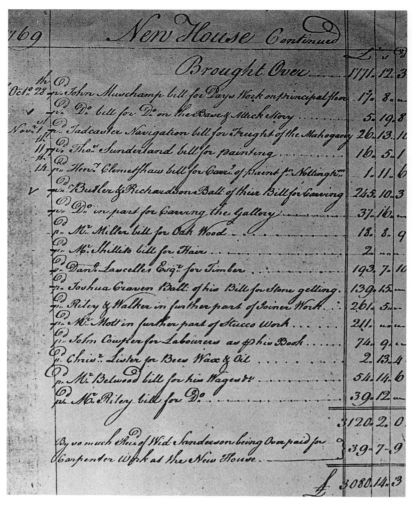

Fig 11 A further extract from Popplewell's Ledger, October and November 1769. The decoration of the house is in its final stages and payments are being made to the artist craftsmen concerned. The accounts were made up by the Steward annually in November, when the year's wages were paid to Belwood, the Clerk of the Works, and to his assistant, Riley. John Carr recieved his fee for 'his drawings and attendance'. (HA Building Accounts, no 496)

dozen similar pairs; 40 cheaper sets of these, dovetail hinges, mortice locks, brass dowelling pins, brass framed sash pulleys and a remarkable range of 'Engine cutt screws' brought this second bill

to just over £100.

Tobin is an outstanding example of the versatility that could distinguish a craftsman at this time. His premises in Leeds were already used by Carr in 1754 as a place where the latter's clients might leave messages and instructions and from there Tobin supplied all the ware of a whitesmith's trade. He undertook the skilled work of fitting these metal parts and became a member of Adam's circle of artist craftsmen. He certainly made the simple iron baluster rails of the lesser staircases at Harewood House and available evidence suggests that only he could have wrought the original balustrading of the Main Staircase. His signature does not proclaim him as a man accustomed to penmanship, but his work stamps him as a master. He was not given the commission for the gilt door and shutter furniture of the principal floor, for this was a very highly specialised art, although he was working in a similar capacity on the stable block in 1765.

Like metal, stone and wood, plaster was an essential building material, necessary both in the construction of the carcase and the finishing of the interior of the house. Plaster lent itself also to decorative design of such artistry that it was considered a branch of sculpture especially in the hands of stuccoists of the calibre engaged for Adam's clients. Harewood House illustrates excellently the different types of plasterwork in eighteenth-century building and interior decoration.

At one end of the scale there is the plasterer's work on the shell of the house contracted to John Dodgson and completed in 1765. He and his men spent the next years 'making good' any defects and carrying out fairly minor alterations. They filled in round the ends of the joists, plastered or pargetted the backs of chimneys to reduce the risk of fire, made recesses deeper or more shallow according to the design for the interior elevations, reset some of the flagstones in the Hall and cleared away piles of rubbish. 'A way for the bellrope' was cut, something almost new in domestic planning. Three of Dodgson's men spent part of a Saturday in March 1767 'making good and plastering the back of the pannels for paintings in the staircase', a reference to the mythological paintings by Antonio Zucchi on the Great Staircase. Walker, the joiner, made 'stretching frames for the pictures of the staircase' in August 1772, and Muschamp erected the scaffolding so that they could be eased into place on the walls.

Rothwell and his partner Henderson did both plain and decorative work. In all, Rothwell's plasterers laid about 14,000yd of flooring, in the house and wings, apart from the basement. There the floors were flagged by Muschamp with some assistance from one Josiah Craven, a local quarry owner, a churchwarden and a specialist in flagging drains and floors (fig 11). The weight of the plaster floors in the attic storey was considerable and had to be controlled by screeds nailed in place by the carpenters. Between the joists of the floors reeds were set and plastered into position to serve as a layer of insulation. It was a well-established rather than an effective custom. Strong, clean reeds were difficult to come by and Carr himself had some delivered on his account in 6d bundles; they were preferable to straw, which made an untidy job, sometimes laid in position with the ears of the grain still attached.[24]

In a further effort to deaden some of the sound that reverberated through the house, Dodgson filled up 'about the Timber Bottom of Partitions and walling Brick in the Partitions to prevent ye Noise from sounding out of one room into another'.

On the walls Rothwell put three coats of plaster often with a finishing of stucco, and some ninety yards of interior elevation were 'Laid fair for paper on Laths', so that wallpaper could be put on the canvas stretched on the prepared lathes. Three coats of plaster were also applied throughout to the ceilings and again stucco was frequently used. The texture of this plaster had to be of excellent quality to enable the painters and stuccoists to apply their colour and decorative mouldings.

Thomas Rothwell, his son James, and his partner Henderson, undertook some of the ornamental plasterwork. They are unique among the master craftsmen employed at Harewood House in that charges for extensive decorative work were included in their 'bill of particulars', which stated the agreed prices and detailed their stucco ornamental work in the three storeys of the house.

In the attic storey, where Carr's influence is more obvious, they used the typical vocabulary of Adam's Neo-classical motifs; ovolo and beaded mouldings, running bands of guilloche and circular fluting, roses and paterae, medallions, swags of bells, husks and flowers, raffled and water leaf and 'Knots of Ribinds'. All these were listed according to the price per foot; a moulding of 'Carvd beads and Roaping' at 2d, a cornice of dentils and roses at 4d. In a ceiling of an attic passage, eighteen 'Pattras' (paterae) were 1s

each, ornamental flowers on the ceiling over the back stairs there 1s 6d and '80 Blocks of bells with Losinges [lozenges] and Flowers' in the 'Dorick' room and its dressing room 1s 2d. The upper bedrooms of the house were thus decorated in a suitably Neoclassical manner.

Down in the basement, there were commendably severe mouldings in the Tenants' Room, the Steward's Dining Room and the water-closet. All the passages had unadorned white walls and ceilings, relieved probably by the arched construction in some parts of the basement. But in the Coffee Room, under the Music Room, and in the Sub Hall, the Neo-classical idiom again quietly triumphed in a moulding of large and small ovolos, '230 Carv'd Blocks in Coffee Room Cornice at 9d' and '294 Blocks of Bells with Lozenges at 7d'.

On the principal floor, Rothwell was relegated by Belwood to the comparative obscurity of the water-closet passage to which he gave a dentil ornament at 2d a ft, and a passage to the north where he put up about 60ft of carved cornice. The rest of his work on this floor involved merely laying three coats of plaster on the walls at 6d a yd, a finishing coat at $3^1/_2$d and stucco at 7d. Adam's undisputed masters in decorative plasterwork, Joseph Rose and his assistant, Richard Mott, were responsible for the rest (fig 6b).[25]

Rothwell's total account for all his work was £615 12s 10d, paid in August 1769, when the balance due to him was only about one-third of that sum because payments 'on part' had been made. The high value placed by architects and owners on the interior decoration of the house is obvious; £43 12 0d covered Rothwell's charges for the 14,000yd of plaster floors, the rest was absorbed by his ornamental work, chiefly in the attic storey. He was never commissioned for any of the work directed by Adam on the principal floor, never recognised as an artist of merit like Tobin and his limited achievement was apparently supervised only by Belwood despite its close affinity with Adam's style. Basically all the plasterers and decorative artists in plaster, Dodgson, Rothwell or Rose, used the same medium. Gypsum deposits in the area meant that first-class plaster could be dug from pits at Ribston, where the Lascelles family owned land. One hundred tons at 2s a ton were bought from these in 1766 and local sources continued to supply the house. A fine quality plaster also was the 'roch plaster' at 2s or 2s 6d a ton from the famous quarries at Roche Abbey in the

south of the county.

Lime came in great quantities from the limestone belt east of York. Wire riddles for lime varied in price according to the mesh, but, since some were of brass, these were expensive equipment costing up to 10s each. White hair to bind the plaster was bought in York itself and sent to Harewood in pack cloths (fig 11). Turnpike tolls were heavy and could equal the cost of one consignment of 80 bushels of white hair at 1s a bushel.

The accounts for plaster and lime contain some interesting details. One firm, Plowes of Tadcaster, who supplied much of the white lime, always referred to Lascelles as 'Mr Lashels', a spelling found also in some local parish registers and possibly of phonetic accuracy. Plowes did, however, send in bills on engraved forms, an unusual elegance among the local Harewood building accounts. His bill of 24 March 1766 was 'To be paid on or before the 1 Day of May next at his house in Tadcaster or at Mr. Collet's at the Sign of the Minster in Micklegate, York'. One of the few examples of illiteracy found among the men associated with the building of the house occurs in the bills for plaster where James Robinson signed his receipt with his mark.

Painting the great house was a seemingly endless task and, as late as 1786, Popplewell's son, Samuel, was nervously apologising for the smell. The Harewood building accounts enlighten this most important aspect of Adam's interior decoration.

The first house painter to be given the contract was Ben Ridsdale, whose men were putting some of the finishing touches to the Library late in 1767, varnishing the sashes and giving the bookcases a second coat. Early in the following year they were still busy in the main apartments, when both the Library and the Hall had their 'second collouring'.

Thomas Sunderland was in charge by August 1768, and for the next four years the record of daily work and wages of the painters are more complete than those of any other craftsmen employed. By the time Sunderland's name appears for the last time in the accounts, 2 August 1772, the first painting of the house was virtually complete. His principal assistant, Thomas Cowlam, a surname variously spelt, succeeded him.

Sunderland's men, unlike Rothwell's, were concerned with the decoration of the principal storey. In the week ending 2 September 1769 Sunderland and seven of his men were 'painting in the Hall,

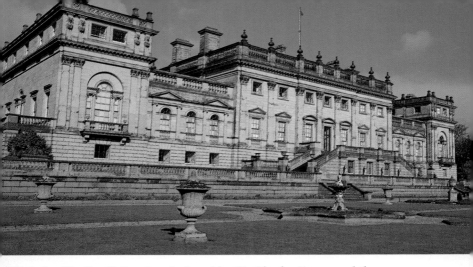

Plate 5 *The South Front, redesigned by Sir Charles Barry, and the Victorian Terrace Garden he created*

Plate 6 *The South Front in 1778 from a water colour by Thomas Malton, Jr*

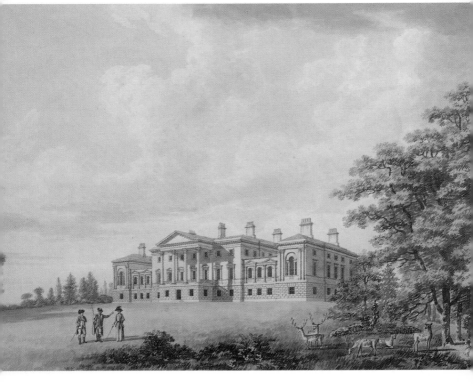

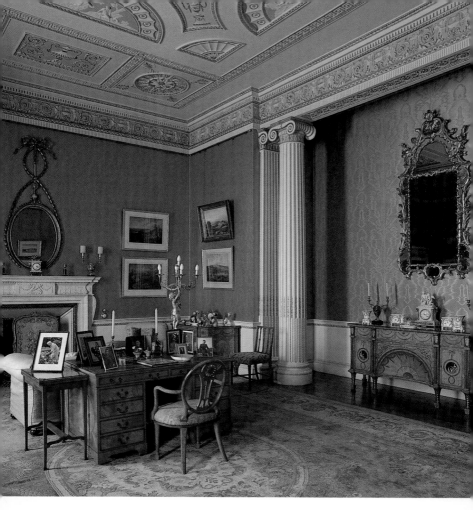

Plate 7 *The Princess Royal's Sitting Room, the former State Bedroom,*
with examples of Early English watercolours and Chippendale
furniture. It retains the Ionic pillars of the recess and fragments
survive of the original green silk damask bed hangings

the Music Room & laying on specimen of Colours for Mr. Adam's approbation'. They seem to have done all the painting of the grounds and only the purely pictorial art remained for Adam's specialists in mural decoration, Antonio Zucchi, Giovanni Borganis and Biagio Rebecca. Hence Adam was relying here to a greater extent than in the case of Riley and Walker, or Rothwell and Henderson, on provincial ability to establish a basis of skilled workmanship which needed only the final fashionable touch to complete a truly Neo-classical interior.

But Sunderland's team were as unvarying in personnel and as adaptable in their own way as Muschamp's men, and more regular in their hours of work. Each had his equal share of work on the principal storey and elsewhere and there was no difference in the rate of pay given; painting in the State apartments, the attic bedrooms, the kitchens, the stables or the 'menagery' were all classed as one for the purpose of the weekly wages bill. During the week ending 29 April 1769, Sunderland and his partner were at work 'in the family apartments and the stable' and, on 14 October of the same year, they had spent their usual six-day week 'Painting in the Saloon & the Circular Dressing Room, & 1st Drawing Room, in the Attic & in the Garden'. Popplewell, however, kept a sharp eye on all the work. 'I thought Sunderland trifled with us by not giving due Attendance to his Men but having received a Severe reprimand from myself & Mr. Belwood he has been better,' he assured Lascelles in the summer of 1770.

Paint was sent from Hull from the factory of the wealthy merchant, Joseph Pease.[26] He signed a letter to Popplewell in May 1768 giving the steward the prices of red paint, common linseed and white lead paint, for which he charged the lowest rates 'for our good friend Ed[win] Laselles, Esq.' There were other suppliers, but artists' colours — flake white, rose pink, prussian blue and spanish brown — came from two specialist dealers, who also sent distilled verdigris, varnish and turpentine. Some of these colours were the same as those used by Sunderland on the ceilings of the house, but the orders which have been preserved seem usually designed for Adam's artists, since the quantities are small.

The surprising feature of the organisation of the building of Harewood House is the order that emerged from apparent confusion. Building a great house like Harewood was a joint effort. Each trade or craft made equipment and tools for others, building

tradesmen undertook a share of work properly the task of more
highly skilled and specialist craftsmen, who in turn ventured into
the province of the decorative artists. The most famous of these
themselves had to rely on the men who built and finished the
house; masons, carpenters, joiners, smiths, plasterers and painters
were all called upon to secure the conditions and give the assist-
ance which would enable such artists to use their careful tech-
niques and their talents to the fullest advantage.

The gradation was subtle and only possible while the industry
was still fluid and spheres of work not rigidly exclusive. Contem-
porary building records list the master mason, bricklayer, carpen-
ter and plumber along with the decorative craftsmen, drawing no
distinction between the merits of their respective contributions to
the creation of a house. They were all 'many ingenious artificers,
many industrious workmen and labourers of various kinds, con-
verting materials of little value into the most stately productions
of human skill: beautifying the face of countries, multiplying the
conveniences and comforts of life'.[27]

For notes to this chapter see pages 174-5.

3
Style, Design and Fittings

'A well regulated economy is ever the source of wealth; and luxury has ever been attendant upon riches' wrote Sir William Chambers, a dictum which Edwin Lascelles's apparently lavish expenditure on the interior of his new and splendid country seat might be considered to substantiate.[1] The editors of the fifth volume of *Vitruvius Britannicus* also underlined the affluence of 'le Digne proprietaire' of Harewood House. 'The worthy owner has spared no expense in decorating the principal apartments from designs made by Mr. Adam.'[2] Contemporary opinion endorsed their view, a mistaken one, for Lascelles was, in fact, seldom persuaded to indulge in any form of extravagance. 'I would not exceed the limits of expence that I have always set myself,' he warned Adam, 'Let us do everything properly & well, mais pas trop.'

If the interior of Harewood House has not the brilliance of Syon, the dignity of Kedleston, nor the elegance of Osterley, it remains one of Adam's most considerable achievements. It was also one of his disappointments. At Harewood, the abandonment of the lunette-shaped court in 1762 was a débâcle which apparently deprived Adam of any further share in the planning of the house, thereafter attributed correctly to John Carr. Whether the patronage which Lascelles had extended to Adam since the summer of 1758 was temporarily withdrawn is uncertain. In April 1759, Adam signed a drawing of a proposed idea for Harewood Church and in the summer of 1760 he was considering a publication of his works, including his drawings for 'Mr. Lascelles's plans & fronts'.[3, 4] What relationship existed between Adam and his Yorkshire patron after 1762 is uncertain, but from 1765 there dates his remarkable corpus of drawings in the Soane Collection for the interior of Harewood House.

By 1765, Adam was already a celebrated figure in public life with a private practice which was attracting increasingly an aristocracy of culture, influence and wealth. To employ Adam ensured Edwin Lascelles of a 'parade' of rooms on the principal storey of Harewood House, decorated with the utmost distinction, and of the eager interest and curiosity of the *beau monde*.

It was a world in which Edwin Lascelles was very much at home. There is a description of Lascelles newly arrived from France in August 1765, bringing with him 'the prettiest watch for Lady Coventry' and some manuscripts 'which treat of the longitude' for a friend and, before getting into his chaise at Brighton about 7 o'clock in the morning, 'giving such a description of his life at Paris and his tour after it that it would divert you beyond imagination'.[5]

In France in the mid-1760s, the *goût grec* was all the rage, a fashionable taste for the world of Ancient Greece, which was often less a matter of artistic and intellectual conviction than a casual acceptance of the Neo-classical ideal and a flourishing market for exquisite toys and trinkets.[6] Lascelles's sharp intuition saw beyond these trivialities to the definitive impact made on English culture by the movement and he turned his attention to the suitability of the style for the entire decorative scheme of his Palladian house. He had failed to implement the earliest Adam attempt at Neo-classical domestic architecture in England, but there were still traces at Harewood House of the original design in the apsed feature of the Dining Room and, at that date, similar recesses at each end of the Gallery.

The spatial effects of convex and concave forms in architecture had been used by Lord Burlington and his followers, such as John Carr, but they relied mainly on carefully measured proportions for the classical character of their rooms.[7] It was an academic rather than an aesthetic exercise. The younger generation of architects, notably Chambers and Adam, bent and broke the rules of the Orders and a new canon of visual perfection was established.[8] The intrusion of coffered domes, apsed recesses, columns and niches gave the rooms of great houses a sense of perspective and an illusion of movement unknown in England for a generation.

All Robert Adam's background, temperament and training fitted him to be the exponent *par excellence* of Neo-classicism. Further, elements from many sources combined to give his work

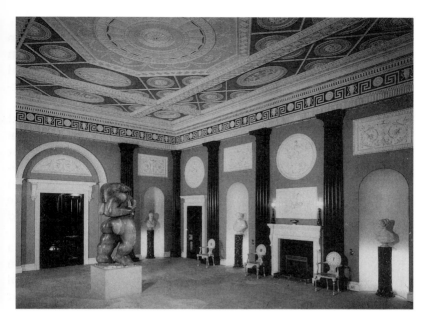

Fig 12 The Entrance Hall with Neo-classical plaster work, Victorian busts and Jacob Epstein's Adam, *carved in 1938-9; through the door is the saloon, redesigned by Sir Charles Barry as the Library in the mid-nineteenth century*

a sense of discipline, imagination and individuality.[9]

For his Yorkshire client, who had already been a source of much wasted endeavour, Adam's drawing office turned out not only alternative designs but variations of these for Lascelles's appraisal. The Soane Collection of drawings for the new house at Gawthorpe reveals the indefinable appeal of the world of antiquity re-fashioned to the mode of the day and Adam's eclectic gift for matching his work both to the wishes of his clients and the exigencies of their houses, for he was usually called upon to decorate houses for which he had not been the architect. At Harewood House he was confronted by a strictly Palladian plan with dimensions possibly not entirely to his liking, but he had the advantage of knowing the place well and having, apparently, a good working relationship with John Carr. It was an enviable commission, likely to enhance his reputation and further his interests, but it was possibly one of the most demanding he ever undertook.

The finished drawings of the elevations and plans for the principal apartments show Adam for the most part at first producing fairly conservative ideas to complement rather than contrast with the older style of Palladian architecture. The Library of the house, now known as the 'Old' Library, is relatively unchanged and very close to the original suggestion for its decoration. Two sets of drawings exist for this room. One indicates an apartment not specifically fitted up as a library, although headed 'the library at Gawthorp'.[10] There is a door on either side of a simple chimney-piece on the south wall and, opposite, three windows alternate with four mirrors under a heavily enriched frieze. Green and pink are the predominant colours — popular colours in fashionable circles and their frequency throughout the designs suggests it was a combination favoured too by Lascelles — with touches of deep prussian blue and white; the whole décor is picked out in gold. Doors on the east and west elevations meant that there was very little space left to accommodate books.

In the 'Design for finishing the Library', the change is notable (see fig 13). The immediate impression is of an array of books, the volumes compactly arranged in a setting impeccably Corinthian. This second design as executed for the Library is far in advance of the first and marks a definite departure from the Palladian mode of interior decoration.

Adam's drawings for the ceiling illustrate the same reluctance on the part of Lascelles to accept out-of-date schemes of interior decoration. The two designs produced in 1765 for the Library ceiling did not find favour: they are crowded, ponderous and altogether too heavy for the dimensions of the room.[11] A third composition assigned to the following year still retains the idea of a ceiling broken into compartments, but the effect is much less cluttered and dominating; the divisions are not conspicuous, the strap work forming them is lightly conceived and the circular motifs are well spaced. The pattern is continued into the cove, a device which gives a greater sense of space to a north-facing apartment lined with books (see fig 14). An unusual and colourful frieze originally intended for the room was never executed. The simple pattern chosen is indeed preferable, balancing by its delicacy the Corinthian pilasters and the coved ceiling. The room was the first to be completed, in 1768, and only the details of Adam's designs were altered.

The decorative programme is concerned with the ancient and modern virtues, a popular juxtapostion and appropriate for the study of a man of classical education and political ambition. The business of the estate and locality were dealt with below stairs in the Evidence Room or the Steward's Room, and, while Lascelles's Study might double as a Smoking Room, the accent in the library was on scholarship and the arts (fig 14).

Minerva, therefore, occupies the central, decorative position on the fireplace wall, Goddess of Wisdom, Learning and the Arts, with three of her nine attendant Muses, those of Epic Poetry, Painting and Epic Song. The painting is by Biagio Rebecca, the artist responsible for the tablet above the chimney-piece, the Triumph of Homer, executed in grisaille, a monochrome technique in which Rebecca excelled and much used in English art to interpret classical themes. A sepia wash sketch of this, endorsed 'Library Tablet, Edwin Lascelles Esq.', shows a fuller and more complex version in bold and confident strokes, its chief charm a group of beautifully posed children watching the scene, overawed and excited.[12] As executed, the composition is reduced in length and simplified. One child only is depicted and the figure is brought into the centre of the composition. This is an illustration of Adam's method of working; an incident from classical mythology chosen and the suggested treatment drawn out 'at large', followed by the artist's interpretation of this, adapting the idea if need be to any limitations imposed.

The subjects of the other paintings are taken from antique sources and recall the nobility and dignity of the statesmen, philosophers and writers of classical Greece and Rome. The busts over the bookcases, a traditional feature of libraries, celebrate the modern giants, Dante and Petrarch, Boccaccio and Machiavelli and the intellectual hero of the eighteenth-century, Sir Isaac Newton. While these paintings and bronzes give interest and distinction to the intellectual ambience of the room, they have also an architectural value, emphasising the upright divisions of the sections and filling the spaces not occupied by books.[13] Chippendale's great library desk was made for this room and his folding library steps, with a mahogany ladder, remain.

Although not large the whole room was a model in Neoclassical design for a gentleman's library. It was usual to keep the bulk of one's books in the country rather than in town, but no

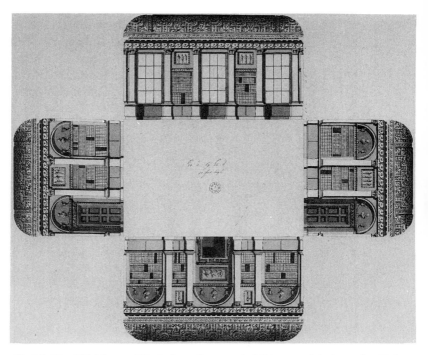

Fig 13 The Old Library: Edwin Lascelles accepted this second design submitted by Adam

catalogue seems to exist of Edwin Lascelles's Harewood House library: nor does he appear to have collected coins or medals, seals or manuscripts, nor been visited by men of letters or politicians of note. It was reported locally that there were at Harewood about 4,000 books 'in most languages, arts and sciences'.[14] Lascelles read his House of Commons Journals regularly, subscribed to Robert Adam's volume on the Emperor Diocletian's Palace at Spalatro and *The Works in Architecture* of the Adam brothers, but not to Sir William Chambers's *Treatise on Civil Architecture*. Perhaps Lascelles did not read much when he was at Harewood, where he apparently diverted himself by keeping a pack of hounds. At his death, in 1795, the inventory of the Library in his London home indicated a taste at once catholic and individual: many were classics in French and Italian translations, as well as original texts, and the list included Evelyn's *Silva*, and Hogarth's *Analysis of Beauty*.

Like the Library, the Music Room of Harewood House has been

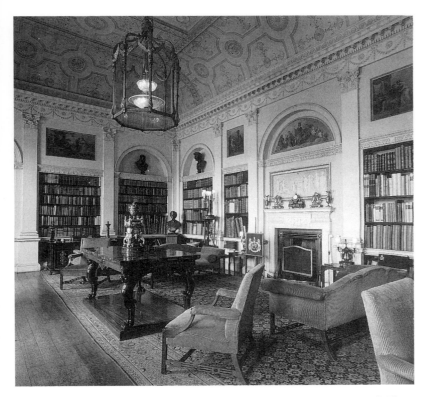

Fig 14 The Old Library as restored by the 6th Earl and The Princess Royal. The room closely resembles Adam's drawing; the Chippendale lantern originally hung in the Entrance Hall

preserved almost as Edwin Lascelles knew it (see plate 18). Situated between the Entrance Hall and the main Dining Room, the title 'Music Room' referred to its decoration rather than its purpose. Music is the ornamental theme and symbols of the art pervade the room like a refrain.

Adam's elevations, in colour here again, are most attractive. He outlines four great paintings to cover the walls, two on either side of the chimney-piece on the south wall, and one on each of the adjoining elevations, with the northern light from the windows to clarify them all. The subjects and the style are reminiscent of Adam's Italian sketches, antique landscapes where his human figures, here in red and blue, are too small in scale amid vast

pediments and pillars (see plate 19).

Antonio Zucchi, an artist associated with Adam from his Italian days and much in demand for his large-scale paintings of classical subjects, elaborated Adam's suggestions so that he illustrated themes infinitely more complex and much more appropriate for an apartment designated 'The Musik Room at Gawthorp'. Against traditional classical backgrounds of dilapidated coffered arches, broken columns and crumbling stonework or a colonnaded and palatial courtyard, he depicts a fair, a group of peasant musicians, a band, each evoking the spirit of lively, altogether more earthy Italy (plates 18, 19).

Over the chimney-piece is now an example of a very different type of painting, the highly professional school of eighteenth-century English portraiture, as characteristic of its period as Zucchi's monumental landscapes. This is Sir Joshua Reynolds's portrait of Mrs Hale, the sister of the 1st Countess of Harewood, as Euphrosyne, one of the Three Graces; she seems the epitome of their 'joy and gentleness', with one foot lightly poised as if about to step out of the frame, dancing to the music played by a group of children. Mary Chaloner married Colonel (later General) John Hale in June, 1763 and, although the portrait is now redated from 1762 to 1764-6,[15] the children can scarcely be any of the twenty-one reputedly born to her. The room is one of Adam's superb achievements, giving the illusion of circular rhythm and movement within the almost square dimensions of the apartment and creating a remarkable impression of vitality in a Neo-classical interior. The subject and its treatment are far removed from Adam's stylised, repetitive design of three figures in classical draperies, which appears on the original plan for the central section of the elevation. But the frame is similar, a piece of delicate filigree with bell husks and swags, clearly intended to be the focal point of the room (plate 18).

The decorative element on the walls is completed by four panels of ornamental plaster work. All have a similar design of urns among a tracery of arabesques and anthemion. Two face each other across the fireplace, placed on the east and west walls, away from the northern light and often less appreciated than the smaller panels over the doorways. Like the ceiling, they are all the work of Joseph Rose. In this account a significant item is £35 5s 0d charged for the four panels in the Music Room as 'extra work' not in the first estimate.

Two Adam designs dated 1765 exist for the Music Room ceiling, each differing little from the other or from the ceiling as finally executed. Curiously, the lyres, the main musical motif of the room, have been omitted and, perhaps fortunately, the eagles surmounting the corners do not appear. A central, circular inset has ten satellite roundels, joined by festoons of bell husks, with a narrow outer ring of urns similarly linked in a continuous pattern. The centre and the ten medallions around Adam's isolated figures have become the Nine Muses, with Minerva keeping watch over the Arts. The four Continents are personified in the corners, for music is a universal language, and in the centre the contest between Apollo with his lyre and Marsyas on his woodwind is judged by Midas. This and the roundels are painted on irregularly shaped pieces of paper, usually three,[16] and are acknowledged to be the work of Zucchi.[17]

Lyres are woven into the fabric, but apart from this the Axminster carpet reflects the pattern of the ceiling, the most outstanding example in the house of this contrived unity of design, and here a circumstance probably due to Chippendale rather than Adam (plate 18).[18]

A final touch of harmony is the chimney-piece, for which there are four drawings in the Soane Collection all incorporating the lyre motif.[19] The design now seen is not apparently any particular one of these. Elements of each appear, with the exception of the frieze, which is richer in ornament and in fact well suited to the elegance of the room. It has lyres and roundels linked by festoons as in the carpet and ceiling and is enlivened by plump sculptured putti. The marble chimney-piece was carved by John Devall, master mason to George III, one of the first of many he worked for Harewood House.[20]

Details of Muschamp's 'extra work' on the principal storey suggest that there may in fact have been two chimney-pieces installed in the room, the second replacing the first after an interval of four years, a possible explanation for the number of designs made. These are dated 1766, 1769 and 1770. During the week ended 25 June 1768, Lofthouse was paid 9s for six days' work, one day cutting away the brickwork to receive the chimney-piece and the next five 'assisting Mr. Devall's man in setting up chimney-pieces in Dining Room and Music Room'. These marble chimney-pieces were unloaded earlier in June. The piece for the Music

Room was put in first, then the Dining Room one, that for the Library was in place by 2 July and other 'sundry chimney pieces' in the East Wing during the following fortnight.

Exactly four years later, another of Muschamp's masons, William Burland, had a full two weeks' work, not a frequent occurrence, between 1 and 13 June 1772, 'assisting to fix the chimney-pieces in the music room and cleaning all the others'. Devall's own records endorse this. On 29 May 1772, his man Mr Gill travelled from Doncaster to Harewood to spend seven and a half days putting a chimney-piece into the Music Room, a reference which seems to imply a completely new fixture rather than a repair to an existing one, since seven or eight days was the average time required for this type of work. He stayed on to clean those already in place in the main apartments, presumably with Burland's help, and returned in September for a longer period to fix the chimney-pieces in the Saloon. A year later, in August, he was back again at Harewood, taking a day as before to travel from Doncaster, to set in position the chimney-piece for the First Drawing Room.

Apart from his first visit, the same mason, William Burland, was assigned to Gill as his assistant, indicating a measure of specialisation in Muschamp's organisation of work. Moreover, on each occasion Lofthouse and Burland were employed 'over time', instances of which are extremely rare during the building of the house. But Mr Gill, the representative of the King's Master Mason, John Devall, could dictate his own terms and brooked no delay.

The Gallery chimney-piece, however, was not his work. This was the apartment designed to be the culminating point of all the varied splendour of Adam's decorative scheme for the principal storey (see plate 16). The stern Roman severity of the Doric Entrance Hall, the Corinthian civility of the Library, the grace of the Music Room, even the carefully conceived Classicism of the Saloon and the Dining Room, all yielded pride of place to the Gallery. It was the last room in the house to be completed and from its inception has been more subject to alteration than any other, with the possible exception of the Dining Room, where the changes have been so dramatic that it is not in any case easy to visualise the original interior. In the Gallery, too, Lascelles's intense involvement with the creation of his country seat is very marked. Not only his apparent refusal to accept designs for the ceiling or for the chimney-piece which he thought unworthy of his most ambitious

plans for the room betray this, but also the exceptional degree of costly enrichment.

Adam's first designs for the ceiling were among the earliest made for the house, two very similar ideas both dated 1765. One has indications of apses at either end of the room so that these must still have been a possible feature of the Gallery's construction as late as 1765.[21] The only prominent feature of the other is the repetitive use of a favourite Adam motif, the hippocampi or sea-horses, one cramped with flying fore-legs and curling tail into each octagon; the design would certainly not have enhanced the room, for it was conceived on much too diminutive a scale and fortunately remained unexecuted.[22]

Three years later the present ceiling was designed in a manner so entirely different that the potential decorative hazard of so extensive an area became an artistic triumph. A superbly devised composition of shapes — elliptical, oval, rectangular, octagonal — combined with Neo-classical ornament controls the interior elevations of the apartment. The air of grandeur imparted by this example 'of palmyran taste', with stucco work deemed 'the first of its kind in England', matches the lavish use of gilding, the furnishings and a later addition, the important collections of portraits and china.[23] Yet these in no way detract from the spectacular use of ornamental plasterwork in the ceiling and the painted insets and coloured grounds. Adam's design is conceived mainly in pink and green, with indications of prussian blue to emphasise the mythological subjects of the painted panels: touches of red and russet offset the white of the stucco classical heads, the moulded flowers, the pairs of griffins, the urns and the arabesques of Rose's plasterwork. The sixteen panels were painted by Biagio Rebecca and the ceiling itself by Sunderland's men. It is tempting to see in a bill, receipted 4 May 1769, some of the paint and materials used for the ceiling — flake white, 3lb of rose pink at 4s, $^1/_2$lb of prussian blue at 11s, another $^1/_2$ of blue bice at 4s, spanish brown and red lead, 3 'large Badger Tools' at 18s and a dozen large brushes at the same price, one dozen swan quill pencils at 2s and 2 dozen goose, also at 2s.

Rose's sketch-book preserved at Harewood House shows his use of pen and pencil. His detailed working, dated 1770, for part of the Gallery ceiling states the measurements of the whole at 77ft by 24ft: some areas are left blank 'for painting' and the treatment

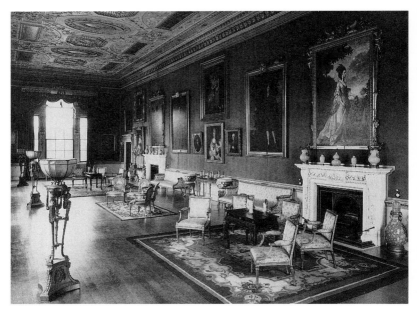

Fig 15 The Gallery before restoration in 1988-90, showing the two Victorian fireplaces. The Lascelles family portraits now hang in the Cinnamon Drawing Room

of the cornice is omitted. He takes up his decorative plasterwork at the line of a band of bell husks. The small heads portrayed inside the octagons are drawn in and the whole sketch is done first in pencil, then in ink with the use of a very fine quill pen.

The bill for his work throughout the principal storey includes £335 for the 'Great Gallery' but £20 is deducted, 'for finishing over the chimney not done'. It was examined by Adam and the final payment receipted 7 August 1770, by his nephew (also Joseph Rose), 'for the use of my uncle, Joseph Rose', which gives a terminal date for the plasterwork of the Gallery.[24] There is no mention of the masons setting up a hearth and curb in the Gallery, 'for Mr. Rose's man' as in some other apartments where the plaster was prepared for use. Nor does the ceiling specifically figure in Popplewell's disbursements, although Mott was clearly much engaged on the decorative plasterwork of the house at the time.

The Gallery is the only room which notably exceeds in its wealth of decoration Adam's design as apparently accepted by Lascelles

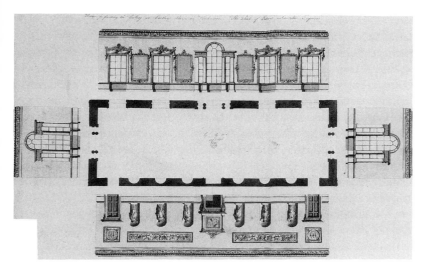

Fig 16 Adam's proposed Neo-classical treatment of the east elevation of the Gallery, which was probably never executed

(see figs 15, 16, plate 12). The treatment of the window furnishings by Chippendale is infinitely more ornate. Above the windows on the west wall, simple gilt crested cornices have been garnished with wreaths and swags and with festoons of ribbons and knots, all heavily gilt. Below, the pelmets, once two short falls of looped drapery, have become deep, prominent features, Chippendale's masterly interpretation of wood carved to give an illusion of taffeta hangings.[25] The mirrors dividing these windows were to be set in light gilt frames with anthemion motifs above, but the glass has been divided by vertical lines of finely gilded ornamental moulding in Adam's latest style. The four oval paintings above of lovers in Arcadian settings — one is of Diana and Endymion — are garlanded by gilt flowers held by golden putti. Oval paintings inset with foliage motifs are among Chippendale's most attractive devices.[26]

Whether Adam's design for the eastern elevation was ever carried out is difficult to decide (see fig 16). It closely resembles, for instance, the Gallery at Croome Court. On either side of a single chimney-piece he suggested that three round-headed niches should be placed, presumably to hold full-length statues, with a tablet over each arcade bearing his griffin and arabesque, or rainceau,

motif. Doors at either end of this elevation led, as now, to the Dining Room and the Second Drawing Room, with a panel above each for a circular stucco relief.

The chimney-piece finally chosen by Lascelles was, like the ceiling, of an entirely different design from that first presented. In all, five variations of the accepted subject were drawn, two of them dated from Adam's own quarters in the Adelphi in London on 11 June, and two more on 13 June 1777[27] All are similar to certain early Adam chimney-pieces at Croome Court, Kedleston and Hatchlands. The chief feature is a pair of female figures, caryatids, their classical draperies ever more elegantly disposed and their profiles increasingly intent on their task of supporting the marble shelf above, a position they did not take up permanently until 1780, only to be removed to the Dining Room in the nineteenth-century alterations, and returned to the Gallery in 1989.

The whole unified scheme of carved enrichment in the great room can be attributed to Christopher Richardson of Doncaster and especially to Burnet Butler.[28] For local artist craftsmen of no great fame, they were very highly paid and justifiably so. The balance of their bill, £345 10s 3d, was paid on 14 November 1769 and on the same day a further £37 16s 0d was given to them 'in part for carving Gallery' (fig 11). Butler had already received substantial sums for carving, £413 14s 0d in mid-November 1767, and £410 12s 0d a year later. Smaller payments on account, varying from £20 to £120, had been made to the two men and to Carr's favourite carver, Daniel Shillito, from the beginning of 1766.[29] The Gallery is the only apartment mentioned by name in the records of payments to the carvers, a further indication of the importance attached to this room as the climax of Adam's decorative treatment of the interior of Harewood House and the realisation of Lascelles's ambition to own a house acclaimed as the perfect expression of a country seat.

During the years 1769 and 1770, the Gallery was the scene of intense if spasmodic activity. The finishing of the room went on simultaneously with the work of the artist craftsmen, who, in any case, required the assistance of the masons. William Lofthouse was much in evidence, Muschamp's usual choice for this type of skilled help. In August 1769, for instance, he was 'plugging for brackets in the gallery' and taking down scaffolding. He then went straight ahead with the job of completing the windows; he pointed

and filled in sashes, 'Rabetting window Cills in the Gallery, altering work of bricks in Do' and then returned to pointing the sash frames. Just a year later, he took one day to cut 'stone to sash frames and Venetian windows in Gallery'. The arrival from London of the forty 'large squares of best Crowne glass', in 1769, may have had some connection with Lofthouse's work, since all the other rooms were virtually complete by this time.

The floor, however, was not relaid until 1776, when Lascelles was increasingly impatient, and it was not until 1780 that the caryatid chimney-piece was fixed in position by Richardson's son-in-law, Christopher Theakstone.[30]

It was therefore nearly a decade after the house was first occupied before the Gallery was to receive the admiration of visitors. They were rewarded by 'a show of magnificence and art as eye hath seldom seen'.[31]

Meanwhile, in the later 1760s, work went on in the other principal rooms, without much appearance of organisation of the building labourers and craftsmen. The artist craftsmen also came and went, fitting in their visits to Harewood with those to other great northern houses in a similar state of decorative upheaval. Carr, Adam and Belwood were all employed at Newby Hall by William Weddell and the same craftsmen worked at both houses for patrons who differed completely in temperament and attitude.[32]

Apart from the Library, Music Room and Gallery, Adam's finished plans and elevations or sections are extant for most of the major rooms at Harewood House, including the State Bedroom, the Saloon, the Dining Room, Lascelles's own suite of a Study, Dressing Room and Bedchamber, the Circular Room and the Entrance Hall and Principal Staircase. There are also drawings for fourteen friezes, that is for all the main apartments, over forty designs for ceilings, and about thirty for chimney-pieces, although several show only slight deviations from themes originally submitted for Lascelles's approval.[33] This when it came was succinct; he wrote in an undated letter to Adam: 'I have been in expectation of hearing from you ever since your Plans for finishing the Hall & Staircase came down, both which I approve.' Adam's meticulous and time-consuming work was sent to Lascelles, often with pencilled notes on the designs and indications of the colouring, and with sections drawn out in detail for his benefit, all for a matter of

a dozen apartments. Yet, on balance, an examination of the Adam drawings for Harewood House leads to an exoneration of Lascelles's insistent perfectionism. In most instances, his reliance on his own judgement and taste was apparently justified.

The ceiling of the First or Yellow Damask Drawing Room is a case in point. There are in existence four designs, each exhibiting a refinement of detail almost trivial to the casual eye, but of considerable significance in reality.[34] The design finally accepted and executed without any modification is one of enchanting interest, a delicate lacework of light stucco relief, billowing in a tracery of flowers and arabesques, yet set in a framework of a strongly tied design — a four-pointed star reaching from the inner circles to the outer corners of the square of the ceiling (plate 11). As in the Music Room, Adam overcame structural limitations by the geometry of his design and again the Axminster carpet reinforces the illusion, this time perhaps reflecting rather than matching the ceiling and described as 'answerable to the ceiling'(plate 10).

Quite the most outstanding feature of the entire decorative scheme was that proposed for the Circular Room. It was almost certainly never put into effect and the room itself disappeared in Barry's radical alterations. Had Adam's designs for the elevations and ceilings of this room been carried out, Lascelles would have possessed an Adam masterpiece. Moreover, the changing designation of the Circular Room reveals the flexibility of Palladian planning. The truth of Robert Morris's contention is proved: an early eighteenth-century architect had no need to indicate the purpose of his room to a prospective client, since 'Any apartment may be put to any use, as in Ovid'.[35]

The metamorphoses undergone by the Circular Room were sufficiently startling to merit the simile. It began in Adam's adaptation of Carr's plan as 'Mr. Lascelles's Dressing Room', an inconvenient arrangement which separated the owner from his Bed-chamber by the distance of the eastern circular court, or, alternatively, the Library, and a passage. Carr's later plan calls the apartment 'the Common Dining or Supping Room' (see figs 7, 8). Another suggestion was the 'Billiard Room or Chappell'. It may well have been regarded as the Billiard Room until the replanning of the accommodation in the early 1760s, when the Billiard Room was re-sited in the base storey. Whether it was ever considered seriously as a private chapel is another matter. Adam produced a

section and plan for a 'classic chapel' for Lascelles.[36] The section shown is strongly Neo-classical and secular in treatment, as befitted the tone of the age, but there are no ecclesiastical overtones whatever. The plan is for an apsed room 44ft long and almost the same width, 24ft, as the 'diameter' of the Circular Room. The date of these two drawings has not been established, but in 1767 further designs were made for the Circular Room now termed by Adam 'the Gentleman's Dressing Room', which reveal a remarkable identity with those for the chapel.

The first section shows a much plainer version, conservative in ornament, restrained and unremarkable in colour. The ceiling to accompany this is by contrast a lively stucco conception but, despite its brilliance of colour, the design is not in any sense a departure from Adam's accepted style, rather a superb example of his capacity for its infinite variation.[37]

His alternative proposal for the Gentleman's Dressing Room is, however, an intensification of the already remarkable chapel interior.[38] Only the painted panels differ significantly, for the colourful pattern is more complex, arabesques twining in grotesque manner round urns, pedestals, lyres, and medallions and soaring upwards to support the final motif of eagles. The designs for the ceiling are particularly striking. Each female figure wears a different and subtle harmony of colour, blue, green, yellow, russet, and the similarity with the design for the Round Room of Kedleston is marked. The alternating elliptical areas are strictly formal in his best Neo-classical manner; cherubim, torches, urns and the concentric circles of richly painted motifs high in the domed ceilings are given eight medallions forming the outer ring, united by putti, merman-like with anthemion tails, a feature omitted in the Kedleston design but seen also in both Adam's design and in Rose's sketch for the Harewood Dining Room ceiling. The whole was 'proposed to be painted in the style of the Antique', but the inspiration is Gallic, a French distillation of the Neo-classical revival which is especially apparent in the painted panels.[39]

Mirrors were considered by Adam an integral part of the decoration of interior elevations and two of his drawings of mirrors with branching candelabra exist for the Circular Room.[40] They are ornate and attractive, but not in any sense exceptional. In all, only four designs for mirrors at Harewood House remain, yet

this small collection includes two of Adam's rare incursions into chinoiserie, successful and charming frivolities of eastern fantasy, with painted insets where coolies sit back to back against a pagoda, a classical urn puffs smoke into a pantomime landscape of steps, fragile pillars and trellis work, and pagodas and junks adorn riverside scenes, all depicted in pink, green and gold. Both designs are dated February 1769, but there is no indication that they were meant for any particular apartment.

Other important features of the principal storey were the ornamental metal fittings, the wrought iron of the staircase, and the door and window furniture.

For the Main Staircase Carr ordered Roche stone, sent from Bawtry by inland navigation to Tadcaster. The freight charges from Stockwith, near the quarry, to Bawtry alone were equal to the cost of the stone itself. It arrived 'as soon as posabel' in the spring and summer of 1768 — for in winter freight increased by 1d a ft — and in March 1769, William Lofthouse was 'clearing off Lime for flagging ye grand stairs with Roach Abbey stone'. Earlier that year Lofthouse and Burland had assisted Mr Tobin's men to set the iron work of the West Wing stairs, on the steps of which Lofthouse later put wooden covers, and of the east and west cellar stairs. The East Wing stairs they seem to have done completely on their own. Nowhere is there any indication of the masons helping with the iron work of the Great Staircase.

Yet the regularity and amount of Tobin's payments are commensurate with those of other leading artist crafsmen commissioned for the principal storey. There is Popplewell's entry for 11 January 1769, 'Mr. Tobin towards staircases £50', an interim payment in a series which included £182 11s 9d in October 1769 and £116 15s 0d in January 1770. Taking this into account, with the stylistic evidence and his known work, the Great Staircase cannot be attributed to any other wrought-iron worker.

The upper flights, the returns, have an Adam design, one of his almost 'stock' patterns, used both at Kenwood and Newby Hall, a honeysuckle motif between vertical bars. It is a more effective and economical design than Carr's work on the lower flight, a combination of anthemion and rosettes which he used also at Fairfax House in York. This is Carr's only known contribution to the interior decoration of the principal floor of Harewood House and rests on stylistic evidence. The mahogany hand rail, a Vitruvian

scroll carving by Theakstone, was not added until June 1773 at a cost of £23 3s 6d.[41]

This was the year in which most of the door furniture was fitted by Thomas Blockley's man, Mr Walls.[42] Blockley was a Birmingham smith, able to avail himself of the great and varied output from the factory of Matthew Boulton, and of high reputation.[43] Thomas Blockley junior came down to Harewood from London early in 1773, charging £1 1s 0d for coach hire, and Walls arrived on 29 October. He was there in all about ninety days until 7 March 1774. Blockley supplied all the gilt ornamental fittings for the mahogany doors and for the shutters of the main apartments. For the doors there were 178 drops, 86 'nobs', 60 scullions and a careful pencil note in Belwood's records shows the need for 24 extra 'nobs' and an excess of gilt drops, '8 overmany'. For the shutters there were roses, spindles, handles at 12s each and for the windows sash 'nobs' at 22 for 3s and fastenings, not gilt, at the same price. Walls fitted the locks, cleaned them and then lacquered the plates. Popplewell found his attitude unsatisfactory, but his work remains evidence of his conscientious care and all the locks are in first-class order after over two hundred years of use.

The gilder, John Brown, fixed the window-shutter ornaments and handles during 1774, after Tobin had installed bells in the State Bed Chamber and Dressing Room and in the two Drawing Rooms.[44]

For notes to this chapter see pages 175-7.

4
Furnishing and Landscaping

Thomas Chippendale was born in 1718 in Otley only a few miles up Wharfedale from Harewood. Whether in his early days he ever had any association with Edwin Lascelles is uncertain, but by the time he paid his first visit to Harewood House in 1767, he was a most successful 'upholder' in London, established for well over a decade in his St Martin's Lane premises.[1]

The third edition of his influential publication *The Gentleman and Cabinet-Maker's Director* in 1762 illustrated a wide range of furniture from organ-cases to picture frames, with the assurance in his preface that 'if no one Drawing should singly answer the Gentleman's Taste there will yet be found a variety of Hints sufficient to construct a new one'.[2] His confident approach and his claims were not merely a contemporary foible; they were the result of his need to attract and retain wealthy and distinguished clients who, in giving their patronage, expected in return unlimited credit facilities, which he could not always afford. On one occasion at Harewood he finally went on strike and even Popplewell saw the point of it. 'I do not wonder at Chippendale's Stoping if he had so much owing as he said he had,' he told Lascelles firmly and suggested that his master might perhaps consider payment.

In December 1772, after three years of employment on the Harewood commission, the sum outstanding was £3,024 19s 3d. By June 1777, it had risen to £6,838 19 1d, a total for the furniture and furnishings of the house about one hundred pounds more than 'Capability' Brown's bill for the landscaping of the park and pleasure grounds. Only trivial amounts of up to £25 had been paid on account during these eight years, a marked contrast to the

regular and often considerable sums given to both building and artist craftsmen.

Chippendale's business depended, however, on many circumstances outside his immediate control. Lascelles found him disorganised, but there seem no real grounds for complaint, considering the general complexity of the whole undertaking, the many skilled trades involved, the difficulty of transporting fragile goods safely to Harewood and the perpetual refurbishing that went on.

His work at Harewood House is of the greatest importance. Much has been written about the sheer brilliance of his Neoclassical furniture there and the development of his style to this peak of excellence illustrated by the known pieces made by Chippendale for Edwin Lascelles.[3] His less spectacular but equally fine contributions, for instance, the splendid seat furniture now in the Music Room, have received less than due attention. Recent research, however, not only redresses the balance, but indicates that Harewood House is a major source for an intensive study of the range and scope of Chippendale's work and his method of accomplishing a country commission, in this case two hundred miles from his London premises.

The loss of the first part of Chippendale's bill, up to December 1772, for Harewood has always been accounted a misfortune. The Harewood Collection, however, offers the compensatory evidence of a Day-Work Book, inventories of 1795 and 1801, some references in the Popplewell correspondence and various hitherto unidentified drawings: descriptions given in Tourists' Guides and the comments of visitors to the house supplement this. The vicissitudes of the Victorian refurnishing, inevitable modernisation and the use of the house as a hospital in both world wars account for the re-use, abandonment, damage or hasty storage of pieces recognisably Chippendale in style.

Specialist work in the field of furniture history and design has resulted in the authentication of the famous group of Dining Room furniture, until now only attributed to Chippendale (plate 17). Similar scholarly detection has led to the identification and recovery of other examples of Chippendale's great and comprehensive oeuvre for Edwin Lascelles.[4] (see Chapter 8)

Above all, neither on documentary nor stylistic evidence is it possible to support the view that Harewood House provides the leading example of the Adam's close association with Chippen-

dale. 'One must therefore eliminate Adam at Harewood, giving Chippendale his due credit.'[5]

If this partnership is now known to be a 'myth exploded', the influence of Adam's Neo-classical style on Chippendale and even the association of the two men on occasion as designer and cabinet-maker is not thereby excluded.[6] Adam did, of course, create his own market, for there was a demand for case-furniture and ornamental pieces especially as extensions of his decorative schemes. His main contributions to English furniture design were his inventive use of the pier glass and his dining room furniture, a sideboard with wine-cooler, urns and pedestals en suite, both superbly realised by Chippendale, whose mirrors for Harewood were much admired.

The only known Adam drawings for furniture at Harewood House amount to half a dozen; four for mirrors (see chapter 3, p83), one for a tripod and another for a vase, none of them apparently executed. There is, however, a pair of Adam pedestals in the Inner Hall leading to the Main Staircase, brought from the London house.[7]

Chippendale's reaction to the task ahead of him in 1767 is recorded in a letter to Sir Rowland Winn of Nostell Priory, another Yorkshire house on the interior of which Adam was then engaged: 'As soon as I had got to Mr. Laselles and look'd over the whole of the house, I found that Shou'd want a Many designs.'[8]

On 20 October 1769, Samuel James arrived at Harewood to put into effect Chippendale's plans. He spent two days 'coming and going to Leeds', where merchandise from London as well as locally woven material could be bought and which supplied some of the wallpaper, curtain fabrics, serge, baize and carpets for the house. Then James began work on the bedrooms or 'lodging rooms' in the attic storey, preparing canvas on which to hang the 'India' wallpaper,[9] unpacking bedding and furniture, setting it up and having one Weston 'assisting to colour'. The rooms were named according to the design of the paper, the Red Stripe the Blue Stripe, the Bamboo, the Pea Green, the Chintz Pattern. Bedrooms now had complete individuality with curtains and hangings to match the wallpaper.

One of the interiors he fitted up was the Couch Bed Room, with crimson draperies to match, next to Edwin Lascelles's Dressing Room. The bedstead was crowned with a dome ornamented by a crane about two feet high in gilt lime wood, chosen by Chippen-

dale as 'the emblem of Care and Watchfulness … .' Somehow this beautifully carved figure survived despite Victorian gilding, the break up of the couch bed, and a century of existence as an ornament in the house. It was sold in 1951 and finally disappeared, but was recognised at a minor sale, bought by the Chippendale Society and restored to be displayed as part of the Society's Collection at Temple Newsam House in Leeds.

The base of the couch bed was rediscovered and sold at Christie's Harewood House sale of 1 April 1976, when it was acquired by Bradford Art Galleries and Museums. Extensive research enabled the sofa-bed to be reconstructed, with its crimson draperies and a replica of the crane on the dome, and exhibited at Bolling Hall Museum, Bradford. Recently the original dome and poles, in a very poor condition, have been purchased. Chippendale's *Director*, third edition 1762, plate 60, has a design for a similar couch bed, which proved invaluable in the restoration.

James left Harewood two days before Christmas. He had put in $58^1/_2$ days, working 12 hours in each. His actual wage is unknown, but Chippendale charged Lascelles at the rate of 4s a day for James's attendance. He later went mad — 'the poor man', wrote Lascelles — and the work at Harewood for a few months apparently came to a halt.

In March 1770, his successor, William Reid, travelled from London to Harewood, the first of his many journeys. In 1775 his coach hire for the return journey was £3 13s 6d with £1 4s 0d expenses; 'Sundry parcells and Boxes' went by coach, but his own personal box was sent by slower transport, the 'Waggon to Town'. Next year Lascelles paid only his share of these expenses, a total of £2 2s 6d, for Reid had been working for Daniel Lascelles at Goldsborough and for William Weddell at Newby Hall, both houses in the neighbourhood of Harewood.

He was in residence continuously until December and for most of the years 1771 and 1772. He did not return until the autumn of 1773, working, however, right through Christmas and New Year until 23 February 1774. After a break, he was at Harewood again from November 1775 until May 1776 and his last visit was made from July until October of that year, when he finally 'packed for Town'.

Popplewell had no criticism to make of either Reid's work or his attitude. He wrote of him in 1770: 'the upholsterer is very diligent

& Mr. Belwood (who is a better Judge) says he does his Work well.' Six months later a report was sent to allay Lascelles's constant apprehension about idleness at his new house. 'I have visited Mr. Reed Several times since you left us & I confess I have never found him loitering.' There cannot have been much chance of it during a regular six-day, seventy-two hour week under Belwood's supervision and Popplewell's ubiquitous eye. Popplewell calculated that up till the middle of January 1775, Reid had been employed at Harewood House for 956 days; he had spent $144^1/_2$ of them 'putting up Canvass & paper Supposed to have been Measured but Mr. Chippendale charges them along with the other days works'. Reid added at least another 150 days to this number during his final prolonged period of residence from November 1775 until October 1776.

There were during all these hundreds of days few when he could not get on with the job. About the end of February 1772, Popplewell complained to his master that Reid had 'rec'd Nothing lately from Chippindale, but some materials for Matrasses' and the entry for his work during the first two weeks of April consists of one word — 'waiting'. Reid had written to Chippendale about the delay and Popplewell placated Lascelles until a start was made again on 16 April. But in February 1774 a consignment of serge failed to arrive; there was no denying it — for three days Reid was 'unimployd', and a similar situation recurred in the autumn. Otherwise, the only recorded intermission is a seven-day break in 1776 when the wallpaper for the Gallery, a special order, failed to arrive in time. Chippendale's packing cases were carefully checked and weighed on arrival at Harewood and all the seat furniture — chairs, sofas, stools — was upholstered at the house, a saving of time and money and an insurance against damage in transit.

The State Bedroom and its Dressing Room provide the fullest evidence of Chippendale's furniture for the house and Reid's extensive responsibility for the furnishings. The formal Adam ceiling is intricate and highly decorative. Adam regarded the ceiling as the most important feature of a room. His drawings and his correspondence with his brother, James, in Italy bear this out.[10] The four panels in high relief plasterwork illustrate the classical theme of the Loves of the Gods. The choice of Diana and Endymion is particularly appropriate because the peerless Chippendale 'Diana and Minerva' commode, made for the State Dressing Room next

door, now stands in the Ionic, pillared bed-recess. The delicate enrichment of the frieze and the shafts of the pillars and the Greek fret motif on the moulding of the doors and windows, repeated in the design of the ceiling, all combined to form an exquisite setting for some of the finest furniture ever produced by Chippendale.

When he supplied the State bed, the alcove was deeper than it is now and encompassed the very large 'State Bedstead with a Dome Canopy decorated in the Inside with rich Carved Antique Ornaments — a large Antique Vauze on the Top, with Corner vases and sundry other Ornaments, the Cornishes with Emblematic Tablets and Swags of Roses, with various other ornaments exceeding richly Carved — the whole Gilt in Burnished Gold, Exceeding highly finished'. This magnificent object, resting fortunately on large castors, cost Lascelles £250. He supplied his own damask to furnish the room and one of Reid's first duties on arrival at the house was the inspection of this green material.[11] Now he set out to make 'a furniture' for the State bed. With silk tape thread he drew up the damask in to a fringed drapery to cover the dome at a charge of £16. He needed green lustring for the valance, 120yd of silk 'line' at 9d a yd and 28 more at 6d, 92yd of green and yellow fringe, 8 of brown linen, a dozen large silk tassels and 10 smaller ones, 8 brass pulleys in frames, and pins.

The bedding was one vast luxury; a large bed tick, a bolster filled with the finest and best Hudson's Bay feathers, two down pillows at £1 each, a large hair mattress, in white linen, and an upper mattress, 2 'largest size Superfine Blankets' and an under blanket. 'An exceeding large Superfine white Callico Quilt' was an extra, costing £10, including the tape, thread, making up and fringing the edges of the quilt and of the counterpane.

The whole edifice was shrouded when not on view or in use. Reid made canvas and paper covers for it and later, in February 1774, coverings of baize. A visitor in the 1790s found it so astonishing a sight 'as to create a Universal Taciturnity' among the party of tourists.[12]

The walls of the room were hung with damask stretched on canvas prepared by Reid. It was still considered a more effective and opulent hanging than wallpaper, although the latter could simulate damask and was rapidly increasing in popularity. The sewing silk alone used for these green hangings for the whole room cost £9 10s 0d and the 'rich Carved Antique Border, gilt' was

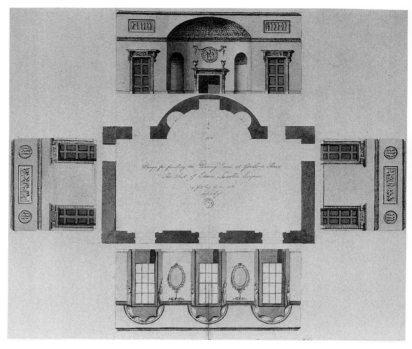

Fig 17 Adam's finished drawings of 1765 for the Dining Room in Neo-classical style show the apse he intended to hold a sideboard, urns on pedestals and wine - ooler used instead for the fireplace. Sir Charles Barry's plans for the redecoration of the room are dated 1845

£110 5s 0d for a length of 420ft.

The window curtains continued the decorative scheme, green damask, toned with yellow. They were lined with 41yd of green Tammy at 1s 6d a yd, fringed with 42yd of green and yellow silk which cost £25 4s 0d, and adorned with 12 silk tassels at 4s each. Chippendale also charged for Reid's tape, thread, extra lining and lace, silk braid and plumbets, brass screw pulleys, wrought pins, iron brackets, locks, keys and two circular pulley laths. Over both windows Reid fixed 'rich Carved Cornices', gilded, an expensive pelmet feature which cost £26 0s 0d for the pair.

For the walls Chippendale supplied two oval glasses each costing £100, set in matching frames heavily gilt with 'rich Carved Antique Ornaments' which added £69 to the price of the pair. Glass was exceptionally expensive, so that old glass was reused

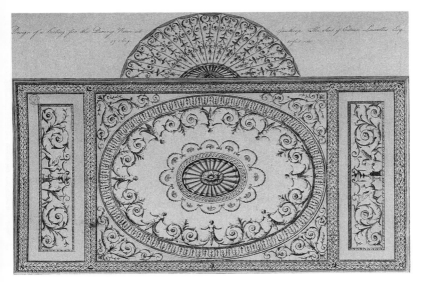

Fig 18 Adam's drawing for the ceiling of the Dining Room shows his use of the circular motif of putti or 'merfolk' joined by anthemion, which formed part of his design for the ceiling of the Circular Room

after repairing and resilvering to avoid paying duty; by comparison frames were cheap. A third mirror is attributed to him, interesting because it shows the continuing influence of Chinoiserie and its importance in a State apartment.[13]

There were in addition a very large pier glass, nearly twice the price of an oval one, in a carved gilt frame and six very fine cabriole arm chairs 'Carved in the Antique Manner, gilt in Burnished Gold, Stuffd & Covered in your own damask', which were in all £60. Two long stools en suite were also upholstered by Reid, who stitched green serge cases for these most expensive chairs and crimson cases for the stools, now in the Music Room (plate 18).

Chippendale designed the three outstanding pieces of marquetry furniture veneered in satinwood seen in the Princess Royal's Sitting Room. The original location of the secretaire and the smaller dressing commode in the house is not recorded, but the unique 'Diana and Minerva' commode was made for the adjoining State Dressing Room (plate 8, 9).

The secretaire, influenced by French taste, has a fall-front which opens to reveal drawers and pigeon holes for a society of enthusi-

astic writers of letters and diaries. The smaller commode, apparently a companion piece, has a central medallion, depicting The Three Graces. This is executed in paint, a remarkable simulation of the marquetry potraits in ebony and ivory of the two goddesses on the second commode.

This 'very large rich Commode' described by Chippendale in the careful detail he reserved for his favourite creations is constructed in mahogany, oak and pine. There are drawers at each end, a cupbourd in the middle and a fitted dressing drawer above, which remains intact with its cosmetic compartments. Invoiced at £86 with £1 for a damask cover for the satinwood top on 12 November 1773, it was the most expensive item of cabinet furniture ever entered in his accounts and regarded as the finest (plates 8, 9).

These important commodes reflect the need to furnish such bedrooms with the same style and distinction as the public apartments, for they filled too the role of reception rooms during the long hours spent in the ritual of making one's toilette. Already, however, purely functional dressing tables were in vogue and Chippendale supplied these 'toilets' for Harewood, complete with their 'pettycoates'. Ladies' dressing rooms were used as their private sitting rooms — Lady Fleming appears to have had two, her own and the Crimson Couch Room — and small closets or wardrobes served for dressing.

This splendid commode arrived from London with other goods in a packing case, 'the Joints well secured' with 2,548ft of string, at a cost of £42 9s 4d. A further £9 5s 0d was charged for the deal for battons, screws, nails, paper, packthread and the packing and loading of the whole, protected by eleven large 'matts' and two blankets.

Reid did most of his work for the State Bedchamber during the winter of 1773-4, beginning in October after he had laid the carpet on the Great Staircase, covered it with oilcloth and serge, and seen to the curtains in kitchen maids' room and the canvas blind in the store room. Walker, the joiner, and his new partner, Bottomley, helped him to fix the gold border on the green damask walls and William Collins,[14] the London statuary employed at several other great Yorkshire houses, was paid six guineas directly by Chippendale for '3 Basso Relieves for the Tablets of the State Bed Cornices not included in the charge of the Bed', a sum then charged to

Lascelles's account. Reliefs over the Hall and Saloon fireplaces illustrate on a much larger scale Collins's style of classical sculptured panels. While Reid was waiting for the serge to come for the furniture, he fashioned canvas covers for the door handles and filled sandbags, a necessity rather than a precaution to combat draughts.

The furnishings of the Bedchamber were expensive, but not exorbitant, when compared with the sum of £1,220 which Walpole was estimated to have spent on the trimmings of the state bed at Houghton a generation earlier.[15] The dressing rooms at Harewood House — the Gentleman's Dressing Room en suite and the Lady's Principal Dressing Room — greatly advanced the cost, however, for both were fitted up as superbly as the bedroom they adjoined. In the former there was a pier glass, listed by Chippendale at £360 and the three brushes and four bottles for the dressing-tables, which cost in all 8s for the set, show the detailed attention lavished on the State apartment, already becoming an outmoded status symbol.

In 1767, the year Chippendale first saw the rooms, the masons were still working there cutting a doorway between the State Bedroom and the Circular Room, destined to serve finally as the Lady's Dressing Room, and a labourer spent half a day removing stones from the State Bedchamber itself. Rose's very beautiful ceiling was completed in 1770 and Chippendale's furniture perfected a room already superbly finished and decorated. The last mention of Reid's work at Harewood House is a day work entry for 22 July 1776: 'uncovering Furniture in the State Apartments'.

The range of services offered by Chippendale in the houses he furnished was of so comprehensive a nature that it included the initial maintenance of all the work carried out by his firm, as well as the setting up of his furniture and the incidental labour involved in the countless tasks associated with an 'upholder's' business.

All this devolved upon Reid. He unpacked and fixed furniture, mirrors, girandoles, and lamps, hung walls with damask or paper, made up 'bed furniture', upholstered and covered seat furniture, laid carpets and put up blinds (including those called 'Venetian') and made covers for every possible article, 'pettycoates' for the toilet tables, leather covers to encase the posts of the family bed, and oil-cloths for the side-board of the celebrated Chippendale suite. He cleaned the furniture, the mirrors, the hangings, the beds and the mattresses, restuffing and beating them, thereby eradicat-

ing any errant bed bugs.[16] Nor was Reid's work confined to the
principal apartments; the plate closet was lined with baize, an
intricate job which took him $13^1/_2$ days, the steward's room and the
housekeeper's were given floor coverings, the coachman's bed
was altered and set up, the carpet for the back stairs was sewn and
laid, the church pew had a new cushion and hassocks, the organ
stool a covering, and a plan of 'Capability' Brown's was given a
canvas backing.

Reid also found himself subject to the whims of the new
mistress of Harewood, the widowed Lady Fleming, whom Lascelles
married in 1770, six years after the death of his first wife, Elizabeth.
Lady Fleming, the title by which she continued to be known, was
a charming woman of active temperament, fashionable appear-
ance and wide interests.

In the autumn of 1773, she set Reid to work 'preparing and
covering a tambour for my Lady', a delicate task at a time when he
was busy hanging the walls of the State Bedroom with their green
damask. Two years afterwards, however, he was able to upholster
a set of green and white 'Splat-backed Japannd Chairs with
Cabriole Seats stuft and Covered with your needlework and
finished with Brass nails'. The matching stools were not ready
until 1777, 'two large Circular Stools covered with your needle-
work', invoiced on 7 June, 1777. One of these has been acquired by
the Chippendale Society, with the original cover woven in yellow,
pink and red and arguably Lady Fleming's handiwork.[17]

Both the Popplewells were devoted to her. The older man
thanked her on one occasion for her 'kind and entertaining letter,'
and his son was equally enslaved, however demanding she might
be. Lady Fleming had her husband's trenchant attitude to waste
and inefficiency. She complained that 'our cowes calf at improper
times and likewise the pigs are ill-managed in that respect'. Yet
Popplewell could always engage her sympathy for animals, writ-
ing to her about the desperate plight of an Alderney cow: 'she
Breaths with great Difficulty' and the cow doctor from Leeds can
do nothing for her.

Lady Fleming's suite was most elegantly appointed and her
daughters, Jane and Dorothy, had 'a very agreeable room for their
own Studies'[18] near the Circular Room. The famous portraits by
Reynolds of these extremely attractive young women, the 'belles
of Harewood', hang in the Cinnamon Drawing Room. Henry

Plate 8 Chippendale's 'Diana and Minerva' commode, marquetry on a satinwood ground, in the Princess Royal's Sitting Room, a masterpiece for £86 with a leather damask cover costing £1

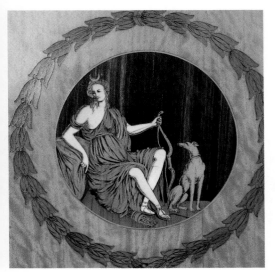

Plate 9 Picture medallion of Diana, Goddess of Hunting. Chippendale's exceptional use of ebony and ivory indicates the superb quality of the piece

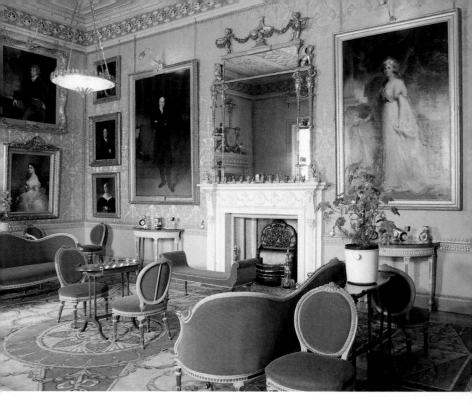

Plate 10 The Yellow Drawing Room. A portrait of Jane, Lady Fleming, the second wife of Edwin Lascelles, hangs to the right of the chimney-piece

Plate 11 The Yellow Drawing Room chimney-piece by Nollekens, with Meissen animals, and the repainted Adam ceiling reflected in the magnificent Chippendale mirror

Singleton's portrait of their mother is next door in the Yellow Drawing room. In her early sixties and apparently gifted with good looks and a sense of humour, she wears a white gown and her coronet and peeress's robes are on a table to her right.

The family usually arrived at Harewood about the end of the first week in June, when the Parliamentary session was over and the Season had ended in London. Daniel frequently joined the family at Harewood and, despite his ownership of Goldsborough Hall, had a room reserved there for his own use. The Summer Recess extended well into the autumn and often Christmas was spent at the house.

The Christmas of 1778 was the occasion of 'great masquerading'.[19] Dorothy, now Lady Worsley, and two friends rode the Harewood cart horses into Leeds — Lascelles would not lend them his coach — to enjoy three riotous days, during which they ransacked the Spencer's library at Cannon Hall near Barnsley. At Harewood House itself, her caps and band-boxes were found hanging from a tree in the early morning light, the revenge taken by a guest whose clothes had been flung out of his bedroom window by Lady Worsley.

From 1771, despite the final chaos, the Lascelles were in residence. The great house came to life.[20] Reid lined card tables, made green cushions for a dozen rout chairs and constructed a 'markey' which took him eighteen days to finish. There were the customary problems associated with settling into any new home. Belwood suggested ventilators for the kitchen: 'he thinks they will in a great measure take away the disagreeable smells', but there was 'a water-closet which stinks all over the house'.[21] A domestic disaster was only narrowly avoided when Mary Hewit, the housemaid, forgot to take down the Library chimney board when she lit the fire. Devall's chimney-piece, Rebecca's tablet, Rose's stucco were all 'to the top as black as the fire back'. The door to Lascelles's Dressing Room was open and the smoke 'yellow'd the ceiling and stucco as far as the top of the Dado very much'. However, by washing and sponging 'the nicest Eye cannot discern it'; 'The poor Girl was terribly affected with it … I hope it will warn her', concluded Popplewell. Lascelles replied that Mollie — he used the diminutive form of her name — was a good servant and all the chimney boards must be burned. A visitor noted that the grates in the house were 'the handsomest and best polished I ever Saw.'[22]

The two library sofas had not long been re-stuffed when this happened and the cushions for the hassocks had been altered, but Reid's covers for Lascelles's renowned library table[23] and stool and for the sofas show the unquestioned wisdom of the intensive care given to Chippendale's furniture.

The family evidently preferred the Yellow or First Drawing Room next to the Saloon. It was used in Lascelles's day apparently as the Sitting Room. His own yellow damask was made up by Reid into chair covers and curtains, ten cabriole chairs were carved and japanned in yellow and white, varnished and covered with damask for £44 0s 0d. Two *bergères* each with down cushions and yellow serge were similarly upholstered and there was enough damask to have two curtains falling in festoons from their carved cornices, burnished in silver. The walls were hung with yellow silk damask.[24] A most expensive glass cost £160, but for its frame Chippendale charged only £75. A large 'circular' table of 'Sattin wood with Antique Ornaments... and Emblematic Heads in Ivory' has been described as 'undoubtedly one of the greatest pieces of English furniture', a Chippendale masterpiece for which he charged £60. The decoration on the table top of medallion heads and trophies is of great interest in the context of the iconography used in Chippendale's pictorial marquetry work.[25]

The Coffee Room in the base storey, where Lascelles was reported on New Year's Day 1774 to be convalescing after an illness, had an 'easie' chair with a cushion made by Reid, a set of chairs upholstered by him and a marble-topped table. Next door in the Billiard Room, it was Gillow's firm which supplied the billiard table.[26]

Reid's last important job at Harewood House was the hanging of the Gallery wallpaper. The under-paper came from Leeds, possibly from William Armitage, who supplied a considerable quantity of wallpaper for the house; usually Reid ordered the paper, making his initial choice from patterns or samples. Popplewell inspected the quantity and the price of the orders and, on one occasion, a sample was hung for his master's opinion of its suitability.

The Gallery wallpaper was specially designed and printed. It was Lascelles's policy to use materials available locally where he thought them adequate for his purpose, but to insist where he considered the outlay justifiable on merchandise of the highest

quality from London, for, as he pointed out, 'this place furnisheth the completest artists'. Chippendale's fee for designing the wallpaper and 'making a Drawing at large with the proper colours for the paper maker' was 3 guineas, and the '41 pieces of paper of Antique Ornament with palms etc. on a fine paper with a pink ground' were 30s each.

The paper was sent by coach to Leeds, but its arrival was delayed, so that Reid had to wait seven days, a period of unemployment which cost Lascelles about the price of one piece of the paper. On 9 September 1776, Reid began work on the Gallery and finished hanging the paper three weeks later. The use of wallpaper in the Gallery not only emphasises its increasing popularity in more important apartments than bedrooms and boudoirs, but raises the question of the completion of Adam's design for the eastern or chimney elevation, The arcades of the niches would have diminished radically the area to be hung with paper (see fig 16), so that it seems unlikely that so many pieces would have been necessary or that Reid would have taken so long to complete the work: nor would wallpaper have been perhaps the best choice for a room in which windows and mirrors occupied three elevations and six full-length niches the fourth.

Specialist assistance was given to Reid during his years of residence at Harewood House, but not extensively. There were 'one or two Taylors working at sundry times' and Brewer, a painter, who also helped to repair some India wallpaper, was boarded by Mrs Burrows, the housekeeper, for 7s a week: Brown, the gilder, was employed by Chippendale, but in two instances was paid directly and, it seems mistakenly, by Popplewell. Local men were employed; John Walker, the Harewood joiner, made some furniture and Theakstone carved ornamental details.[27] Muschamp's masons were available although they do not appear to have been called upon often.

Chippendale, in fact, fulfilled what was expected of an upholder: 'This Tradesman's Genius must be universal in every Branch of Furniture.' He visited the house certainly twice, in September 1774 and February 1776. The settlement of his account was a long-drawn-out affair. The upholder 'must be no Fool' in order to succeed, and Chippendale was sometimes hard pressed. The question of some substantial payment arose early in 1771 when Chippendale was feeling the pinch of giving so much

extended credit.[28] Popplewell wrote to Lascelles: 'If you should settle your acc'ts with him … please to remember to stop £6 1s 6$^1/_2$d which I paid to Mr. James by his order for wages, Chippendale has the Accnt.'

It was not easy to sort out his contracts with specialists like Brown, the gilder, to whom Popplewell had paid money, or the money given to the tailors which the steward presumed was included in Chippendale's normal charges, but in fact appeared as a separate item on his bill.

In 1773, Lascelles decided on a settlement and told his steward to examine his books for the three past years and send details 'in short of everything that relates to him and those who were employed by him in order to adjust his very great account', now well over £3,500. 'Chippendale's bill I dare say will be very long & heavy & perhaps tedious to settle,' replied Popplewell. Two years later no progress had been made and Popplewell was sending 'Mr. Chippindale's Books and Papers & his Acc't by Lady Fleming,' who was about to leave for London. It was 1777 before a settlement was achieved. In May, Popplewell sent the final statement of goods supplied and work done at Harewood House by the firm of Chippendale & Haig. He had tactfully despatched to Lascelles on the previous day a box of Mrs Burrows's potted lampreys. But before the month was out he wrote to his master in a panic lest the bill should have already been paid: 'when looking my Books very carefully Over yesterday I find that … I have omitted £16 16s 0d, I beg ten thousand Pardons … this tells me that Things of Consequence shou'd always be very carefully examined.'

His book-keeping to the end was unorthodox. It is full, for instance, of duplicate entries for the same work couched in differing terms; yet by some sleight of accounting his books balanced and the total outlay is available for each year. The heaviest expenditure came between 1765 and 1768, when the building craftsmen and the decorative artists were at work; 1766-7 was the peak year, when over £4,000 was disbursed. Lascelles's estimate of £30,000 was exceeded by about £7,000, with another £13,000 approximately to Chippendale and Lancelot Brown, in all about £50,000, excluding Robert Adam's fee, which it is not possible to determine.

Lascelles had done very well. To provide one's own materials and negotiate contracts separately with building craftsmen and

tradesmen was in accordance with the best architectural practice of the day[29] The estate was made to yield whatever resources it could towards the building of the house. Economic conditions were favourable, since he could postpone the issue of rising wages by offering continuous employment and the patronage and per-quisites of a still closed and manorialised society, the establish-ment of a landed estate. Wages increased as the 1760s advanced, but by 1771 the Harewood masons were still earning only 1s 8d a day, 2d more than in 1759. Apprentices and labourers remained at 1s 2d, an acceptable differential, however, since labourers were not required to provide and maintain their tools. Yet in the West Riding of Yorkshire in which Harewood lay and even in the area to the north, traditionally associated with a low wage-structure, 2s a day was being paid in 1771.[30]

Moreover, Lascelles had been able to commission a unique team of artist craftsmen to decorate his house, ranking from acknowledged experts to men 'of unknown character'. Some were considered almost an Adam monopoly, others had strong links with Carr and one or two had little experience of work of the quality demanded at Harewood. Rose (Joseph Rose junior per-haps rather than his uncle), Collins, Devall and Blockley were all the finest exponents of their particular branch of decorative art and the first in particular seldom worked for any architect other than Adam. Tobin was well known to Carr before he was associ-ated with any Adam house: Shillito was a carver in wood and stone often employed by Carr in Yorkshire: Richardson, Butler and Theakstone were provincial men, never widely known, a group of carvers associated with Doncaster.

Although no extended allegorical theme or family emblem is evident in the interior decoration of the house, the iconographic programme conveys the image of Harewood as a villa where the ancient Roman ideal of cultivated leisure on a country estate could be enjoyed. In most of the State Rooms, notably in the Library and the Music Room, the symbolism referred to the function of the room. Certain themes recur, taken from the popular mythology of Greece and Rome — the arts and learning, country pursuits and agriculture, the amours of the gods and goddesses, particularly Venus and her ubiquitous son, Cupid. These subjects were usually presented on ceilings not in relief but in the small-scale paintings preferred by Adam, for they gave the colour he advocated on

interior elevations and could be readily appreciated by a society well-versed in the interpretation of classical allegory.

If the programme seems conventional, based mostly on the fashionable literary sources of the antique world like the works of Ovid and Virgil, the influence of Lascelles cannot be in doubt, especially when the personal and contemporary nature of the iconography of the Entrance Front and the Entrance Hall is considered. On the wings of the Entrance Front, the four bas-reliefs by Collins representing Liberty and Britannia, Agriculture and Commerce proclaim at the outset the patriotism of the owner, his country's prosperity and the origins of his own wealth. The statement continues in allegorical terms within the Entrance Hall, where Adam's martial trophies recall the might of imperial Rome. The two large panels, also by Collins, develop the theme. Mars, god of war — with an interest in family history and pedigree — recieves the laurel crown and the palm from a winged Victory; on the opposite wall, a shell full of the pearls of riches is extended towards Neptune, ruler of the seas and protector of travellers. Taken together these signify the defeat of France in 1763 and the establishment of Britain as the leading colonial and mercantile power, an essential factor in the continued welfare of the nation and the Lascelles family.

Beyond the Hall, in the Saloon, the social centre of the house and now the Library, two large roundels, again by Collins, depict Bacchus and Venus revelling in Wine and Love. The natural haunt of Bacchus is, of course, the Dining Room and even the fourteenth-century castle of Harewood pays tribute to him in the vine leaf scroll carved on the built-in stone buffet in the Great Hall.

The most interesting example of the use of an early classical source is in the China Room, once the Little Library. This is a panel of the Aldobrandini Marriage, one of the treasures of the Vatican Museum and dating from the first century AD, painted by Rebecca in reverse and differing very slightly from the original. As early as 1762, Robert Adam wrote to his brother, James, in Rome to get the fresco copied in colour, possibly by Zucchi. It would be well worth the 'truble and expense' to have it for the English clients whom Robert hoped to dazzle with 'the beautiful spirit of antiquity.'

His accepted design for the ceiling of the Gallery is indeed something of a text book of mythology, with figures of the Four Seasons placed down the long central axis. Its inspiration came

from the only literary source Adam used, Robert Wood's *The Ruins of Palmyra*, published in 1753. The ceiling is clearly late in Adam's oeuvre, when the diversity of subject matter had been subordinated to the general scheme of colour and pattern, and allegory has become an incidental rather than a central decorative feature.

Chippendale's pictorial marquetry is equally distinctive in its employment of symbolic references. His 'Diana and Minerva' commode is particularly appropriate at Harewood, in recognition of Edwin Lascelles's love of hunting and the interest of Lady Fleming in the arts. Learning or Study is personified in the traditional pose reclining under a tree, on the secretaire in the Princess Royal's Sitting Room, a delightful piece often overlooked. His most ambitious and successful iconographical programme, however, was the decoration of the pier table dated 1775, once in the Yellow Drawing Room. Emblematic heads represent the Four Elements and Apollo and trophies illustrate the attributes of the Arts.

Whatever the medium, the myths and the legends of the antique world were realised at Harewood with consummate artistry, a tribute to the patron, who in this case almost certainly directed the choice of subjects, the architect and the decorative craftsmen, who executed the designs with individuality and expertise.

The decorative artists who worked at Harewood House were schooled and trained in the Neo-classical tradition;[32] Zucchi had workd with Tobert and James Adam in Italy. Rebecca and Zucchi could be relied upon to express an acceptable interpretation without asserting any individuality of style which might obtrude and so destroy the whole balance of a decorative scheme. Team work was essential and such names became literally household words to his clients.

Only Zucchi is mentioned in the building accounts or any relevant documents (see chapter 2 p61). Popplewell paid 'Mr Zucchi by Mr. Borgnis £6 6s 0d' on 19 August 1773. This was the Italian artist, Pietro Maria Borgnis, who was presumably assisting Zucchi at the house and worked with him on the decoration of the Etruscan room at Osterley. An entry for 20 August 1797 in the personal account book of Edward, 1st Earl of Harewood, records the payment of £5 5s 0d to 'Mr Rebecca'. Biagio Rebecca died in London in 1808. Apart from the Roses, Adam paid these artists directly, as, for instance, Chippendale paid William Collins. 'I

hope,' wrote Lascelles to Adam, 'the contract made with Rose will continue me in the same good opinion of them.' And it was Adam, not Carr or Belwood, who examined Rose's bill when it was presented for settlement in 1770.

Adam's association with Harewood continued certainly until 1783. In 1780, Popplewell died and his son, Samuel, took over as steward, on the understanding that he could not 'in conscience do business upon the Sabbath day.' Correspondence between him and Lascelles during the years 1781-3 refer to Adam's designs for the main gateway, flanked by two pavilions. Muschamp's uncooperative attitude prompted Lascelles to write: 'Mr Adams reply is very particular and therefore [I] desire John Mushcamp wou'd pay strict attention to it'. The great entrance gateway was not begun until 1801 by Carr, who redrew Adam's original drawing with some mishandling of Adam's detail.

Meanwhile, in 1782, directions were sent north for setting up the 'bas reliefs compositions', which Muschamp was instructed by Lascelles to read so that he might not 'have difficulty in fixing the figures and the ornaments when they arrive.' These were delivered, undamaged, in cases and put up to Lascelles's apparent satisfaction. Presumably the 'ornaments' were the four low relief panels inset in the north facade of the wings terminating the entrance front, described as the work of Collins from designs by Zucchi (figs 4, 8).

Old Gawthorpe Hall was demolished. In 1770 it was stripped of its glass and chimney-pieces; the latter were probably re-used in the base storey of the new house and not in the attic floor, where Carr had put in twelve marble ones in 1767. Two years later Muschamp's men were taking down the Hall and, by 1773, Popplewell was tired of the mess: 'I am weary of seeing it, but cannot tell how it can be avoided.' It was another three years before the portico Lascelles had added to his first home at Harewood was removed and the masons' lodge pulled down. Then the last traces of the coach-house went and finally the site of the old Gascoigne manor house was left to disappear. Aerial photography has revealed the outlines of the foundations of Gawthorpe Hall discernable just to the east of Carr's stables, on the level ground between the Victorian terrace garden and the lake, about 300yd downhill from the South Front of the house.

The lake had been the watery grave of many reputations,

including Brown's, for as Lascelles found 'water can be commanded only in certain situations and circumstances'.[33] Although Brown on evidence paid an early visit to Harewood, he did not return to direct work on the lake and the planting until 1772. Lascelles was an enthusiastic gardener, knowledgeable and intolerant of inefficiency, more especially when this involved the expense of buying nursery seedlings and plants from Mr Perfect of Pontefract, or Mr Telford of York.[34] He was adamant that his gardens must supply the household with peaches, pineapples, french beans, strawberries and melons, delicacies which were sent up to his London establishment. Lady Fleming was equally interested both in the landscaping of the grounds and in growing flowers, provided no women gardeners were employed. A garden was made for her, possibly near the North Pleasure Ground to the west of the church. Scented flowers, like sweet peas, appealed to her most of all and Popplewell carried out her request for four flower tubs to be painted green and filled with 'mininette'. Possibly they were for the portico outside the Saloon windows; Elizabeth, 1st Duchess of Northumberland, noted in one of her travel journals that it was 'spacious & quite full of pots of Mignonette Balm of Gilead & all kinds of Green House Plants.'[35]

Popplewell was delighted to supervise another commission for Lascelles's wife in 1785, the construction of a Rotunda, which still stands in the Pleasure Ground on the northern boundary of the park. She chose the position carefully, on the escarpment of Harewood Bank, overlooking the countryside beyond the Wharfe to Harrogate, with a view up Wharfedale to her left and on the other side to the castle that crowned the ridge. The little temple was extravagantly described as 'this majestic edifice ... with an elegant dome.'[36] Perhaps it was a favourite spot. In the background of Singleton's portrait of Lady Fleming, about ten years later, a small classical temple with a view of distant hills can be seen.

Despite Brown's years of absence and Lascelles's apparent responsibility for the landscaping of his own place, it seems that contact with Brown was not entirely lost for the planting of part of the pleasure grounds was supervised by White, one of Brown's men, who later became a distinguished landscape gardener in the north-east of the country and in the Borders. The early stages of filling in the old Cut or straight Canal (see fig 3) and damming the

Stank beck caused difficulty and this increased to formidable proportions when the large lake was being constructed. The water kept leaking out and in 1778 there was still, according to Popplewell, a hole next to the plug 'large enough to bury a horse'. Brown was unable to complete the job to Lascelles's satisfaction and was superseded by the surveyor, John Hudson, who guaranteed the work in 1780 to last for twenty-one years on a security of £1,000.[37]

When Brown asked for the payment of £900 due to him for his exertions in connection with the lake, the planting of the slopes and the making of islands in the lake, Lascelles was obdurate: 'I have always said and did insist upon it that the ground was Scandalous lay'd & beggarly Sown, and that Several other parts were Slovenly Run over and badly finished.' Brown had to promise that 'if any part is not completely finished to my approbation and the most competent judge, he will see that it shall be'. In February 1780, two years later, Brown was paid £300, being forced again to importune Lascelles at his London house for the final settlement of his account. In May 1781 Lascelles told Popplewell at last 'I have settled accounts with Mr. Brown.'[38]

Brown's foreman at Harewood, Sanderson, continued to work for Lascelles. Relations between Sanderson and Popplewell had lacked harmony, a quite natural circumstance when both men needed an adequate labour force. 'I told him in plain terms he was a lyar and a dirty scoundrel,' Popplewell wrote to Lascelles, 'I own I was at fault for using such unbecoming language, but who can bear his insolence.' Sanderson's terms of employment indicate that a patron's usual practice was to pay a specialist worker through his master. In this particular case, however, 'it is a matter of indifference to Sanderson whether he receives the money from you or Mr. Brown.' The arrangement must have been approved by Brown for Lascelles wrote to Popplewell: 'I do not find any works are likely to go on at the Duke of Rutland's at Belvoir or that Mr. Brown has any works in hand for Sanderson.' Since it was a pupil of Brown's, Webb, who remained in charge at Harewood, the landscaping, the gardening and the planting were without doubt in the Brown tradition (fig 20).

Lascelles was always pleased to show his new house to visitors. In May 1780, for instance, Mrs Burrows, the housekeeper, was instructed to receive one, Mr Hay, who was breaking his journey to Scotland, offer him refreshment and show him round, indicat-

ing in particular the place under the great dam that Lascelles had chosen for a grotto. Large shells were to be supplied for it by the East India Company, whose service Mr Hay had recently left. The grounds were to be shown to him by Sanderson.

Whatever criticism might be made of the house, 'stark and palpable', there was no hint that its landscaped setting lacked the perfection effusively described by Anna Seward, a conscientiously literary lady, as she drove from the Entrance Gate to the house: 'Harewood's glassy waters shone through tangled brakes in the glens, expanded into the lake or slept on the lawn.' She found the house itself an anti-climax: 'With what comparative sobriety of spirit I surveyed the artificial splendours of the seventeen state rooms in Harewood House.[39]

For notes to this chapter see pages 177-9.

5
Regency Harewood

Edwin Lascelles, Lord Harewood, died at Harewood House on Sunday evening 25 January 1795. He was eighty-two. His obituary in *The Gentleman's Magazine* was devoted entirely to the praise of 'his noble mansion at Harewood ... deservedly ranked with the first buildings in the kingdom'.[1]

The Leeds Intelligencer did not even mention Harewood House. The reference to the sterling qualities evinced by its owner in public and private life, his affable, courteous and hospitable nature, his care for his tenantry, and the 'universal and deep regret manifested at his death' are perhaps only the conventional phrases of any eulogy of the period: yet there is a ring of sincerity in the assertion that 'His princely fortune was employed in such improvements as afforded support to all the neighbouring poor. The whole parish regarded him as their father and their friend.'[2]

The new squire was Lord Harewood's cousin, Edward Lascelles, a man already in his mid-fifties and well known at Harewood, for his country seat was at Stapleton nearby. In their younger days he had been closely associated with the Lascelles brothers, Edwin and Daniel. His name appears with theirs for instance on subscription lists for the York Assembly Rooms: he, too, had been born in Barbados, and had represented the borough of Northallerton in the House of Commons. He differed in experience, however, for he had fought with cavalry regiments in the Seven Years' War.[3]

Edward Lascelles's Yorkshire connection was greatly strengthened by his marriage in 1761 to Anne Chaloner of Guisborough, in the east of the county. Soon they were both very much part of the family circle growing up around Harewood. They were on the best

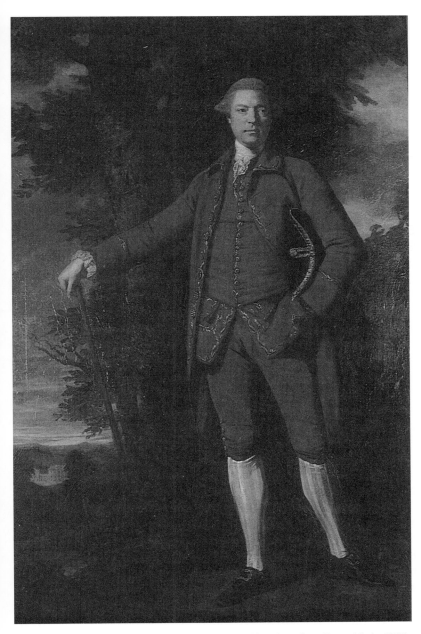

Fig 19 Edwin Lascelles, Lord Harewood, painted by Sir Joshua Reynolds in 1768, with his new house in the distant background. The Cinnamon Drawing Room.

of terms with the elder Popplewell, who wrote in 1763 to offer young Mrs Lascelles some of the Gawthorpe housekeeper's concoctions — peppermint water, pennyroyal and elderflower water — 'if she pleased to send for them'. All the family felt the attraction of the new country place and, as old Henry Lascelles had doubtless intended, regarded Harewood as their headquarters and their home.

Latterly, a coolness seems to have developed between Edwin Lascelles and his heir. A passage from a letter of August 1785, the year after Daniel's death, does not suggest that the cousins were closely in touch. Lascelles wrote about some property in Northallerton for which the signatures of both Edward and his son were necessary: 'Edward Lascelles' son went upon his travels a month ago and last I rec'd a letter that he was at Tours in France. I did not know he cam of Age in January last.'[4]

It was another ten years before Edward inherited all the Lascelles estates, including Plompton and Goldsborough, once Daniel's possessions, and the plantations in the West Indies controlled from the merchant banking house founded by Henry Lascelles in London over half a century before. The London house in Portman Street was left to Jane, Lady Harewood, for her use in Lord Harewood's thoughtful and generous provision for his wife by the terms of his will.[5]

With the death of Edwin Lascelles, Lord Harewood, the peerage became extinct in the absence of a direct line of succession. The title was revived, however, in June 1796. By August the insignia of nobility were on display in the hall of the house in Hanover Square. Chippendale's firm painted 'Crests & Coronets in Medallions' on the six chairs there, a set the same or very similar to those made by the elder Chippendale for the Entrance Hall at Harewood where they still remain (see fig 12).

Edward, Baron Harewood of Harewood, took his seat in the House of Lords in March 1797, a ceremony which cost him fifteen guineas in 'Introduction Fees'. The presence of the Garter King of Arms at a fee of £2 10s 0d and a clerk who read out the Letters Patent for one guinea were less expensive necessities than the eight door-keepers among whom the new peer had to distribute four guineas 'as usual at a first creation'. Attendance at Court of George III and Queen Charlotte at the Palace of St James followed, an additional expense of £2 12s 6d, for the Marshalls, Yeomen,

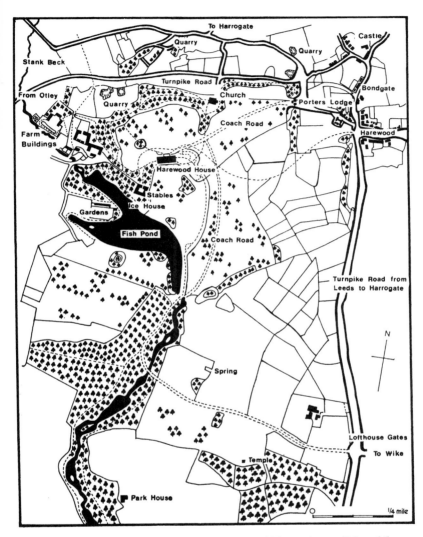

Fig 20 The park and pleasure grounds of Harewood House, from a 'Map of the Townships of Harewood and Weardley, 1796', by Jonathan Teal. A totally different pattern of landscape and land use emerges after the work of 'Capability' Brown and Edwin Lascelles (compare fig 3). The Entrance Gates opposite Harewood Avenue have not yet been erected nor the rebuilding of the village completed. The emparkment of Harewood did not involve the destuction of the village: only a few houses were removed. (HA Estate Maps no 44)

Groom, Porters and 'Their Majesties' Yeomen' all had to be paid.

In 1812 Edward Lascelles was created the 1st Earl of Harewood and Viscount Lascelles is the title borne from that time by the eldest son. The Earl's full length portrait by Hoppner shows him in determined resplendence, robed as a peer of the realm.

He enjoyed his inheritance for fifteen years and, with his succession, a new chapter opened for Harewood House. It had been left by Edwin Lascelles a proud and confident building, expressing in its clear-cut classicism the very heart of Georgian privilege and power. 'But nothing within interests the mind; no production of the arts, unless the labours of the gilder and uphol-sterer may be considered as deserving that character' wrote a clergyman, Richard Warner.[6] This was a deficiency made good, for in the time of the 1st Earl the house acquired a new fame. To its undoubted architectural merit and splendid interior decoration there was added an important collection of porcelain and china and some fine portraits and watercolours. Both the 1st Earl and more especially his eldest son, another Edward, were interested in the arts and gave Harewood House its early and continuing reputation of a country seat particularly associated with these.

The older man loved music. He had his own band of musicians and, as a local patron, saw to it that Harewood Church produced a reasonably well-trained choir. The organist, John White, was retained almost as a member of his household. As early as April 1795, his expenses were paid to London; thereafter, regular fees for his services occur in Lord Harewood's account book. In 1800, musicians from Leeds were given 10s 6d and a week later Lord Harewood spent three times as much having his instruments repaired. His account book notes the purchase from Raimondi of a violin at eight guineas, and the hire of a pianoforte for 3s 9d from Ball of Grosvenor Square.[7] 'The singer Cianchettini' received a fee of £5 18s 0d 'for music'.[8]

Lord Harewood patronised both Opera and 'the Play', taking a box at Drury Lane and subscribing to a benefit night for members of Tate Wilkinson's stock company at The Leeds Theatre in Hunslet Lane, Leeds. To one of Wilkinson's plays the Earl also donated a guinea, continuing on a modest scale the patronage so liberally extended to the actor manager by Lady Fleming.[9] 'To the fund for decayed musicians' he paid a year's subscription of one guinea in June 1800.

Lord Harewood had an obvious preference for the amusements and diversions of town life. The account books recording his personal expenditure between 1790 and 1797 suggest that he enjoyed the best that London could offer in the last decade of the century when calamitous events in France had reached the climax that led to the outbreak of war in 1793. He had an Italian tailor and a most expensive hairdresser. He took warm baths in Harley Street, subscribed to a lending library, belonged to White's Club and lost surprisingly small sums at cards. He bought confectionery at Gunter's and soda water from Mr Schweppes.

Harewood House benefited from his patronage of the painter, John Hoppner, whose portraits of various members of the Lascelles family augmented the Reynolds collection already assembled by Edwin Lascelles.[10] Hoppner belonged to the same school of eighteenth-century English academic portraiture, but he lacked Reynold's unerring sense of occasion, his ability to transfer on to canvas the possessive dignity, the aristocratic poise and the certainty of status which characterised the men and women he painted. Lord Harewood commissioned Hoppner to paint three portraits: Mary Anne, his daughter; Henrietta Lascelles, the wife of the Earl's second son, Henry; and the Earl himself. The first instalment of the artist's fee was paid in the autumn of 1795, £65 12s 6d, and a gift of £15 7s 6d followed almost immediately. It was customary to pay such fees in two instalments and the second payment was recorded in May 1797 for 'Half Portraits of Mrs H. Lascelles, Miss Lascelles and a head of His Lordship'. Hoppner is well represented at Harewood House and his delightfully serene portrait of Henrietta Lascelles, who became the 2nd Countess of Harewood in 1820, was considered one of his more successful works.

Particular interest attaches to the two Hoppner portraits of Edward, Viscount Lascelles, the eldest son and the heir to the title and the estates. To him Harewood House owes many of its treasures, and his death in 1814 deprived both the family and the house of an enlightened patron and shrewd connoisseur.[11] In appearance he seems the essence of the late Georgian period, of the cultured leisure associated with Regency England, debonair and casually elegant, his coiffure and neck cloth dérangés to a nicety, his expression romantically Byronic. A physical resemblance, due in some measure to overweight, but mainly to a fondness for

dressing in the first style of fashion, gave the Viscount a strong likeness to George, Prince of Wales and Prince Regent from 1811 until 1820, an identity considered by His Royal Highness to be not only totally mistaken, but even offensive (fig 21).[12]

Edward, 'Beau' Lascelles, may have inherited from his father his interest in china and porcelain. The 1st Earl recorded purchases of a jug and cover from Wedgwood, an inexpensive little trifle at 3s, and a desert service of French porcelain at Christie's, said to be secured by his agent for £43 1s 0d at the sale of Baron Nagel's effects there in 1795.[13] Lord Harewood also bought 'desert figures' from William Duesbury II, proprietor of the Derby factory.

Viscount Lascelles was, however, no erratic purchaser but a serious collector, whose percipience and acumen secured for Harewood House some of the finest pieces of Sèvres porcelain ever made, dating from the great days of the industry before the French Revolution. He took advantage, like other collectors and artists, of the temporary cessation of hostilities which resulted from the Treaty of Amiens to go across to France in 1802. There he bought in the sale rooms of Paris exquisite examples of French porcelain and of china before these aristocratic legacies of the ancien régime were lost or dispersed in the renewed war which lasted until 1815.

His most valuable acquisition was the Louis XVI Sèvres tea service dated 1799, the gift, according to tradition, of the City of Paris to Marie-Antoinette. Apart from the sheer delight of the decorative painting of children and animals, the service is of the greatest significance; the sumptuous quality of the gilding and the exquisite miniatures in the reserves, the areas 'reserved for painting', are evidence of the unsurpassed craftsmanship at the Royal Porcelain Manufactory in the decade before the Revolution. This theory is supported by the brilliance of the ormulu mounts on the Chinese porcelain vases in celadon green in the Harewood Gallery, their colour enhanced by these gilded bronze mounts made by French experts (plate 12).

In December 1807, he settled a bill for just over £600 presented by Robert Fogg, the china dealer who had recently inherited his father's business in New Bond Street. Lascelles's purchases of Sèvres ware included a 'Dejunie', cups, sugar dishes, a pair of 'Seve Tee Tureens' at fifteen guineas, a figure stand, a vase and nearly twelve dozen plates at eight guineas a dozen.[14]

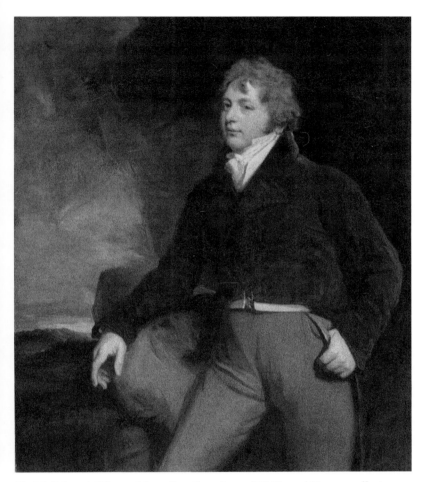

Fig 21 Edward, Viscount Lascelles, the patron of Girtin and Turner, collector and connoisseur, painted by John Hoppner in 1797. The Yellow Drawing Room

Moreover, he was himself a talented painter. John Hoppner found that 'Young Mr Lascelles… has a taste for the arts' and the two men made excursions together in the neighbourhood of Harewood 'to remarkable places'.[15] But the style of Lascelles's own work was influenced predominantly by an artist of a very different school, Thomas Girtin, one of the new generation of artists working mainly in the delicate technique of watercolour, a medium particularly well suited to express in visual terms the

Romantic Revival which so strongly influenced the literature of the period. It was a far-sighted and generous gesture on Lascelles's part to invite three very young artists, Thomas Girtin, J. M. W. Turner and John Varley, to Harewood House. Like Thomas Malton junior, whose pupils Girtin and Turner were, they found the place an inspiration and their patron was rewarded by the possession of a collection of watercolours and sketches of great intrinsic value, which are in effect a series of landscape studies amounting almost to social documents of the English countryside in the age of Wordsworth and Southey, of Thomas Bewick, the engraver, and Gilbert White, the naturalist. As a topographical record of Harewood House and its surroundings at the close of the century, the collection has unique historical interest. These artists delineated the great house from every angle, depicted it in every mood and, because the earlier exact architectural approach of Malton had not yet been subordinated to a more romantic impressionism, Harewood House in its classical hey-day, the untouched late Palladian villa of Carr and Adam, has been recorded with enviable freshness and clarity (plates 4, 6 and fig 4).

Girtin in particular appreciated that the relationship of a great house to its surroundings implied more than the sheer pictorial beauty of a setting.[16] To fulfil its function, a country seat must be involved with the reality of country life, part of the land itself as well as of the landscape.

Turner was inspired by Thomson's poems, of 1726-30, *The Seasons*, copies of which were bought by Edward Lascelles in the year before the twenty-two year old artist came to Harewood in the summer of 1797. *Harewood House from the North-East* (see plate 4) was one of a pair of watercolours, for which Turner was paid £10 10s 0d each in November. In this painting he was not yet concerned with 'the landscape sublime' of Thomson's 'wild, romantic scenery', but with the poet's involvement in the human element in landscape. The natural surroundings and the people are as closely observed as the architecture of the house. The group of estate workers, resting beside their tools, and the felled tree trunk loaded on to a waggon convey the reality of the social and economic life of the place, in contrast to the Malton's intrusive, if elegant, coach. Turner's next commissions at Harewood show him moving away from the 'rustic sentimental' genre: the house above the lake in its artificially created environment is seen from distant

viewpoints in the wider natural landscape of Wharfedale, a record of 'Capability' Brown's achievement, painted in sublime style.

It was this dynamic approach which inspired and informed the alterations made to Brown's famous view from the south front of Harewood House by his successor, Humphry Repton.[17] Repton had a high regard for Brown's work and avowedly disdained the vogue for the picturesque in parks and pleasure grounds which accompanied the Romantic Revival, but his visits to Harewood in 1800 and 1802 resulted in an emphasis in landscaping which expressed in three-dimensional terms something of Girtin's philosophy. By sowing fields of grain on the hillsides and a more varied use of plantations and water than Brown's restrained planning had envisaged, Repton added vitality and softened the outlines of the vista to the south without destroying the original concept of the Harewood landscape as created by Brown and Edwin Lascelles.

Repton left a set of delightful designs including a trellised conservatory for exotic plants in the Flower Garden. The new closer link between house and garden meant that flowers invaded the house, a form in interior decoration not widely accepted until Repton's day. Viscount Lascelles designed flower stands for the Saloon of Harewood House and, from his drawings, John Wood, a local carpenter, made 'two ornamental' oval flower stands.

Repton's drawings and plans for the buildings in the grounds are mostly dated 1801 and remained unexecuted. His imposing entrance gateway was so altered by Carr and Muschamp that Repton was deeply chagrined. He felt humiliated and said so.[18] In 1810, seven years after the completion of this new Main Entrance, 'Beau' Lascelles planned a rebuilding of it in the grand manner of the early eighteenth century. His idea was drawn out by John Muschamp Jr, Clerk of the Works, but never put into effect, a fortunate circumstance since it was completely out of keeping with the village, the house and the whole environment.

During these years of activity, when the Viscount's enthusiasm and talents were engaged in promoting Harewood House as a centre of artistic patronage, there were several schemes to enlarge the house itself. John Carr's plan of 1800 shows an elongated frontage in a manner reminiscent of the early Palladians including a greenhouse and, that extremity of inconvenience, kitchen quarters in a distant wing. Peter Atkinson, Carr's successor, made

drawings in his York office for an additional storey over the central section of the house. Repton offered a design for the north elevation 'shewing the effect of adding wing walls to the basement storey as proposed and also the addition of bedrooms between the Hse[House] & Wings according to the very judicious suggestion of His Majesty'. This can only be a reference to George III, tutored in his youth by Sir William Chambers in the elements of architectural drawing. Yet another idea was an addition to the west wing at basement level, perhaps for the personal use of Viscount Lascelles.

Harewood House was unaffected by Regency domestic architecture, for none of these plans bore fruit. The house, however, attracted royal visitors in addition to tourists who found Harewood a pleasant excursion from the increasingly popular Spa at Harrogate. In 1815, the year after 'Beau' Lascelles's death, Queen Charlotte came with her son, the Prince Regent, to see the Harewood collection of porcelain already renowned and a potential heirloom of great value.[19] The Grand Duke Nicholas of Russia, later Tsar Nicholas I, was received at Harewood House in 1813 in the Saloon, dined off the gold plate, and was entertained in the Gallery by the Earl's musicians conducted by John White and by the Harewood Church choir. 'The glee of the evening was maintained with uninterrupted eclat' and with a programme almost totally Handelian in content. Next morning the Duke professed himself delighted by the picture of rural prosperity presented by the estate.[20]

Louis Simond, a French emigré from New York, had the same impression of the Harewood area. He drove into Leeds late on a March evening in 1811 'through a rich and highly cultivated country'. He noted 'Farmers riding among their workmen — great flocks of sheep confined by net fences in turnip fields' and on approaching Leeds from the north he 'saw a multitude of fire issuing, no doubt from furnaces, and constellations of illuminated windows (manufactories) spread over the dark plain'[21]

Increasingly the association of the Lascelles family was with Leeds, with the politics of its manufacturers, with interests of its society and the patronage of its tradesmen. Louis Simond noted a reading room and a lending library: 'the librarian is a lady'.[22] No one could doubt that in every respect Leeds advanced rapidly.

At Harewood House the changes in furniture design which marked Regency period did not apparently mean any radical

alterations to the style of its interior decoration. Indeed, there is evidence that the 1st Earl deliberately commissioned the younger Thomas Chippendale to supply pieces, which would be in effect copies of his father's style and about twenty years out of date. The best examples of this conscious imitation are the pier tables in the Gallery. These tables are so entirely in the style of the elder Chippendale's mirrors above that they were for many years presumed to be his work. A bill of the younger Chippendale for 1797 proves that the frames with their rams' heads supports and lions' paw-feet were carefully made to simulate the older fashion.[23] The marble tops were the work of one of the best known provincial sculptors, Fisher of York, who also did a bust of William Pitt for his Lascelles admirers (fig 15).[24]

Again, it seems that a small library table was supplied to match the much larger table, a celebrated masterpiece of Chippendale's furniture.[25] Two vast and commodious 'Cloathes Presses' are other examples of an outmoded fashion. These heavy mahogany pieces are equipped with shelves edged with cedarwood and capacious drawers. The larger cupboard is fitted with pegs, the smaller with pigeon holes. Both are in Harewood House, accommodated in separate rooms on the ground floor.

Chippendale's 'Large Horse Dressing Glass in a Mahogany Frame with Claw Stand made to Fix with Ballance Weights', which cost £13 in 1796, is the essence of the Regency period in style and purpose. A cheval glass, standing on a frame of four legs, was a necessity in the dressing room of every gentleman who hoped to pass muster, let alone win acclaim, in the world of fashion. A significant side-effect of this preoccupation with personal appearance was the increasing attention paid to cleanliness. Lord Harewood wrote in June 1798 to Samuel Popplewell with something of Edwin Lascelles's crispness: 'I expect to see the Bathroom finished. Chippendale tells me the Things were sent last week.'

Apart from these accounts of Chippendale the younger for specific work at Harewood House, there are few definite sources of information about other furniture supplied in these years. The 1st Earl certainly spent money quite lavishly in this way, but the details of his expenditure are not recorded. Moreover, the purchase in 1795 of a house in Hanover Square to serve as a permanent London residence adds confusion, for the new property was named Harewood House. He patronised leading cabinet makers

in London and Leeds firms received orders.

The Egyptian craze had a relatively brief vogue. By 1820, the Entrance Hall at Harewood House had been 'fitted up in Egyptian style'.[26] The X-framed stools are still there on either side of the main doorway, decked with the lotus leaf ornaments which so incongruously adorn Marshall's spinning factory in Leeds. The arm rests and the feet of the stools are ornamented by lions' heads and paws. The table in the centre of the Hall had a lion monopodium pedestal, a mahogany frame with an ebony frieze and a scagliola top, a form of imitation marble. Originally the décor was completed by upholstered chairs with curving scimitar legs back and front, inlaid probably with brass, and a pair of writing tables strongly influenced by the Regency fashion, with brass inlaid in the corners and forming the paw feet now in the old library.

The only indication of any proposed change to the interior is a design for the Gallery dated 1820, the year in which the Earl died. It shows the eastern chimney elevation with the two doors as usual at either end, but there are two fireplaces. The walls between these and the doors are filled with bookcases, each with a shelf jutting out at dado level. Narrow bookcases seem designed to fill the wall space beyond the doors. The drawing, which has a strong resemblance to the Gallery or Library of Syon House, can have been only a rough idea for consideration, but it has significance in the context of Adam's work at Syon and Sir Charles Barry's alterations to the Harewood Gallery in the nineteenth century, when two fireplaces were inserted.

Whether the plan was the suggestion of the 1st or the 2nd Earl remains unknown. In the same year, 1820, Henry, Viscount Lascelles since his elder brother's death in 1814, succeeded as the 2nd Earl to a family seat which had remained externally and internally virtually unchanged since the days of Edwin Lascelles. The new owner was apparently content to make no alterations of any kind during his lifetime. He was a man totally different in temperament and interests from his elder brother, immersed in politics and in local administration so that the house at last achieved eminence as the seat of an influential politician and the Lord Lieutenant of the West Riding of Yorkshire.[27]

Harewood House enabled him to maintain with ease and dignity the hospitality which was the duty and privilege of his Lieutenancy. The young Princess Victoria spent a weekend there

in September 1835, relentlessly accompanied by her widowed mother, the Duchess of Kent. After 'a very splendid luncheon which was served up in the music room ... the Princess was too much fatigued to join the party' which set off to tour the grounds by carriage. By six o'clock in the evening she had sufficiently overcome her lethargy to face a dinner of the most sumptuous kind which was served to 130 people gathered in the Gallery with the gold and silver plate much in evidence. The text of the sermon next morning was 'the night cometh when no man can work' and a large gathering congregated outside the church of Harewood to greet their future queen.[28]

Lord Harewood loved country life although the critical issues of the day demanded his attendance in the House of Lords, where he expressed his Tory views as trenchantly, if less frequently, than in the long years of his membership of the Commons. Sir Thomas Lawrence's arresting study of him as Viscount Lascelles defines the calm and firm personality associated with the Establishment, enveloped to his ankles in a dark, heavy greatcoat and magnificently posed in a rocky defile with Harewood House receding into a distant and luminous landscape, literally borrowed from Girtin and Turner[29]. A later portrait by a relatively obscure artist, Eden Upton Eddis, showed the 2nd Earl as the people of Harewood best knew him, mounted on horseback with Sir Walter Scott's present, a dandy dinmont terrier, beside him, and his hounds in the middle distance. The hounds for the neighbouring Bramham Hunt were kennelled at Harewood and it was after a day's hunting with them that the Earl's fatal collapse occurred in November 1841.

Again it was the second son who inherited the title and the estates, for the eldest son had died the preceding year. The 3rd Earl, Henry Lascelles, was forty-four years old, married to the redoubtable Lady Louisa Thynne and the father of ten children, with two daughters still to come.

For notes to this chapter see pages 179-81.

6

Victorian Harewood

With the succession of the 3rd Earl, Harewood House was swept into the full tide of early Victorian England and almost engulfed by the strength of the current. A new world was emerging. Already in 1840 the Lascelles family was making the journey between Leeds and London by train. By road, travelling expenses from Harewood to London with twenty-two servants, nine horses and two carriages cost £80. Rail travel was quicker — a ten-hour journey — but more complicated and expensive; a single second-class fare was £2 15s 0d for each of the servants who had to be taken in hired cabs or hackneys to the railway station at Euston. On arrival at Leeds there was the same problem of transport from the Leeds railway terminal to the coach office and the coach fare to Harewod was another 3s a head, the equivalent of a day's board and wages in London. An omnibus was the answer; it would take eleven servants all the way from Leeds to Harewood for only £1 7s 6d.

The effect of railway communications on the life of a country house like Harewood was profound. Isolation became merely nominal when a railway station was accessible in addition to a reasonably well-developed road system and visitors to Harewood had the choice of either the York or Leeds lines. Furniture, hardware, stores and supplies, even horses accompanied by a groom, could all come by train to Leeds in the 1840s.

The 3rd Countess was the embodiment of Victorian aristocratic attitudes. Lady Louisa Thynne (see plate 16) was a daughter of the 2nd Marquess of Bath and had seen the skilful reconstruction of the family's principal seat, Longleat House in Wiltshire. Under her

father's strict surveillance, Sir Jeffry Wyatville had given this Elizabethan palace manageable proportions and contrived within the house a comfortable and convenient set of apartments for the family.[1]

At Harewood she dictacted her own programme of alterations, but with the opposite aim; she needed more accommodation, not less. Her forceful authority and unabated energy were reminiscent of Edwin Lascelles's zeal. Indeed she so successfully conveyed the intricate pattern of mid-nineteenth-century domesticity that she all but destroyed the essentially eighteenth-century atmosphere of Harewood House.

Arguments were in her favour. The family was numerous and several of the younger ones were not out of the schoolroom, let alone the nursery. In general the accommodation was not lavish, the Palladian plan of interconnecting rooms on the principal or ground floor was inconvenient, the kitchen out of date and the style of architecture old fashioned. Her husband's means were thought to be equal to the expense of extensive rebuilding. Nothing had been done to the house since Edwin Lascelles's day, apart from the modest additions of Regency furnishings. It was a situation only too ripe for development.

The architect commissioned was Sir Charles Barry, knighted in 1852 on the completion of the new Houses of Parliament, which were already in 1842 beginning to rise to his design like some great gothic phoenix on the north bank of the Thames. Barry was very much a professional, highly trained and widely travelled, and then at the height of his fame. His chief successes in architecture included new buildings in Pall Mall for two clubs, the Travellers' and the Reform, which demonstrated his facile command of styles other than ecclesiastical gothic. Both were in his Italian manner and the former was particularly admired on account of the 'grouping of windows of the garden front'. The Anglo-Italian style and the garden front were to be the chief architectural features of his Victorianised Harewood House. He had also in hand considerable work in country house practice and had proved his ability to adapt such houses to reflect contemporary taste and cater for the hierarchical nuances of upper class domesticity.[2] The Queen and Prince Albert set the seal of their approval on the architectural style, but not on the architect, by adopting it for their new residence, Osborne House, built for them by Thomas Cubitt, who was in

business as a contractor and designer rather than in architectural practice.[3]

At Harewood House, the provision of extra accommodation necessarily implied alterations to the exterior, either in the form of wings or additional storeys. Barry built upwards, a choice dictated by the site, and he therefore worked within the area of the old Palladian ground plan. The limitation imposed suited him admirably for he was adept at devising intricate and complicated interiors. The original fabric of the earlier house thus remained. Moreover, Harewood was spared once again the elongated corridors and kitchen wing, so often a potential financial embarrassment and a digestive hazard with a surfeit of réchauffés dishes emerging from a service room adjoining the dining room.

In January 1842, Barry's finished drawings presented Harewood House in the guise of an Italian palazzo (plates 3, 5).

It was all very much in his grand Renaissance manner, a splendid palatial design, but taste was changing; ostentation signified vulgarity and unaccustomed wealth, and the high and homely example of the Court encouraged a new sense of values. Barry's design was modified and the house assumed its present appearance. According to his son, Barry realised that the architecture of Carr and Adam at Harewood House had 'some massivenes of design and merits of proportion. It needed finish, life and variety'. These qualities were not thought difficult to accomplish; all he had to do 'was simply to raise the wings altering their design so as to bring them into greater harmony ... with the centre', improving the design of the centre itself by adding a handsome balustrade and by raising 'the chimney stacks to the dignity of architectural features to vary ... the flat and monotonous lines of the former roof'. As his son noted, 'the effect was considerable'.[4]

Barry's work in fact completely altered the character of the house. His treatment of the elevations was of such a nature that a totally different architectural composition emerged. Although he did add height to the structure, the vertical lines, the carefully proportioned articulation of the parts and the resulting quality of movement of the whole achieved by Carr and Adam were replaced by a strong accent on the horizontal.[5] The high chimneys, the bold balustrading and the ornamented and enriched pediment on the North Front did not compensate for the virtual disappearance from view of the basement below the ground which was

expressly made up to allow for the reduction of Carr's ten entrance steps to five (see plate 3, fig 4).

On the South Front the new terrace garden also diminished the rusticated basement, but it is from this angle that his transformation of a villa to a 'palace' can best be appreciated.

The most significant alteration was the removal of Adam's portico from the South Front. At first Barry seems to have planned to retain this feature and even extend the idea along the facade. The decision to demolish all traces of the portico caused the Countess some misgiving. Barry wrote to her from Westminster in February 1846 that he had considered her proposal to retain the columns of the portico, but he felt he must 'adhere to the opinion that the aspect of the South Front would be best without them'. Barry won his point. Engaged Corinthian columns extending two storeys in height were applied to the elevation. Balconies were added to the Venetian windows, but the proposed south pediment was omitted (see plates 5, 6).

This redesigned south elevation was closely linked stylistically to the new terrace garden round three sides of the house, devised in the Italian manner and regarded by Barry as an architectural extension of the bulding. The massive quality of the whole conception tended to dominate the rural setting, an attitude contrary to the belief held by Brown and Repton that the natural integration of a house in its environment represented the ideal of contrived landscape. A crescendo of stone walls, balustrades, flights of steps and ornamental stonework was constructed up to the level of the flooring of the old portico, and the gentle access of Brown's parkland and Repton's lawn sloping upwards almost to the very walls of the house disappeared from view.

Many of the plans and drawings, numbering about a hundred, made by Barry for the alterations at Harewood House concern the terrace garden. Among them his most remarkable horticultural contribution is the design of a monogram HH for a vast garden bed to be outlined in green sea gravel and cut in boxwood, the letters intertwined as in the cove of the new Dining Room ceiling and the iron firebacks of the principal rooms.

Work began on the terrace in the summer of 1844. A pencilled note by Robert Banks, later a partner in the firm, on a plan dated 9 July 1844, indicates his impending visit to Harewood to initiate the project. Data posts were fixed setting out the dimensions in

August 1844 and a plan of May 1845 gives in full detail the layout of one-half of the parterre, showing the garden seats in place in the semicircular embrasures of the enclosing balustrade and the setting of the shrubs, all in a manner which suggests that Barry saw himself in the great tradition of English landscape gardeners. At the end of the same year, there is a reference to Theakstone's 'Sphinxes taken from the North Front' (see fig 4) to sun themselves on the new terrace and add a further suggestion of mediterranean influence to the Italianate garden with its flower beds and fountains.

Much attention was paid to the line of the new roof, regarded by Victorian critics as a criterion of architectural merit. Two carpenters were at work in July 1846 'Preparing and fixing temporary figure S front and Ballustrading on Main Roof for Mr. Barry to look at'. Models of the chimney tops were also put in position to show the effect from the ground level.

Below, the new terrace garden progressed well. At the end of that year the stone walling and brick arches were covered up to protect them from the winter frosts. The previous season had been severe, and snow lying on the roofs and in the gullies had hindered work on the exterior of the house. When spring came in 1847, the garden began to take shape. Dangerfield, the head carpenter, and his chief assistant set posts where flower beds were to be made and about midsummer they cut templates for the masons who were staking out the garden and gave assistance to the gardeners preparing the terrace. It took two and a half days of 'Blasting roots in Terrace Garden for the labourers to be able to dig them up' and another day of the same explosive treatment next month to complete the job. Rabbits were a problem, solved by placing 'boarding hurdles' round the area, but hares were an even greater nuisance and a device optimistically called 'hare proof fencing' was fixed. An intricate drawing of closely interwoven fencing survives.

Most of the architectural work of constructing the stone steps, walls and balustrades was not done until 1847-8.

The most expensive single item in the terrace garden was the fountains. In March 1848 moulds were cut in preparation and stone for their construction came from Rousham Hill, in Oxfordshire, rough hewn at the quarry face there to save transport cost. When it was realised that the Lascelles's finances were being stretched beyond measure by the new works to the house and garden, an exception was made for 'the completion of the central

Fountain and Basin', 'a contract for which has been undertaken by Mr Hope, the late Foreman of the Masons at £170'.

Indoors Barry triumphantly produced a house admirably suited to the complex structure of upper class Victorian society. Everyone had his or her ordained position, everything a place, each day a timetable and each room, closet or pantry its function. Part of the Victorian obsession for domestic organisation on this scale was due to their love of privacy and it is noticeable that Barry's carefully drawn elevations show every window of the reconstructed Harewood House heavily curtained. Yet Adam's planning, too, had emphasised the need for differentiation of function and the careful siting of the main apartments to suit the pattern of life set by the eighteenth-century nobility and gentry. It was simply that, by the mid-nineteenth century, a new society made new demands.

In these circumstances the most obvious casualty was the suite of elaborate State Apartments, now considered inappropriate and a trifle *démodé*. The house could ill afford the space and they were converted for the personal use of the Countess, a sensible arrangement since they adjoined the rooms which had always been reserved for the family on the east side of the principal storey. The Countess chose the State Bedroom as her sitting room, a function it fulfilled for her successors for the next hundred and twenty years (see plate 7). The alcove which had housed the State bed was reduced in depth to allow for a passage, 'the Countess' corridor'. The Circular Dressing Room behind, facing into the inner court, was considered to be expendable and part of it was used for corridor space. Whether this enigmatic circular room had in fact been in use as a family chapel is an interesting speculation. When the Earl and Countess were due to arrive at Harewood House in the autumn of 1844 the alterations indoors were in hand; part of the work done by the carpenters was 'preparing and fixing frame and cove to form lobby to Temporary Chapel'. Attendance at daily prayers was a spiritual duty required of the domestic staff of any Victorian establishment and the 3rd Earl was a strong churchman, but the village church in the park of Harewood remained the place of family worship.

Next to the Countess's Sitting Room, the former State Dressing Room became a breakfast room and was given a dual role by the addition of bookshelves. Both rooms faced south over the new

gardens, but the pleasurable outlook was marred by the distance of the Breakfast Room from the kitchens and arrangements had to be made for a sideboard to be fitted outside in the Countess's corridor.

From the Breakfast Room one moved directly to the Saloon, which had been intended by Adam and Carr as a reception area. Without the protection of the portico the Saloon could scarcely be termed snug, but Barry rose to the challenge and produced a handsome Library, a curious amalgam of one of Adam's finest interiors and mid-Victorian luxury.

Adam's two Neo-classical recesses Barry filled with great book-cases of mahogany, vertically inlaid with brass, continuing the line of the shelves to curve beyond the apses so that the whole wall was filled. Only the double doors leading to the Entrance Hall break the effect of row upon row of books. Opposite between the windows he placed more bookcases. These fittings were prepared and set in place by the Harewood carpenters, Dangerfield and his men.

This change of function of the Saloon meant that the Old Library was superseded. Barry proposed it might be used as a bedroom or a smoking room, but in the event the place was left in peace. A bathroom and water-closet were constructed from the room adjoining that which had served the master of the house as a dressing room or study, called the Little Library.

Barry intended that from the Saloon one could reach the Entrance Hall, the South Terrace, the Breakfast Room or the new Billiard Room. This last was the former Yellow Drawing Room used once as a sitting room by Edwin Lascelles's family. To bring the Billiard Room upstairs from the basement storey was entirely in accordance with the planning of the period. At Harewood House it now lay between the Saloon and the Principal Drawing Room and may perhaps have been used as a smoking room. Nothing could be more convenient than a Drawing Room which adjoined a Billiard Room on one side and a great Gallery on the other, used on occasion for concerts and dinner parties.

In the Gallery Barry's alterations were not as radical as once supposed. By removing the single caryatid chimney-piece to the Dining Room and substituting two innocuous Victorian pieces, he was in fact restoring the room to Adam's idea of having two fireplaces to break up the great length of the apartment, and

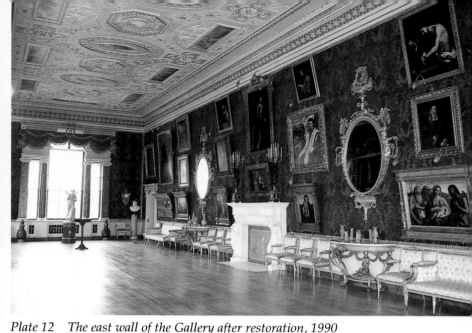

Plate 12 *The east wall of the Gallery after restoration, 1990*

Plates 13, 14 *Portraits by Sir Joshua Reynolds in the Cinnamon Room:*
(left) Lady Worsley, (right) Jane, Countess of Harrington

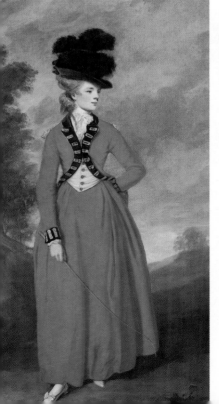

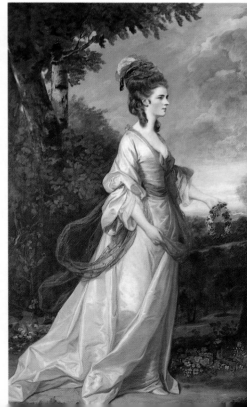

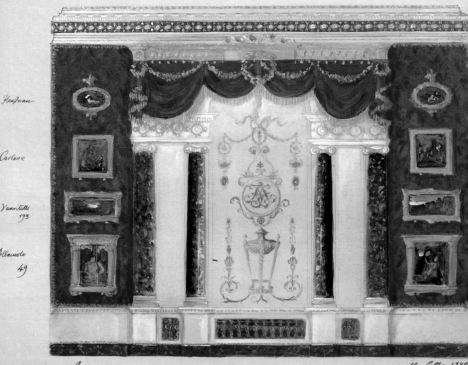

Plate 15 Alec Cobbe's design for the restoration of Carr's Venetian window on the south elevation of the Gallery, 1990

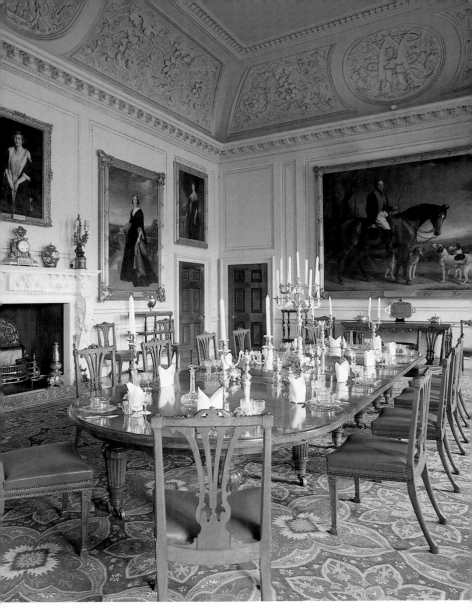

Plate 16 *The Dining Room, showing Sir Charles Barry's remodelling in the 1840s of the Adam interior. Portraits, left to right: HRH The Princess Royal, Louisa 3rd Countess of Harewood painted a few years before she died in 1859, Florence the 5th Countess and Henry the 3rd Earl of Harewood by Sir Francis Grant*

*Plate 17 Chippendale's renowned Dining Room suite: the sideboard is
flanked by leadlined urns, supported by pedestals, one for
warming plates, the other for rinsing utensils, with a pot
cupboard below. The cellaret is said to be the finest ever
commissioned by an English patron*

accepting the proposal dated 1820 for the elevation. Whether Barry was aware of this, however, is open to speculation. His design for caryatid supporters for the Venetian windows fortunately remained unexecuted.

The Main Staircase was altered to give a more imposing single flight branching on the half-landing into return flights with the ironwork of the balustrading carefully copied to match the eighteenth-century work, but he achieved his most notable and drastic change in the creation of the Victorian Dining Room (see plate 16, fig 17) and the reconstruction of the interior of the house in that area. The deep fireplace recess which housed the elaborate Adam apse was destroyed to make way for a service passage behind. A butler's pantry, a china room and a lift to hoist food and utensils from the kitchens below were constructed. A most important addition was a domed lobby to connect the Drawing Room directly with the Dining Room and beside this lobby rose a service staircase from the basement to the principal floor. The Music Room remained unaffected by this re-building and on occasion served itself as a dining room.

Below the Music Room, where Lascelles's Coffee Room had been located, Barry put the Servants' Hall, where rows of bells hung from a deal board, terminal emblems of the new bell system installed laboriously apparently by one man, 'the bell man', through the main rooms of the house. Levers partly fashioned of mahogany operated the system so that the old bellropes were discarded. The kitchen itself remained below the north end of the Gallery beside the scullery and still room. The maid servants' hall was isolated at the other side of the basement well out of harm's way. The men-servants slept in the half-floor over the Gallery with their own washbasins and cupboards with locks.

A wealth of trivial references reveals the ordered complexity of running a country seat such as Harewood House in the nineteenth century: a shoe, knife and cleaning room, brush boxes for the housemaids, closets for the housemaids, a cheese cupboard, a cistern to wash plate in, a hot water closet, new sinks with zinc surrounds, saws and cleavers for the cook, peels for the baker, jelly stands for the kitchen, tubs for the larder, and, on special occasions, an ice trough and a dresser prepared for the confectioner. The kitchens at Harewood House might still be too near the principal apartments, for smells, however appetising, cannot but

travel upwards: yet even Mr Lumley, a partner in the firm of Messrs Oddie & Lumley who handled Lord Harewood's legal and financial affairs and acted as his trustees, could not but deny the improvement. The kitchens were lighter, airier, more convenient. When the alterations were finished in 1851 he wrote that the kitchen quarters were 'as commodious as any I ever saw'.

In the East Wing over the family apartments were the nurseries, where there was a positive quiverful of young Lascelles and the frequent presence of the family obviously caused dislocation in a house undergoing what amounted to a complete refashioning of most of the interior. When for instance the master and mistress were due to arrive in October 1844, constructional work came to a halt to allow doors to be rehung and eased, temporary floors laid and window sashes put in order, carpets put down and beds put up, pictures hung and fires lighted.

The year 1845 involved the family in momentous events just when the building operations had got underway in both the house and garden. On 20 March, the fifth son, Alfred, died at the age of sixteen. The estate carpenters were summoned from their humdrum task of preparing a new melon frame in the garden to fashion the cedarwood coffin shell and then 'attend' upon the plumber with lead coffin. They made the outer case of mahogany with its half-inch tassels and finally acted as bearers, carrying the coffin into the family vault in Harewood Church. Eight days after his brother's death, the Earl and Countess lost their fourth son, Algernon, only one year older than Alfred, and the carpenters spent a second successive week in performing exactly the same duties. A reference in their work book notes bluntly 'Overtime caused by these two deaths, 32 days'.

Emotions were happily reversed in the autumn. The heir, Henry Thynne, Viscount Lascelles, came of age in June and married in July Lady Elizabeth de Burgh, the eldest daughter of the Irish peer, the Marquess of Clanricarde and a grand-daughter of George Canning, the statesman. The double event was celebrated at Harewood House in October and November. Dangerfield and his carpenters spent the last two weeks of October enclosing the West Terrace to act as a refreshment room, fixing up a gallery for an orchestral performance, attending to the needs of upholsterers and a 'Lamp Man' and 'preparing Stools, Tables, Knife Boxes, Moulds for Confectioners, preparing in the Pavillion,

Putting roof over fireplace to roast Bullock and sundry jobs at the race course'. Perhaps the new sculptured coat of arms to add weight to the North pediment was ready for the event since two men helped 'Mr. Jones to trim the Arms' and the piece was certainly out of the carver's shop before February 1846.[6]

The celebrations continued in the last week in November. Having cleared away after the first event, Dangerfield with eighteen of his men and three labourers then spent six days 'Fixing Work in Gallery and refreshment rooms, Preparing Stools, Tables, Trussels, etc.' for the tenants' dinner and taking them down afterwards. The house account also shows them 'Attending on man with Lamps and firework, laying floor and sundry other jobs in Pavillion, Fixing Booths etc. in the Park and Attending at the Fête.'

Everything finished in fine style with a fire in the West Wing on Saturday 8 November, but Harewood House had its own fire-engine ready to hand for just such an emergency and extinguishing the fire appears in the house account as part of a normal week's work. There were other matters to attend to in the same week, 'Taking down calico from Gallery and refreshment room and rolling up Do. Taking down Orchestra, Rehanging Doors, Taking down Pavillion and Booths and Taking down and clearing away all materials used at the Fête'.

Then the men went back to work on the new Dining Room, removing Rose's plaster work and Adam's apse, straightening the walls and squaring them off and putting ash boards in the ceiling. Zucchi's[5] large paintings were removed.

Christmas came with a day off, but after Boxing Day, the last week of an eventful year had one more interruption. Furniture was repaired and moved and Dangerfield's men then began 'Fixing transparencies, preparing a box for the Confectioner and fitting up a kind of theatre, fixing tables and taking down Do ... after the Childrens Dinner etc. on New Years Day.' The week's account transmits the very essence of upper class Victorian life; simple amusements, family gatherings at Christmas and New Year, abundant food and an amplitude of servants.

By next Christmas, the new Dining Room was sufficiently advanced to permit its use by the family. The carpenters were busy in December 1846 'Removing Benches etc. fr[om] Rooms at the House for Cleaning out Dining Room and the passage adjoining and temporary fitting up for family to dine in New Room on

Christmas Day', directed by John Parsons, Clerk of the Works.

A temporary floor was put down for the occasion and, after the Gallery chimney-piece had been removed to the room in August 1847, it was found that the joists of the floor were in need of renewal, 'the old ones all rotten'. That winter a completely new floor replaced the oak floor put in by Sanderson. The old mahogany doors were cleaned up and new window frames put in with thicker glazing bars than of the earlier pattern.

Barry dated his plans for the interior decoration of the room July 1845. Produced at his Westminster drawing office, they show details of the wall panels and the architraves for the windows and mention putty enrichment. Moulds were prepared for this decorative plasterwork in May 1846 and the execution entrusted to a local craftsman, John Waggitt. The decoration is confined to the deep cove and presents a sprawling, florid adaptation of Adam's rainceau motif intertwined with the monogram HH. The ceiling above was left in plain plaster work (plate 16).

If much of Barry's transformation of the house was acceptable only to contemporary taste, there can be no doubt that he greatly facilitated the running of the household and domestic organisation in general. Apart from the improvements in the kitchens and the dining area, the convenience of the corridors in the house and an efficient bell system, the plumbing and the heating of the house were completely overhauled and brought up to date.

Piped hot water in iron pipes was an advanced luxury. There was a 'ladies' bathroom' and a reasonable supply of domestic hot water. The main cistern was located in the roof and a new boiler house had a high chimney-stack. Central heating was installed, a tedious and complicated affair, since the system chosen was hot air, emerging through stone grilles cut in the floors. The carpenters conscientiously took up floors for 'the hot air men', relaid them, made good deficiencies and then often took the floors up again. The system was not always effective and, when it was, adequate ventilation could become a problem. Jeakes of London was employed and the work went on during the years of general reconstruction. Sanitation was modernised with the addition of numerous water-closets, including six at basement level on the garden front and one in the Dining Room passage. The solid fittings of mahogany were french-polished, but unvarnished oak served the needs of those 'below stairs'.

Building materials not in evidence when the house was first constructed were used, copper angles for the domed lobby, copper wire, tarpaulin waterproof sheeting for unfinished work on the exterior and zinc for the cornice moulds of the new Library and in the new Dairy. Insulation was specified by Barry in the additional storey of the two Wings, 'a double ceiling above & below the Ceiling Binders to be formed over the two wings as a security against heat and cold'. The flat roof in the West Wing was of 'Whole timber halved, bolted and trussed with iron' and the roof over the centre section of the house 'left as at present'.

The scale of the reconstruction attracted much local interest and regularly a labourer had to be paid three quarters of a day's wage 'watching to keep people from injuring the stonework'.

Expenses mounted, yet labour was cheap enough. In 1845 a wage of 3s 4d a day was paid to the estate masons directed by the master mason, Hope. The familiar names of Lofthouse and Muschamp occur. Labourers received 2s 4d or 2s 6d, and apprentice boys 1s 2d, a scale which shows remarkably little advance in the rates paid by Edwin Lascelles just under ninety years earlier. Bricklayers got 3s a day, plasterers 4s, plumbers 5s and the latter had board as well. Hours of work were still long, eleven or twelve a day, with an hour less during the winter months from September and, for some, a day off with pay at Christmas Day and Good Friday. By 1850, the wages had not risen. The real extravagance was Barry himself. Initially in November 1847, Lord Harewood's trustees were not displeased. Mr Lumley wrote: 'I must confess I thought the amount already paid £15,300 very moderate for the extent of the work and the style in which it has been done, even taking into account the advantage of having the Stone on the spot and there is at least this satisfaction in the expenditure that the work has been capitally done & produced almost a better effect than could have been anticipated.'

But the 3rd Earl and Countess were spending prolifically and in 1848 there was a sudden change of heart. Lumley ordered Maughan, the Harewood agent, in a long and 'disagreeable letter' to curtail any unnecessary expenditure for the next two years. All the extra work was to cease, 'except it should happen that the stone bordering should not be completed, in which case that alone is to be gone on with gradually'. The central fountain, too, was exempt. Inside only necessary improvements were to be done; for instance per-

mission was given to finish the Dining Room floor. By 1850 the financial crisis must have been surmounted for the renovation of the kitchen quarters was allowed to proceed in 1850.

The crisis was short lived and possibly Lumley intended to act decisively and quickly. Barry's total fee exceeded all expectations, so much so that his final account was questioned by Lord Harewood's agent and Sir Charles took umbrage. The final figure was nearly £37,000 for 'additions and alterations' to Harewood House.

Interior decorating and refurnishing added another £7,000 to the cost of Barry's alterations. This work Lady Harewood put in the hands of a highly successful London firm of cabinet makers, George Trollope & Sons, Decorators to Her Majesty. They offered a comprehensive service as upholders and their decorators, upholsterers and cabinet makers left Harewood a model of mid-nineteenth-century fashionable and cluttered comfort. Well-sprung, well-stuffed seat furniture lost all elegance of outline and heavily draped windows cut out the light: yet the interior remained for the most part obstinately Adam in character. Only in the Dining Room, Barry's own distinctive contribution to the principal apartments, was the decorative scheme of the eighteenth century entirely swept away and even here the furniture attributed to Chippendale is still the outstanding feature. In the rooms Trollope's men decorated, Adam's work was brought into uneasy conformity with current taste and the repair and renovation carried out actually encouraged its survival.

Attention centres at Harewood House so much on the structural changes wrought by Barry to the exterior and interior, and on the Victorianised atmosphere created by Trollope's extensive refurbishing, that it is easy to lose sight of the repairs and renovations which accompanied these alterations.

The complete overhaul put the fabric into first-class condition and the interior in particular into a state of cleanliness and order. Every principal apartment benefited; even the books were removed, dusted and replaced on their shelves.

The Entrance Hall provides a typical example of Trollope's service (see fig 12). The walls, pilasters and woodwork were all rubbed down to a uniformly smooth surface with pumice stone and water, and the ceiling, cornice and enriched work made good for £21 18s 0d. One coat of oil and two of distemper were applied

'to enriched work' and the grounds given 'rich blue tint'. The 'highly enriched cornice' received five coats of oil and the frieze four coats. It was then 'flat marbled with Key enrichment picked out in white'. The less ornate part of the cornice and the soffit absorbed four coats of oil, and 'rich colours' defined clearly the ornamental features of the ceiling and cornice. The shafts of the fluted columns were treated with five applications of oil and painted to give the appearance of marble, then varnished twice and hand polished between the coats.

The Hall had already experienced the brief vogue for the Egyptian style of furnishing, but the strongly marked Neo-classical treatment of the elevations retained undiminished the martial and severe atmosphere. The Victorians had a penchant for combining idealism with utility and accordingly an attempt was made to give the Hall something of its historic function in domestic architecture as the central living area of the house, and to make it at the same time an entrance beyond which lay an expensively overfurnished suite of apartments. Like everything else, outdoor clothing and muddy boots had their place in a well-run establishment, and the Hall at Harewood was therefore provided with a 'stout brush cocoa mat' at the front door and a solidly constructed mahogany stand for hats and umbrellas.

To add a sense of warmth and welcome, the Hall was furnished with curtains of green damask rep lined with green tammy, which were 'suspended from handsome mahogany rails' over both windows and the front door and equipped with the slides, pulleys and tassels, dear to a newly mechanised age. Two oriental carpets and two sheepskin rugs, dyed scarlet, partially covered the expanse of flagstone floor. A second large sofa was added to the existing furniture and there were easy chairs covered to match the curtains and edged with twisted gimp and fringes. The Regency furniture defied complete modernisation, but the X-framed Greek stools and the 'broad topped' chairs were repaired and covered in green. Chippendale's Hall chairs were re-japanned as rosewood, a decorative deception regarded as acceptable only where choice, circumstance, or scarcity of popular woods necessitated simulation; their carved enrichment and ornamental crests were renovated and the grounds picked out in gilt. The pair of writing tables on either side of the door lost their silk and brass panels so that rosewood might be inserted. Both tables were french-polished.

The old monopodium table was joined by the massive mahogany piece costing £28 15s 0d and distinguished by its polished slate top 'in imitation of Granite' supported by four ebony legs carved in the form of lions, their paw feet resting on a shining rectangular plinth, which has been transferred to the Spanish Library.

In the Adam niches, busts on pillars of scagliola 'in imitation of verdantique' discreetly replaced the classical statues and a scagliola bracket was mounted over the fireplace in the east wall to hold a clock. The Entrance Hall then emerged a rather confused essay in decorative unity, Neo-classical in design, Victorian in style and pseudo-Medieval in purpose: but the new furnishings must certainly have absorbed in some measure the draughts to which the Hall was prone and achieved an illusion of homely comfort. A stove replaced one of the fireplaces.

At the other end of the Hall from the main entrance, a similar double doorway with glass panels opened into the new Library (fig 12). Straight ahead, across the room, the centre window formed a door leading on to the Terrace Garden, a southern exit shaded from possible sunlight by 'an outside Spanish blind of scarlet and blue cloth'. These were the colours of the decorative scheme into which purple obtruded royally. Purple morocco leather covered the two Ottoman seats, with their matching angle seats by the Neo-classical fireplaces. Chippendale's ten cabriole chairs were repaired and re-japanned as walnut to match the frames of these new pieces of seat furniture, restuffed with sprung seats and covered also in purple leather with the same silk gimp trimming, all for £35. Blue leather was chosen for the large octagonal Ottoman, the Chesterfield sofa, and six chairs, four of them described as 'easy'. Three more, termed 'lounge' chairs, had fine canvas covers and a spare set of blue canvas was cut out for them but not made up. Crimson velvet curtains were hung, white holland spring blinds fixed and a new carpet laid. Trollope supplied in french-polished walnut a centre table, three smaller tables, and two *étages*, or what-nots, mounted in ormolu, costing £10 10s 0d for the pair. Barry's great mahogany and brass book cases dominated the entire room.

Overhead Adam's regal ceiling with its deep, beautiful cove was painted in 'superior colours', with arabesques in encaustic colours, 'the whole finished in an artistic manner from Original Drawings made specially for the purpose'. Beneath this epitaph

the Adam Saloon was temporarily buried.

Next door, in the Breakfast Room, the décor was en suite, purple leather for the chairs and crimson velvet for the curtains.

The new Billiard Room adjoined the Library on the other side. This was the former Yellow Drawing Room and here much of the work was done by Dangerfield's carpenters using material supplied by Trollope. After the family celebrations of 1845 were over, they took down the chandelier, unpacked the billiard table and fixed over it a billiard table lamp, complete with two large silk and worsted tassels for £1 7s 0d. They fitted a new carpet which cost £75 and put up the white holland blinds with their cords and tassels over the windows draped in crimson and maize damask. The Yellow Drawing Room thus transformed, apart from the delicate stucco ceiling, was used as the Billiard Room of the house until the 1930s.

This misappropriation left Harewood with only the White Drawing Room, sited between the Billiard Room and the Gallery and with direct access to the Dining Room through Barry's newly constructed lobby. To this room therefore considerable attention was given and the expenditure proportionately greater than for other apartments redecorated by Trollope.

Interest centres on the treatment of the ceiling. It was one of Adam's less typical and more monotonous designs, a repetitive pattern of prominent floral cruciferae linked geometrically by lines of bell husks.[7] The drawing in the Soane Collection shows attempts to lighten the effect. These may have been disregarded, for Rose's sketch book illustrates a continuation of the heavy design of the ceiling throughout the depth of the cove. Now the whole concept of the ceiling was changed.

Trollope's bill includes a sum of £185 for 'a highly Artistic Decoration for Cove from Original Drawings, the 4 pannels filled with Life Size Figure emblematical of the Elements, and a large Group painting for Centre of Ceiling'. For this work the firm directly commissioned the artist Alfred Stevens, on the advice of their chief designer, Beavis, who had been a pupil of Stevens. By 1852 Stevens had not yet been accorded the fame which his monument to commemorate the Great Exhibition of 1851 and his Wellington Memorial were to bring. Nevertheless, he was of independent mind and in no hurry to execute the Harewood House murals. A month after the commission had been given, Mr

Trollope called with Beavis at the studio to remind Stevens of the importance of the work, only to be told politely 'If I do it at all, I must do it in my own way and at my own time.'[8] And on these terms the paintings were duly accomplished.

Stevens's four panels on the cove are markedly Italian in influence, but his central group of four human figures resting in a *trompe l'oeil* manner in each corner of the larger square panel raises a problem.[9] The same figures, identically posed, are drawn in Rose's sketch book clearly intended for this White Drawing Room ceiling, but probably in view of the reference to Stevens's work they were never executed by Rose. Perhaps Stevens merely copied the design from Rose's sketch and the 'Original Drawings' mentioned in Trollope's account are those for the four cove panels only.

The chief feature of the elevations themselves were the large wall panels. Fifteen pieces of new canvas were strained and $153^1/_4$ yd of rich silk damask arranged and hung for £155. The windows were draped with green and white curtains of satin damask lined with silk, a most expensive fabric for the cost in all was £256: there were inner curtains of muslin lace. White spring roller blinds, from which tasselled cords dangled, ensured that no damage could be done by sunlight to the new £170 Axminster carpet specially designed, or to the rich Beauvais tapestry upholstery.

This material 'made to original design' was used for Chippendale's eighteen cabriole chairs for the State Bedroom and Dressing Room, renovated and recovered for £279.[10] Another £98 was spent in repairing and covering two sofas with the same material and fixing castors on them. Five easy chairs were renovated en suite.

For all this valuable seat furniture two sets of loose covers were made up, identical in pattern, 174yd of chintz with a red ground and a lining of white material for each set. 'Extra under Cases of White Glazed calico partly lined chamoise leather' were also provided for the chairs and sofas.

These protective coverings indicate not only the presumed value assigned to the old as well as the new seat furniture and its upholstery, but the high regard in which the Drawing Room of the house was held as the inner sanctum of elegance and ultra refinement. The type of furniture bought for the room underlines this perfectionism: three tables of Boule and Ormolu, one of them 'An Elegant Writing Table en suite the top lined velvet' and covers for

them all of 'Embossed Leather lined Moleskin and bound', a total outlay of £127 16s 0d. A new chimney glass 'In an enriched frame to suite the Decoration of the Room … Gilt in Mat and burnished Gold and Brass Strip at £45' replaced the one relegated to the Billiard Room. Two pier glasses were made from 'repolishing and resilvering existing plates and new Outer frames with enriched top of your carving made out, gilt and burnished for £38 10s 0d'.[11]

By contrast, the Gallery was relatively unaffected since here cleaning and renovation superseded refurnishing. To Chippendale's carved wooden draperies, matching blue curtains of fine cloth lined with tammy and bordered with a wide gold band of silk gimp were added. A top member was added to the already ornate cornice, some regilding was done and the four large pier glasses were unmounted for repairs to the plates. Their respective tables were overhauled and then regilded. The pictures were cleaned and varnished, and £5 10s 6d spent 'on arranging and writing on picture frames'. Thirty-eight pieces of oiled flock paper were fixed on to the new canvas on the walls. Much the most expensive item in the whole of Trollope's refurbishing was the repair and regilding of the Gallery woodwork for which he charged £490, adding about £240 for his men's railway fares, lodging expenses and the carriage of the painters' materials.

Trollope's work extended to the bedrooms in the upper storey, where his upholsterer repaired and restuffed seat furniture in the Crimson Room, the Rose Room and the Bachelor's Room. Downstairs, the servants' hall and the steward's and housekeeper's rooms were redecorated.

The account for £6,043 12s 9d was finally settled by a payment of the outstanding balance and receipted by George Trollope on 2 June 1853. It included packing cases for the transport of furniture, pier tables and glasses, and cornices to his London warehouse for skilled repair. The goods were conveyed by hired 'Spring Vans' to and from the stations at Leeds and London and did the rest of the journey by rail. The glass had a special 'Expanding Glass Van'. The price of cast glass was still so high that it paid to resilver old mirrors even at this trouble and expense, but such precautions did not ensure safety for one of the plates belonging to the Gallery broke.

The pride of achievement belonged to the Countess. To her Trollopes directed their bill, their apologies for its delay and their

humble thanks for 'the honour of her patronage'. When retrench-
ment was obligatory in 1848, it was to the Countess that the agent,
William Maughan, was told to apply for advice about which
aspects of the works it was absolutely necessary to continue. Lord
Harewood's trustees clearly ascribed his financial embarrassment
to the extravagantly abundant hospitality kept at Harewood
House and the Countess's lavishly careless housekeeping. The
cook, Lumley felt, was unaware of the need to use 'the offal parts'
and the quantity of meat consumed he found quite alarming.

George Richmond's portrait of the 3rd Countess (see plate 16)
shows her in a black gown and paisley shawl, posed confidently
against the symbolically bright and unshadowed background of
her terrace garden, eminently Victorian in all her plump and
matriarchal splendour.

Louisa, Dowager Countess of Harewood, survived the death of
her husband on the hunting field in February 1857 for less than two
years: she bequeathed a legacy of jewels, horses and carriages,
furniture, china, plate and the leasehold of a London house to her
quartet of unmarried daughters.

When Henry Thynne, Viscount Lascelles, returned to Harewood
House as the 4th Earl of Harewood in 1857, he was a widower. His
winsome Irish wife died suddenly at the age of twenty-eight,
leaving him with a brood of young children and the right of her
descendants to inherit the Clanricarde fortune. In April 1858, he
married the daughter of a West Riding landowner, Diana Eliza-
beth Smyth, whose father was the owner of Heath Hall near Wake-
field, a sound and splendid example of John Carr's earlier work.[12]

For the next forty-five years, Lord Harewood lived in the high
noon and into the evening of the Victorian era. His father's
extravagance had been the outcome of ebullient generosity, whether
in his hospitality, the alterations to his house, or the performance
of his Christian duties. The 4th Earl was not in any way averse to
charitable donations, but the moral and religious strictures which
so tightly bound the upper classes in early Victorian times were
breaking down by the 1860s under a philosophy which questioned
their creed, scientific advances which challenged their beliefs and
material progress which scorned their piety. Industry, invention,
Imperialism and even intellect held the key to success and the
simple, unsophisticated hopefulness of the 1840s and 1850s with-
ered away.

Lord Harewood's temperament was well suited to this new and pleasurable materialism. He had a sociable nature and his money melted in London. He enjoyed belonging to clubs; membership of the Carlton, the Marlborough, the Pall Mall, the Prince's, the Travellers', White's, the Turf and Tattersall's was not inexpensive and, while his payment of £2,000 to the Turf Club is an exception, it indicates the scale of his involvement in such matters, when compared with a fee of 4s 6d for his passport and his subscription of £9 to the Wetherby Ball in 1879.

Nevertheless Harewood House was well maintained. The improvements undertaken were naturally in those areas which Lord Harewood considered most important — heating, lighting and plumbing. The house was already furnished to distraction and brimful of both bric-à-brac and heirlooms.

During the years 1862-3 gas was installed. Leeds had already several tradesmen who styled themselves gas fitters. The materials for the work at Harewood House were supplied by Leeds firms and indicate the type of equipment used in the installation of gas at this time. Richardson of Briggate was in business as an ironmonger, smith and founder; he supplied iron gas pipes of quarter-inch bore, gas cocks, bracket backs and tee joints. Nelson & Sons of Far Headingley, on the outskirts of the town, sold India-rubber vulcanised piping and Heaps Brothers of Ludgate Hill received orders for lengths of quarter-inch diameter composition gas pipe.[13] Under the direction of John Parsons, still Clerk of the Works, a 'gas house' was built of stone, lime and pantiles and, by the autumn of 1863, Harewood House was ready to manufacture its own gas.

The plumbing and the hot water system had a complete overhaul and again the details reveal developments in Victorian house construction. Most of the orders went to Nelson's who supplied iron work for two force pumps and two outer valves for the hydraulic pump. They also made furnace doors and a 'galvanised iron circular cistern with inch connection for flow and return'. In August 1863 they delivered 46ft of 'dry hair felting to fix round hot-water cistern, non-conductor', a very early example of lagging.

The sanitary fittings were the last word in convenience. Richardson supplied one water-closet with a copper pan, another with 'a shoe valve and blue basin complete', as well as the more usual stock of waterwork-tap keys, washers and 'plugs to pattern

for hot water'. The Farnley Iron Company, part of the monopolistic concern of William Armitage's empire, sent sanitary circular syphon traps. In June 1873, Londsdale and Cross, who supplied most of the glass for repairs to the house and estate, forwarded two 'patent ventilators' possibly because the steam central-heating system dried the atmosphere.

Blake, the head plumber on the estate staff, was employed almost constantly at the house; in 1865 he once more repaired the main water pipe and under his supervision the old boiler-house was demolished. It was perhaps only sensible to keep the fire-engine in good order and two buckets were repaired during the year in which gas was put in.

Some of the material used in the 1860s came by train to Weeton Station, some by carrier and some, like the new glazed tiles and red hassocks for Harewood Church, by post. A Post Office in the village was fitted up in the spring of 1860 with a glass partition, a desk for delivering post and shelves at back with pigeon holes.

Throughout his long and leisured tenure, the 4th Earl did not therefore neglect his house or his estates. In 1886, the firm of Cubitts, who had built Osborne House, were employed as architects to design new chimney-stacks for the balustrading on the wings. These differed only slightly from Barry's, but were less ornate and, since they fitted in place as part of the balustrade, were an improvement visually as well as structurally.

Lord Harewood sat for his portrait to Sir Edward Poynter, a study dated 1888 which catches something of the ambience of his later years.[14] Poynter presents the Earl as an elderly, bearded and thick-set figure, in a grey suit, with a watch-chain spread across his waistcoat, his plump hands holding a stick, a pair of gloves and a hat. Behind is a landscape of trees and greenery, an early type of collage, 'based on motifs from the Park' .

For notes to this chapter see page 181.

7

Harewood House in the Twentieth Century

The 5th Earl, Henry Lascelles, found himself on his father's death in 1892 faced with a dilemma he never personally solved: how to enjoy the expensive tastes of Edwardian society and how at the same time to live within his means so that his trustees were satisfied that the estate was in no way diminished. The reaction from the ownership of landed property, which had been first obvious in his father's time, continued and a policy of selling real estate and investing heavily in railway companies on a world-wide scale was adopted. Harewood House in Hanover Square, London, was put on the market in 1898. The Dowager Countess survived until 1904, the recipient of a jointure of £3,800, a sum very little less than the income yielded by the West Indian estates in 1899-1900, on which tax had to be paid, and there were other similar annuities charged on his estate. The money, from whatever source, came in and promptly went out and his bank balance remained at the end of each financial year usually lower than his mother's jointure. Property in Hanover Square and Oxford Street was sold. He insured his life heavily to provide for his wife, Lady Florence Bridgeman, daughter of the 3rd Earl of Bradford. Harewood House itself was insured for £17,000, the contents for over £30,000, and the horses, carriages and harnesses for £4,000. The premiums were modest, a total of £79 5s 3d.

The report in 1900 by Messrs Nicholl, Manistry & Co, who had succeeded Messrs Oddie, Lumley & Nicholl as the trustees of the Harewood Estate, was more heartening; yet Lord Harewood was

cautioned: 'the list of investments is beginning to look quite imposing, but, of course, it represents property sold'. However, the situation in the West Indies was not as serious as in the 1870s when his father had been advised to sell out. Even Nicholl admitted that 'the accounts from the Barbados are certainly a great improvement in recent years'.

Thus encouraged, the Earl was able to install electricity for lighting purposes at Harewood House, paying £2,700 for the year 1901. This exhausted his efforts as far as improvements to Harewood House were concerned and the estate, although not allowed to run down, did not have enough capital ploughed back into it. King Edward VIII's visit to Harewood House in 1908 was social recognition of so expensive a nature that Lord Harewood was allowed an extra £700 by his trustees 'towards expenses of the King's visit'. 'I can only hope,' wrote Nicholl severely, 'that there will certainly be no extra expenditure in the estate this year... and we can only hope for something from the West Indies to keep us in easy funds for ordering or extra payments.' In the event, the plantations yielded only £500. By 1910, matters were worse; the purchase of a house at Newmarket, Machell Place, had reduced capital by over £11,000, and there were the leaseholds of two London houses in Upper Belgrave Street and Dorset Mews and the upkeep of a yacht, the *Dolores*, to be paid, apart from regular expenditure. Harewood House could expect no consideration, since Nicholl wrote to express his hope 'that any interference with your personal amenities such as stables, garden, pleasure ground & game will neither now or hereafter by necessary'.

The future of the house lay in fact with the eldest son, Henry, Viscount Lascelles, who had spent two years (1905-7) in Rome as honorary attaché to the British Embassy there. Lord Lascelles had little use for politics as such, but a great deal for the fine arts, and in Rome he put his time to good account. His private allowance, secured by an annual rent charge on the estate, was £750, with £120 for his year's lodgings in Rome, which did not lend itself to expensive living. But Lord Lascelles began then the collection of paintings which was to amount to one of the most important in private hands in the twentieth century. His taste, for a man of twenty-five, was informed and precocious. He bought, for instance, in Rome in 1906 two Italian scenes by the Flemish artist, Joan Philip Spalthof, a unique acquisition since the works of

Spalthof had been known to exist only through recorded evidence.[1]

Lord Lascelles fought throughout World War I with distinction, first joining the Yorkshire Hussars and later returning to his own regiment, the Grenadier Guards. It was during these years of wartime service that he met briefly in London in February 1916 his great-uncle, the 2nd Marquess of Clanricarde, himself a notable collector of paintings.

On the Marquess's death shortly afterwards, it was found that he had left the bulk of his fortune, estimated at £2$^1/_2$ million, the derelict Portumna Castle in County Galway and his collection of Italian and Flemish paintings to Lord Lascelles, a circumstance of the utmost significance in the history of Harewood House and a pleasing windfall to a man whose private income in 1910 had been reduced to £600.

Meanwhile, between 1914 and 1918, Harewood House had become a convalescent hospital for those wounded in action. The family retained the east wing which could conveniently be sealed off with its own separate staircase.

After the war ended Lord Harewood began to put Harewood House in order again, but the days of Edwardian security had gone and the economic climate did not encourage anything beyond the necessary repairs and restoration. He died in 1929, the first Earl of Harewood to number motor cars as well as carriages among his personal effects and to consider the Harewood House fire-engine worth mentioning as a particular bequest to his heir.

Over at Goldsborough Hall, Viscount Lascelles had been in possession of the Clanricarde fortune for well over a decade. His marriage to HRH Princess Mary, the only daughter of Their Majesties King George V and Queen Mary, on 28 February 1922, brought him a young and delightful wife who fully shared his interests and his pleasure in country life. Together they set about the restoration of Harewood House, now their home.[2]

The Princess Royal, the title given to her by King George V in 1932,[3] had inherited Queen Mary's love of antique furniture, of jade and ornamental stones and miniatures. Her own interest in the graphic arts was so well known that many of her wedding presents took this form. Horses, hunting and racing were in her blood, gardening — especially rose growing — was an absorbing hobby, music a relaxation. A conscientious upbringing to serve in

the tradition of Royalty allowed little time for personal interests, but it was her deep and happy involvement in her home which made Harewood House in effect a royal palace during her lifetime. Queen Mary paid an annual visit in the late summer and the great days of pomp and circumstance temporarily returned.

The move from Goldsborough to Harewood in 1930 called for certain decisions, some of which it was apparently very easy to make. Princess Mary found, for instance, a dearth of waste-paper baskets and soiled-linen baskets at Harewood House and Goldsborough Hall was forthwith denuded of these. Electric table-lamps were another priority, but as the Princess wrote from Sandringham in October 1930: 'voltage at Harewood is different'. This occasioned the first essential circuits. It did not amount, however, to a complete overhaul and renewal, a circumstance which Her Royal Highness regretted in future years when the increasing use of electrical appliances tended to over-load circuits not designed to meet such extensive demands.

The Earl had already some experience of building repairs in his abortive attempt to make Portumna Castle habitable.[4] At Harewood, structural work on the interior was put in hand at once. Sir Herbert Baker was called upon for architectural advice and in January 1930 produced his proposed design for alterations and improvements to Harewood House, working in conjunction with the York firm of architects, Messrs Brierley & Rutherford, who had succeeded Carr & Atkinson in practice there and still retained Carr's plans for Harewood House. Lord Harewood accepted the proposals and the house was carefully modernised so that the existing plan as finalised by Barry was disturbed as little as possible. In the eastern side of the house, principally occupied by the family, the lift was given the safety and efficiency of a lift control and a gearing shaft, so that it became an automatically operated passenger lift rather than a hoist for food and luggage. Since it passed near the Breakfast Room on the principal floor and came to a halt on the first floor beside the main bedrooms and within reasonable reach of the Nursery and Schoolroom, it was a feature much appreciated by the whole household and their guests. In the same area, Sir Herbert Baker found, near the staircase running up from the basement and by the lift-well which adjoins it, space for extra bathroom accommodation at first-floor level. On the other side of the house, in the west wing, he altered

an existing staircase and replaced a housemaids' closet and bucket-sink on the first floor with new bathroom facilities. An early and elementary form of oil central-heating was put in, but the risk of explosion and fire was too great. It was replaced by solid fuel which in turn gave way to the present oil-fired system.

The most important new work architecturally was the creation of a Dressing Room for Princess Mary on the main floor of the house. The new room lies on the North Front, between the corner bedroom on the north-east and the Study or Little Library, that is the present China Room adjoining the Old Library. It is a pleasing pastiche in the Adam manner, with plaster work by Sir Charles Wheeler, simple and quietly elegant in a style popular in the 1930s when a taste for eighteenth-century interior design revived. The deep apse contains glass-fronted cupboards designed by Sir Herbert Baker, one on each side of the Adamesque fireplace and they form admirable show cases to display the 7th Earl's pieces of jade, amber and rose-quartz.

There was so much detailed planning involved that the removal of the furniture, pictures and effects from Goldsborough Hall was done in stages. The selection of these was a task demanding both disciplined taste and common sense. Many of the finest paintings and much of the furniture were at Chesterfield House, the London house, which was given up in 1932. Goldsborough Hall was a red-brick Jacobean house partly redecorated in Adam's style by Daniel Lascelles during the years when his brother's house at Harewood was being built and furnished. Goldsborough, therefore, had formed an ideal setting for the 6th Earl's collection of furniture and pictures which contained examples of various periods of design and many schools of painting. But Harewood House called for a less eclectic choice, for most of its interior was so markedly Adam in character that it seemed to Princess Mary and her husband to demand a restoration basically eighteenth century in decoration and furnishing. For about ten years there was much reorganisation and rearrangement between the two houses until Goldsborough was rented to a school and subsequently sold.

As soon as it was feasible, both Princess Mary and Lord Harewood wanted to have with them their personal possessions, a choice dictated by familiarity, sentiment and immediate utility. Hence a remarkable juxtaposition of articles was loaded into removal vans. Persian rugs and carpets, boxes of books, the baby

grand piano from the Goldsborough Drawing Room, a piano stool and a music rack, dress hangers, cushions, a library chair covered in corduroy, a footstool in Victorian needlework and 'odds and ends'. A note at the end of a typed list of items due for transport at one point to Harewood House has a firm instruction appended: 'If the van will not hold all … it is important that the sponge trays and bathroom chairs are brought over.'

Most of the contents of Princess Mary's own apartments were removed to her new home. First of all, her most personal possessions arrived, her mahogany dressing table with its triple mirror, her manicure set and cut-glass, gilt-topped toilet bottles, the twenty-one pieces of a 'set of tortoiseshell requisites inlaid silver with silver gadroon edges initial and Crown', an alarm clock, a weighing machine and a bidet in a painted white case, and the comfortable furnishings of her bedroom. Princess Mary's care and chief concern was the safe arrival of her collection of quartz, amber and jade, and of her miniature ornaments. She directed that Mr Ward, the head of the Harrogate firm of removers, was himself 'to pack all ornaments in my sitting room, bedroom and dressing room, china etc., from own cupboard… jade stand with tree and glass top from drawing room, also two chinese trees from room above, china and glass in walnut cabinet' and so her instructions continued until the list was complete.

The two cabinets containing the miniatures were in Princess Mary's bedroom; an array of such things as tiny models of animals, cats, birds, rabbits, elephants, diminutive tea services, little trays of pots with artificial flowering plants, a small-scale scent bottle, a pomander and a multitude of boxes, many enamelled like one described as 'a very miniature circular box and cover'.

In her sitting room, the walnut 'William and Mary' cabinet held the collection of carved amber and quartz. At that time these objects were fragile and rare, but not of excessive value in monetary terms. One carving, 'A laughing God standing on a frog', was valued at £12 10s 0d, but a pair of circular Canton enamel jardinières with shrubs of mother-of-pearl and leaves of jade were precious by any standards. The collection of jade was displayed in another late seventeenth-century cabinet. This included some exquisite conceits, like a mountain carved in malachite with a jade lion on the summit and rabbits and birds of jade below. Among the items of this highly individual collection were a carved ivory owl

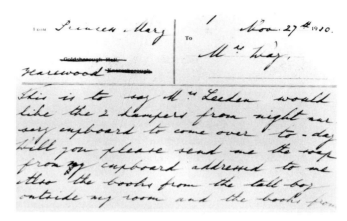

Fig 22 A memorandum from HRH The Princess Royal concerning the removal of household goods from Goldsborough Hall to Harewood House, dated 27 November 1930. (Inventory of Goldsborough, 1925 with papers re transfer of furniture etc to Harewood, HA no 304)

in a tree trunk, valued at £3 15s 0d in 1926, a translucent cream-coloured jade teapot at £120, a green jade vase at £400, and, the true collector's anti-climax, a pair of enamel trays worth 30s.

In the day nursery at Goldsborough, Viscount Lascelles and the Hon Gerald Lascelles, aged six and five when their father inherited Harewood House, had their own small collection of miniatures in a cupboard of polished pine, where part of a toilet set in rosebud design kept company with a Meissen china basket with a handle and wreaths of flowers. The nurseries at Harewood House were as usual at the top of the house, in the east wing. To re-equip them, the corner wicker-basket for soiled linen and the brown pile carpet, complete with underfelt, and a brass clock were sent from the Goldsborough nursery, and Princess Mary further instructed that 'when the furniture van collects the various things, I want the rocking-horse, also the low round table from the Day Nursery and the glass medicine cupboard from the Night Nursery'.

From the first, Princess Mary saw to it that her new establishment was well supplied on the domestic front. China, glass, kitchen equipment and linen were brought over and this last item is of special interest. Linen was still regarded as an important inheritance and a very valuable part of household equipment. The

linen at Goldsborough Hall was estimated in 1926 at £2,305 in a survey which listed one pair of fine linen sheets 'embroidered with monogram and coronet', at £20. Most of this stock came to Harewood House; the 'old linen' included sheets and tablecloths dating back to 1846 and a gross of linen damask dinner napkins; the 'new linen' was that purchased since 1923. The inventory evokes the domestic scene of the inter-war period; toilet-table mats, crochet-bordered tray-cloths, small embroidered d'oyleys, head-covers for the backs of sofas and chairs, and linen damask tablecloths four and a half yards long. For shooting parties, there were blue-striped tablecloths and, in the autumn of 1930, Princess Mary wrote to ask that there should be sent from Goldsborough 'All the small blue napkins for our luncheon case to Harewood & washable linings for plate, glasses, etc. for ditto'.

The linen specifically for use in the kitchen quarters continued the best domestic practice of a separate cloth for every job and the Victorian tradition of lavish specialisation of function; dishing-up cloths, glass-cloths, knife-cloths, soup-cloths, pudding-cloths, basin-cloths, housemaids' cloths, hearth sheets, dust sheets, carpet druggets and one hundred dusters replenished the drawers, the shelves and closets at Harewood.

Princess Mary and Lord Harewood began the refurbishing of an Adam interior sadly changed. The Old Library on the left-hand side of the front door had nearly degenerated into a dump. Slowly and painstakingly, the Earl managed to get the room restored to its original appearance, a task in which he was so successful that the room is nearer to Adam's design than almost any other in the house (see figs 13, 14). The Billiard Room at a later date he re-created as the Rose Drawing Room. The former yellow damask hangings and furnishings from which the room had taken its name were not restored, but the effect was delightful, complementing the delicate tracery of the ceiling. The ponderous equipment of the Billiard Room was moved back to the basement. The Entrance Hall retained its Victorian function to a lesser degree; it was furnished with adequate comfort so that, with a fire lighted and a rug or two, the effect of warmth and welcome overcame the rather chilly austerity imparted by Adam. Here, as in some other apartments, restoration of Chippendale's furniture took place. In the centre of the Hall, Chippendale's great octagonal lantern was rehung, and is now in the Old Library (fig 14).

In time, each room on the principal floor began to reassume its eighteenth-century character, apart from the Dining Room, which was irredeemable, and the Saloon, where the Victorianised Adam décor had become an inextricable fusion of styles. An important new feature were the Spanish leather hangings in the Breakfast Room, renamed by the 7th Earl the Spanish Library, once the State Dressing Room.

By 1939, Harewood House had become an extremely distinguished residence. Above all, the collections of paintings assembled by the 6th Earl enriched the house.[5] The Italian School of the fifteenth and early sixteenth centuries is particularly well represented. It was Lord Harewood's earliest and greatest interest. A receipt of 1 August 1918, from a London art dealer, acknowledges a cheque for £7,500 from 'Major the Viscount Lascelles Grenadier Guards BEF France, for the two cassoni which formerly belonged to Lord Crawford'. The stamp duty on the transaction was 1d. These panels, the fronts of cassoni or dowry chests, are the work of a fifteenth-century Florentine artist, Appolonio di Giovanni, who painted the two as a pair, his theme, subjects familiar in the history of Ancient Rome, the Rape of the Sabines and the Generosity of Scipio. They now hang in the Gallery.

Most fortunately the Princess Royal and her husband were able to reassemble the greater part of the collection of Early English Watercolours, sold in May 1858 at Christie's. An example is the return of the well-known work 'Distant View of the South Front of Harewood House', painted by Turner for Edward, Viscount Lascelles, and dated 1798. It was presented by the Countess of Wharncliffe to the 6th Earl as a wedding gift in 1922. This watercolour was that lent to Sir Thomas Lawrence along with one of Girtin's to enable Lawrence to fill in an accurate background to his portrait of the 2nd Earl. At the beginning of the twentieth century, the painting was considered so valuable that the 5th Earl paid a separate insurance policy for it, although the work remained in the possession of his aunt, Lady Wharncliffe. This now hangs with other topographical studies in the room once the State Bedroom and later the Princess Royal's Sitting Room (see plate 7).

In the room known as Lord Harewood's Sitting Room are the paintings which have family associations. Many came from Goldsborough, notably Frank Salisbury's 'Princess Mary Signing the Register... at Westminster Abbey', and the companion paint-

ing of their wedding day, Sir John Lavery's 'The Wedding Procession'. But Sir Oswald Birley's beautiful portrait of the Princess Royal went from the Entrance Hall of Goldsborough to the central place among the family portraits, over the chimney-piece in the Dining Room (see plate 16).

The appointment of Lord Harewood in 1930 as a Trustee of the British Museum was a recognition of his ability rather than a conventional tribute to a distinguished connoisseur. One unexpected expression of his skill and enthusiasm can be appreciated in Harewood House. He was an expert in petit-point tapestry and the covers of four Chippendale chair seats in the house are his work.

The restoration of the interior of the house had just been completed when war broke out in 1939. Harewood House became for a second time a convalescent hospital and the family retained again only the east wing. To make a convenient entrance for the staff and patients, the Venetian window on the North Front of the Gallery was removed and a canopy fixed overhead. Cooking for the hospital was done below in the original kitchen of the house with its vast Victorian range. A second kitchen for the family was made under the Gallery at the other end, overlooking the south terrace, in the Housekeeper's old room, where an Esse cooker was used, but the journey across the basement and up to the Breakfast Room on the west side offset the convenience of the more modern stove.

Viscount Lascelles, serving with the family regiment, the Grenadier Guards, was wounded and taken prisoner, spending his captivity in the intensive study of music, especially opera, which was to make him an international expert in the subject.

The end of the war brought the necessity for a second renovation of the house after the hospital was evacuated; only a decade had passed since the completion of the previous refurbishing. The 6th Earl died in 1947 before he could undertake this onerous task, which devolved upon his young heir, George Lascelles 7th Earl of Harewood. The Princess Royal was given by His Majesty King George VI, her brother, a flat in St James's Palace, but Harewood House remained her home and a joint household was set up, an arrangement which was to last for nearly twenty years.

The Princess Royal had the former State Bedroom as her Sitting Room (see plate 7). Here she lived with her books, which became so numerous that they overflowed into the bookcases of the Little

Library, her tapestry work and her knitting. Much of her time was spent attending to her correspondence and the detailed planning of her official engagements with the help of her Lady-in-Waiting. Upstairs the Princess Royal had the Red Bedroom over the main entrance on the North Front — a name preserved, like those of many of the bedrooms, since the time of Edwin Lascelles. Across on the South Front, the Rose Bedroom became the Lady-in-Waiting's office and the adjoining Dressing Room her bedroom. The Secretary had an office and a bedroom in the basement with the use of a distant bathroom, an inconvenience remedied when a private one was made for her nearer her rooms.

Lord and Lady Harewood lived in the East Wing, the part of the house traditionally reserved for the family. The Nursery quarters were no longer overhead; the Portico Bedroom over the Library was the Day Nursery and its Dressing Room the Night Nursery.

Both establishments used two rooms in common: the Spanish Library as a dining room and the Library as a drawing room, where the evenings after dinner were spent when both families were in residence.

Their guests had bedrooms on the first floor, perhaps the Wreath Room situated on the South Front next to the Nursery, or, on the opposite side of the house, the White Bedroom, which in the eighteenth century housed a Tent Bed reputed to be proof against bed-bugs.[6] The old School Room and the room next to it at the south-east corner of the house gave extra bedroom accommodation. The West Wing, where is the low-ceilinged, mezzanine-type floor over the Gallery designed for the man-servants and, in more spacious days, for visiting valets, each connected by an individual bell system to the room of his respective master, was less frequently used. Above, the storey added by Barry had long since outlived its original purpose as accommodation for the bachelors who encrusted or adorned the fabric of Victorian society.

In 1950, the decision to open Harewood House to the public was taken. In reality it had never been closed since interested visitors could always have permission to see the State Apartments in the West Wing and it had been a tourist attraction on Saturdays in the early nineteenth century, with the Harewood porter and guide-book author, John Jewell, to show visitors round. These were the rooms from 1950 regularly on view. Throughout the summer months, on Wednesdays, Thursdays and Sundays, visitors crossed

the Entrance Hall to see the Great Staircase, were ushered into the Rose Drawing Room and by way of the Green Drawing Room, the Gallery, the Dining Room and the Music Room made the journey back to the Hall.

At 1s 6d for the house and 1s for the gardens, business began to boom in the mid-1950s. It was clear that something more sophisticated than a bus serving tea and buns and the minimal lavatory accommodation in the stable block would have to be provided. An amateur side-line was fast gaining professional status.

But rising costs and shortage of staff were increasing problems. About 1957 Lord and Lady Harewood gave up the East Wing as private apartments and moved up to the Chintz Bedroom suite on the North Front. Lord Harewood took over the Spanish Library as his sitting room, but the Library next door was still a joint drawing room. A new dining room had to be found for the family and the Billiard Room in the base storey was a natural choice since it was near the new kitchen, which had been fitted up in the 1940s to allow the hospital the use of the original kitchen of the house.

These new dispositions enabled visitors to see most of the East Wing. They entered first of all the Old Library on the left-hand side of the front door, and then went into the redesigned Little Library where the Princess Royal had formerly kept her books and some of her possessions in the grille-fronted bookcases. In 1958 Richard Buckle, as artistic adviser, restored to this room the Adam decorative scheme. Its original purpose had been as a dressing room or study for Edwin Lascelles, and the Adam ceiling executed by Rose corresponds exactly to the Adam drawing in the Soane Collection. The frieze, too, is identical in detail.[7] There were thus the elements of a small and perfect Adam room, despite its later use as a study and a library. The alcoves were expertly reconstructed to hold a selection of the Harewood Collection of Sèvres porcelain built up by Edward, Viscount Lascelles, and other pieces belonging to the family, so that a cabinet in which porcelain and china can be perfectly displayed resulted. The room was an immediate success.

Visitors then walked through the apartments of the East Wing until they reached an exit near the Princess Royal's Sitting Room, and were diverted back into the Hall. This meant they were unable to see three rooms, Her Royal Highness's Sitting Room, Lord Harewood's Sitting Room and the Library. However, when it was not in use by the family, this last room was on view. The cord

round the handles of the double doors into the Entrance Hall was untied and as visitors crossed the flagged floor en route for their tour of the State Apartments, after their rather restricted view of the East Wing, they had an enticing glimpse of a room where an atmosphere truly *en famille* could on occasion prove a greater excitement than Adam's superb decorative scheme restored by the London firm of Ashby & Horner in 1958, at a cost of £1,725. Their estimate for removing the layers of Trollope's conscientious work, now nearly a century old, and redecorating the Adam plaster work of the coved ceiling and the arched recesses over the bookcases was £1,315. It was well worth it, for an appreciation of the former Adam Saloon was made possible.

The next year, 1959, marked the bicentenary of the laying of the foundations of the House. Richard Buckle arranged in the stable block an exhibition room where material relating to the history of the house, the work of the estate and other exhibits could be permanently on display, or altered as discretion and interest dictated. On the other side of the entrance, a new cafeteria was opened. For the use of the ever-increasing number of visitors a car park was provided near the north-west corner of the house and more lavatory accommodation was installed nearby. Inside the house, he supervised the rearrangement of furniture and pictures so that the public might see the finest examples of these in the most advantageous situations, without depriving the family of their own favourite or valued possessions. The opening of Harewood House to visitors had become business, established on an attractive and efficient basis.

The death of the Princess Royal in 1965 ended an era. Her personal standard no longer flew from the flag staff as it did during her periods of residence. Today, a banner with the Lascelles's golden, decorative cross on its black background indicates that the family is in residence. At other times a Union Jack is flown.

Since 1965 the whole of the East Wing, including the Princess Royal's Sitting Room, has been open to the public. Since 1967, only the Main Staircase with its inner Hall has not been seen by visitors.

An imaginative and highly enterprising revival of Harewood's eighteenth-century menagerie is the Bird Garden, planned by Lord and Lady Harewood and opened in 1970. It is a classic of landscaping in its own right, built where the ground slopes towards the lakeside between the house and the stables. Edwin

Lascelles's new menagerie mainly for birds was a Palladian structure down at the hamlet of Stank. Lady Fleming refused, in the third person, the offer of an Indian ox, but she grieved over the loss of a favourite bird. Indeed, birds were highly prized in the eighteenth century as charming and ornamental features both indoors and in menageries in the parks.[8] The birds in the Harewood Garden are just that, brilliant, exotic and amusing. A most popular and successful Study Centre was set up in the Garden with the co-operation of the West Yorkshire Education Authority, where children are given talks about bird life, watch films, look at specimens and work in the Garden itself.

An expensive item in 1968 was the redecoration of the Doric Entrance Hall, when layers of Victorian varnish and paint had to be removed. Adam left no indication of the colours he used. Lord and Lady Harewood and Richard Buckle, however, found traces on the columns and in the niches of ox-blood and green colouring dating probably from the Victorian redecoration. This determined their choice of the former colour for the columns and the ground of the frieze above, a most effective contrast with the grey and white of the walls and niches. The result is striking, for the interior of the Entrance Hall now makes a vivid impact, stimulating in white, grey and madder and strong enough to stand up to the challenge of Epstein's *Adam*. (see fig 12). The frames of the chairs in the Library have been recently repainted in their original blue so that they now appear exactly as in Chippendale's design. However, the most important work undertaken was the cleaning of the exterior stone work and the main entrance and the painting of the outside of the house in 1972-3, an outlay of £16,500.

Edwin Lascelles's house has become in its way a commercial venture.[9] It is all very different from the life at Harewood House envisaged by Adam and Carr and Barry. Lord and Lady Harewood have in their unit of rooms on the first floor, a kitchen and the lift once modernised by Sir Herbert Baker. The Portico Bedroom is their Sitting Room, its Dressing-Room his Study, the Wreath Bedroom their Dining Room, and the Rose Bedroom Lord Harewood's Office. There are compensations: convenience, comfort and the finest view over the lake and the countryside beyond that the house affords.

For notes to this chapter see pages 181-2.

8
Restoration 1987-91

The extensive programme of restoration of the State Rooms (1987-91) at Harewood House is of unusual interest both in the circumstances of its inspiration and in the concern shown for the ethics of restoration. Initially the work involved restoration in its literal sense, for the impetus came from the rediscovery in a barn and in workshops in the Estate Yard, situated beyond Carr's Stables, of a treasure-trove of Chippendale's furniture and furnishings discarded by Barry during his decade of 'Victorianising' Harewood.

Apart from the remains of the State Bed, there were looking-glasses and frames and a quantity of dismembered Chippendale ornaments, mostly packed in crates and half-forgotten for 150years.

To restore the mirrors was regarded by Lord Harewood as the priority. Hugh Roberts, now Deputy Surveyor of the Queen's Works of Art, confirmed that complete mirrors could be reassembled and returned to the State Rooms. For over two years the London firm of Carvers and Gilders devoted its expertise and craftsmanship to accomplish this, unscrambling the fragments and putting the Chippendale jigsaws of gilded pieces together again. It was virtually impossible, for instance, to distinguish between girandoles and mirrors, for the candle-arms attached to the frames had been removed or fallen apart. Nor was Chippendale's surviving account very helpful, couched in the extravagant and vague language of the upholder determined to impress. Finally, six pairs of looking-glasses with their frames and decorative details have been and are being assembled, using single mirrors that had remained in the house to make up the pairings, their frames largely shorn by Barry of Chippendale's swags, drops

and filigree decorations.

Two pairs were sold to finance the restoration of the other four, which emerged from the workshops of Carvers and Gilders as brilliant examples of Chippendale's oeuvre, but they could not be re-hung in their original positions because of Barry's alterations in the Saloon and the Dining Room. It was this circumstance which led to the far-reaching decision to find space to display the mirrors and, in so doing, to undertake restoration on a major scale. This began in 1988 with Francis Johnson, the doyen of Neo-classical architects in the north of the country, as general consultant.

At the outset, a problem was recognised — how to clear more wall space for four pairs of mirrors. Only a radical reorganisation of the distinguished Harewood Collection of Pictures in the two Drawing Rooms and the family portraits in the Gallery would solve it. Alec Cobbe was called in to give a specialist's advice and suggested to Lord Harewood that the Italian paintings should replace the family portraits in the Gallery.

The idea of one of the most important collections of pictures remaining in private ownership in an English country house, hung in a Gallery which could potentially rival in the quality of its craftsmanship any similar apartment in Europe, was irresistible. Moreover, Lord Harewood had long wanted to restore to the Gallery the original chimney-piece, which Barry had transferred to the Dining Room, and remove the two Victorian fireplaces the latter had inserted to give the Gallery more heat. This would help to return the room to its eighteenth-century appearance, which Lord Harewood had studied closely in a watercolour he had acquired in 1981, painted by a young artist, John Scarlett Davis, in 1827 and, therefore, visual evidence of the condition of the Gallery twenty years before Barry's drastic alterations. It was consulted extensively during the period of the restoration of the room.

By the 1980s, the Gallery was in any case badly in need of an overhaul. The ceiling had been damaged by the fire of 1885 which began in a chimney of the kitchen below. The east wall of the Gallery is a vulnerable part of the structure of the house, because of the concentration of flues within it and the demolition of Adam's court yard beyond. When building work was in progress to remove the fireplaces, the remains of the brick arches of Adam's semi-circular passage to the Gallery were revealed.

Although the family portraits and the contents were saved from

the fire by men described as 'villagers' and rewarded with 5s each, the accident high-lighted the alarming inefficiency of the Harewood fire-engine and its equipment. The report sent in by the Leeds Fire-Brigade, summoned to cope with the crisis, condemned the useless pumps and broken hoses and recommended that the stand-pipe should be kept in the village as 'it is of no use anywhere else and is likely to be left behind in the engine shed'.

In subsequent years, more flooding affected the Gallery and rehabilitation could not long be delayed. The two Drawing Rooms, the Rose and the Green, were also in need of attention and for these a scheme of redecoration was planned. Some degree of positive restoration, however, had to be undertaken in the Gallery and it was here that work began, directed by Alec Cobbe. With his assistant, Edward Bulmer, he was involved in every aspect both at the practical and the decorative level, as an artist, as decorator, designer and period expert.

As in Edwin Lascelles's day, London and provincial firms and local estate expertise were employed. Notably, much of the specialist work was in the hands of individuals and the Harewood craftsmen led by John Lister, Clerk of the Works. Each of the three rooms restored between 1987 and 1991, the two Drawing Rooms and the Gallery, presents a separate visual experience.

Few rooms in an eighteenth-century country house have a more fascinating decorative history than the 2nd Drawing Room at Harewood House, now the Cinnamon Drawing Room.

It began as one of the additional state apartments created by the loss of Adam's court, in 1762, situated between the Gallery and the 1st or Yellow Drawing Room. In John Carr's plan of the house published in volume V of *Vitruvius Britannicus* in 1771, the room was designated the South Dining Room (see fig 7), but in September of that year, when Elizabeth, 1st Duchess of Northumberland saw Harewood, she found several apartments unfinished including the 2nd Drawing Room. She noted in her journal that it was 'designed for Tapestry from the Gobelins'.

The Earl of Coventry, whom Lascelles knew well, had visited the Gobelins Manufactory in 1763 and ordered a set of tapestries with Boucher's medallion design of the Four Elements. Adam produced drawings for a tapestry room at Croome Court, Worcestershire, and the hangings were ready by 1771. William Weddell was in Paris in 1763 and commissioned a similar set for Newby

Hall near Harewood, which probably arrived in 1767, just before Adam became involved in designs for the Ladies' Withdrawing Room at Newby,[1] to be furnished by Chippendale. Lascelles himself was in Paris in 1765 and must have known of these Gobelins tapestry hangings specially devised for the English market,[2] but for some reason the plan did not materialise.

In 1777, the anonymous author of a *Tour to the West Highlands* viewed Harewood House en route and found the 2nd Drawing Room furnished 'in a most singular manner ... as if fancy and art had exhausted all their choice treasures and exhibited colours the most odd and disagreeable'.

Later, the walls were hung with white damask and the room was known as the White Drawing Room. After the Victorian colour scheme of green and white with gilt ornaments, set off by the present Axminster carpet and seat furniture upholstered in Beauvais tapestry, was adopted, the apartment was referred to as the Green Drawing Room. The green and white marble chimney-piece, with Venus and Cupid, inserted by Atkinson of York in 1785, may have dictated the choice of colours in this mid-nine-teenth century restoration.

In the Green Drawing Room, an apartment in the Regency manner has evolved giving decorative unity to the disparate elements inherited from the eighteenth and nineteenth century schemes. The room is now presented as an interlude between Adam's Neo-classicism and the Victorian refurbishment, and known as the Cinnamon Drawing Room.

In the 1930s, the secular Italian pictures from the 6th Lord Harewood's Collection were hung here, possibly on the advice on Tancred Borenius, whose catalogue of the entire Harewood Col-lection of Pictures was published in 1936. These were taken down in 1987 to be replaced in the Gallery next door and a group of family portraits from that apartment and elsewhere were assem-bled by Alec Cobbe for the Cinnamon Drawing Room in an outstandingly successful hang. Seven Reynolds canvases domi-nate the room, but the smaller portraits are so effectively placed that the individual personalities of the Lascelles family can for the first time be quickly identified.

The portraits by Reynolds give the room immense style and character, which reflects his ambition to elevate portraiture to the status of history painting by endowing it with heroic and poetic

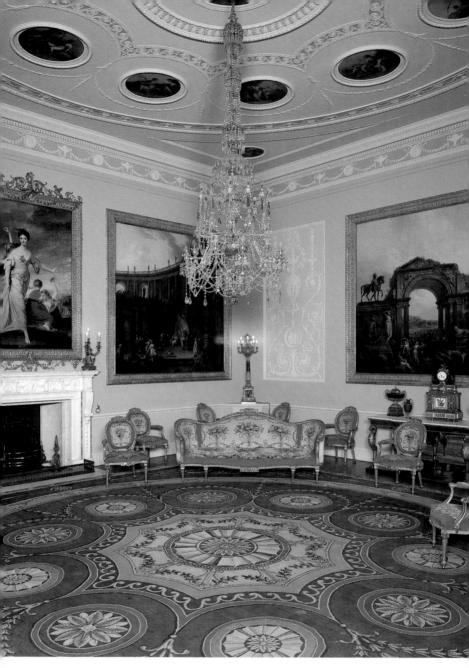

Plate 18 *The Music Room: a splendid example of the identity which can exist between an Adam design and its realisation*

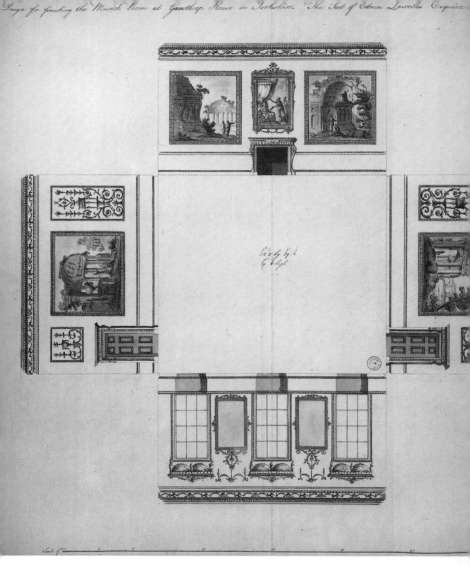

Plate 19 Robert Adam's finished drawing for the Music Room is an interesting example of his designs as presented to his clients

qualities. In this sense Edwin Lascelles was an admirable patron, providing the artist with a succession of handsome and attractive sitters from his extended family and often meeting the fees as well.

Lascelles's own portrait above the fireplace dates from the mid-1760s. The pose is eloquent of the self-image he apparently sought, a man of consequence and authority, soberly dressed in a purple coat, plum coloured breeches and white striped stockings, and very much the master of his new house seen in the background (fig 21). Below, a pastel by George Knapton shows him about the age of thirty-four with an exquisite companion portrait of his first wife, Elizabeth Dawes, probably painted for their marriage in 1746-7. The superb portraits of Lascelles's step-daughters, Lady Harrington and Lady Worsley, in frames no less resplendent, are in Reynolds's grandest manner (plates 13, 14).

The former was painted as Jane Fleming in 1775, four years before her marriage to the 3rd Earl of Harrington. She appears as Aurora, the goddess of 'rosy-fingered' Dawn, in white silk to symbolise purity. Every detail is controlled by accepted iconography. The shades of red and tawny-yellow in the trimmings of her dress and in her feathered head dress and scarf are the colours of the dawn sky, which she faces. The stars in her scarf will vanish with the light and the flowers underfoot will open in the sun. The portrait is one of Reynolds's most pleasing essays in personification, for the subject is not intimidated by her mythological role and the imagery intensifies her youthful freshness and beauty.[3]

A second portrait by Reynolds about four years later of Jane as the Countess of Harrington is in marked contrast. She stands in a conventional setting on a terrace beside an outsize balustrade and urn, clad in the voluminous folds of a 'giant pink bedcover.'[4] This is par excellence Reynolds's historical style of portraiture in danger of being reduced to a certain absurdity. The work reveals a strong physical resemblance between the Fleming sisters, impossible to discern in the two portraits which hang in the Cinnamon Drawing Room. Jane, unlike Dorothy, was happily married, a wealthy woman in her own right and the mother of six children; Lord Petersham, the heir, was a dandy of the Prince Regent's circle.

Her sister, Seymour Dorothy, commands attention in a scarlet riding habit, an adaptation of her husband's Hampshire militia uniform. Her first recorded appointment with Reynolds is dated February 1777, two years after her marriage to Sir Richard Worsley,

when preparations for war against the American colonies popularised the vogue for a military style and accelerated the contemporary trend in emancipation in women's costume. In Bath, for instance, at the end of the 1782 season, 'some of the ladies were in riding habits. Tis tonnish to be so much undressed at the last ball'.[5] Of delightful appearance and dubious morals, Lady Worsley is a model of elegance from the ostrich plumes on her black beaver hat to her flat-heeled shoes in the latest style. The portrait was exhibited at the Royal Academy in 1780. Sir Richard Worsley of Appeldurcombe on the Isle of Wight was a renowned traveller in the Levant, a distinguished antiquarian and collector.[6] Their marriage was stormy and sad, and Lady Worsley's amatory career the source of much scandal and gossip.[7]

Reynolds demonstrates his versatility in his portrait of Mrs Edward Lascelles with her infant daughter, Frances, a commission possibly given to celebrate Frances's birth in 1762. Anne Chaloner married Edward Lascelles, later 1st Earl of Harewood, in 1761 and his portrait by Reynolds in Van Dyck dress hangs, like hers, on the fireplace wall. She was the sister of Mary Hale who sat to Reynolds for her scintillating portrait as Euphrosyne, which in an engraving in mezzo-tint of 1768, intended for publication, was entitled L'Allegro, Milton's 'heart-easing mirth'.

Again the contrasting personalities of two sisters are suggested. Reynolds borrowed the pose of Mrs Lascelles and her daughter from a mid-sixteenth-century Italian print, *Virgin and Child in a Landscape*. The motif of the happy, affectionate infant is the same, but the sense of foreboding so pronounced in the face of the Madonna is absent. Mrs Lascelles, in this portrait of muted colour, has a gentle, pensive expression, which would account for Jewell's description of her in the 1822 edition of his guidebook to Harewood as painted 'in the character of Penseroso,' another reference to Milton's popular lyric poems.

The portrait by Hoppner of Frances's brother, Edward, Viscount Lascelles, who died in 1814, recalls his invaluable contribution to Harewood as a patron of artists and collector of china. It is appropriate, therefore, that the redesigned Cinnamon Drawing Room should be so clearly influenced by the Regency period.

The faded Victorian hangings were replaced by silk hangings in a warm cinnamon brown, in a vertical anthemion design, made for Napoleon for the Palace of St Cloud in 1809, and woven in Lyons.

Pelmets of watered silk and sun curtains were based on various designs, including those of Gillow of Lancaster, and the Regency tie-backs turned up in one of the boxes in the Estate Yard. The fillet round the walls is a very fine example of Chippendale's decorative trimming, originally silvered and subsequently gilded. It has been simply cleaned for reinstatement.

The focus of interest, however, is the return of one of the pairs of Chippendale mirrors and the two years of detective work that went into their restoration. When the room was the Green Drawing Room, the Chippendale looking-glass over the chimney-piece was enclosed in a simple gilt frame, adorned with a plain crest bearing a ram's head, with two small Neo-classical heads set high on the sides. It seemed a stiff, truncated composition. In fact, Barry had denuded this frame of its decorative features and discarded the matching mirror altogether. The latter was known to be in store and the fragments of filigree and ornaments were found packed and labelled in the joiner's workshop. Once reassembled, the pair was hung in the Cinnamon Drawing Room over the Chippendale ram's head console tables with which they had been associated one hundred and fifty years before. Chippendale's drawings showed the plinths he supplied and these were copied to match.

The room is further enriched by the two Chippendale gilt tables from the Music Room, placed at either end below Reynolds's portraits of Lady Harrington and Lady Worsley. The tables are connoisseurs' pieces, highly acclaimed as outstanding examples of marquetry and the use of tinted woods, and they are in pristine condition. Ever since their delivery to Harewood House from Chippendale's workshop, they had been in place between the Music Room windows against a north wall and protected from undue exposure to light. However, their position in the Cinnamon Drawing Room offers at once easier access for visitors and their greater security. Groups of modern white Biscuit de Sèvres china stand on the tables, their pallor a sharp and effective contrast to the wealth of colour in the room. The Cinnamon Drawing Room is a notable and imaginative achievement in interior design which fulfils an eighteenth-century criterion of excellence, for it gives 'a sensible delight and pleasure'.[8]

The Rose Drawing Room situated between the Cinnamon Drawing Room and the Library began as the Lascelles's family sitting room in 1771, taking its name, the Yellow Drawing Room,

from the colour of the French silk damask hangings bought by Edwin Lascelles. During Barry's alterations it became a Billiard Room and in the 1930s the 6th Earl of Harewood and his wife, the Princess Mary, restored it as the Rose Drawing Room and there his collection of Italian Renaissance religious paintings was hung.

This room was the third in the series to be restored. During research a most unusual facet of the relationship between Edwin Lascelles and Robert Adam was brought to light. Adam's coloured design of 1768 for the ceiling, which was accepted by Lascelles, emphasised green and pink tones. Further colour annotations, however, were pencilled in the right hand margin. These were found by Alec Cobbe to indicate a considerable amount of yellow and paint scrapes of the ceiling were close in colour to the annotations. This alteration to the ceiling colours may have been made *in situ* at Harewood to comply with Lascelles's wishes for a scheme to match the yellow silk he had purchased in quantity and obviously wanted to use in the room.

A reference in a Day Work Book for September 1769 points to a similar situation. The painters, who were then working in the Hall and the Music Room, are recorded as 'laying on specimen of colours for Mr Adam's approbation', which indicates that there could be changes in an accepted design. Indeed, when the ceiling of the Music Room was repainted in 1987, traces of a lavender colour were found which exactly harmonised with the tone of Zucchi's skies in his four large wall paintings.

The ceiling of the Yellow Drawing Room is the only one to have been entirely repainted in the present programme. The cornice of cupids astride hippocampi, or sea horses, is drawn out at large in the Adam drawings, with no indication of colour. The purple that has been chosen occurs in the design for the ceiling and was also revealed by paint-scrapes. The former fillet was silver — used extensively in this room — but the Chippendale fillet re-used here is gilded in two types of gold in a dentil design. The dominant colours are pink and green; perhaps it was too late to bow to Lascelles's penchant for yellow.

The Rose Drawing room is once again the Yellow Drawing Room and historic continuity has been preserved in the yellow silk purchased for the curtains and walls, named Amberley, made to the narrow eighteenth-century width. At Newby Hall, one of the curtains for the Adam Tapestry Room has been preserved. Using

this as a guide it was possible to order the same amount of material, braid, fringe and the tammy lining, exactly as in Chippendale's time, for the two Harewood windows.

The Nollekens chimney-piece remains,[9] as does the large mirror above it, and, on the east and west walls of the room, the third restored pair of Chippendale mirrors will be hung with the remaining English pictures from the Harewood Collection.

In the Yellow Drawing Room, the sheen on the yellow silk hangings in the south-facing room and the expanse of glass in the great mirror facing the windows give the room a brilliance, enhanced by the incredible web of pattern and colour on the Adam ceiling, where the hint of gilding again catches the light. The ceiling, one of Adam's filigree confections so denigrated by Horace Walpole,[10] is a revelation of the decorative possibilities inherent in painted plasterwork and the quality of craftsmanship available today. The York firm of decorators, Hesp and Jones, hung the silk on the wall panels, and the Leeds firm of Henson and the Harewood Estate painters were responsible for the paint work.

The Gallery was essentially a room of parade where any picture that might be hung was quite incidental to the calculated impression of wealth and fashionable taste. The proposal to recreate the room according to the painting of 1827 and to replace the portraits of the family with the Italian pictures could not, therefore, offend tradition or sentiment.

There is no evidence that Edwin Lascelles himself ever bought or commissioned a single painting except family portraits. The Gallery was not finished until 1780 when Lascelles was involved with unexpectedly high expenses for landscaping the park and, in any event, galleries of family portraits were coming back into fashion. It would seem that he was probably no connoisseur of the arts and apparently no collector. His great Gallery remained a magnificent void, enriched by the skill of the craftsmen he employed rather than by his personal taste or possessions, in marked contrast with his neighbour, William Weddell, at Newby Hall.

The splendid portraits of the Lascelles family were apparently dispersed throughout the State Rooms with little consistency of plan. In 1789, for instance, Reynold's portraits of Lady Harrington and Lady Worsley were in the State Dressing Room, joined there by 1798 by his portraits of Edward, 1st Earl of Harewood, and his Countess. In 1822 there were portraits in most of the State Rooms.

The existing hang in the Gallery had been devised sixty years before in the 1930s, but altered and revised in succeeding years (fig 15). The new close hang of the Italian pictures by Alec Cobbe makes an immediate and dramatic impact. The pictures are supported on ornamental brass brackets, with no visible chains, to allow a slight tipping or canting forwards, an eighteenth-century device to allow more adequate viewing of the canvases. The bulk of the collection was bought by the 6th Lord Harewood and, faced with the wealth and variety of the Italian schools represented, any selection must be purely arbitrary. Under Titian's study of Francis I, the patron of Leonardo da Vinci, a profile illustrating the close association between medals and portraiture, is Bellini's poignant Madonna, and beside this very human treatment of the Virgin and her Child hangs an early type of candlelight picture by El Greco, a haunting and even sinister allegorical painting. Nearby there is Tintoretto's portrait of a Venetian admiral, where recent restoration has brought out with great clarity the minute details of the ethereal landscape in the background, so characteristic of this artist's work. These four paintings are placed within no more than a foot of each other and the hang of the east wall can be termed an artistic *tour de force*, especially since one of the pairs of Chippendale's mirrors is accommodated within it.

One mirror came from the late Princess Royal's sitting room, once the State Bedroom, the other was assembled from the fragments found in store. Each is now reunited with its matching side-table, again restoring a decorative unity of mirror and console table after a lapse of one hundred and fifty years.

Between them the caryatid chimney-piece attributed to Van Gelder is back in place to complete the astonishing display of virtuosity concentrated on one interior elevation. For the Dining Room, a mid-nineteenth century chimney-piece was found which is more in scale with the dimensions of the room and suitably Bacchanalian in its vinous detail (plate 16).

On the opposite side of the Gallery, the west elevation retains the four vast Chippendale pier glasses *en suite* with the tables made by his son. It is difficult in the later years of Chippendale's life to differentiate his work from that of his son, so that the four highly ornate frames above the pier glasses which contain paintings very much in the style of Angelica Kauffman are probably by Chippendale the Younger. The subjects of these mythological

decorative paintings are four different aspects of love, all in Arcadian settings and three taken from Ovid's *Metamorphoses*, a very popular source. When they were removed for cleaning and examination in 1989, they were found to be in excellent condition by the picture restorers George McTague and William Hood.

The ceiling was washed and retouched, but not repainted. There are certainly traces of later colouring, but not in the background areas of beige, pale blue and pale green. This is of major importance for it has the distinction of being one of the few Adam ceilings to survive with probably original colour.

The Venetian windows have been the subject of comprehensive restoration, with spectacular results. The full extent and design of the pier glasses and the windows themselves can be fully appreciated and the Neo-classical proportions of the Gallery are revealed, no longer muffled by Victorian drapes.

Barry removed the inner Ionic columns and substituted brackets, thus destroying the entire architectural conception of a Palladian window. The outer pilasters, or square responds, at the sides of the windows were left in place but concealed by the curtains ordered from Trollope in 1853 in 'a fair blue cloth, lined Tammy', which also screened the sides of the two adjoining pier glasses on the west wall. The effect of Chippendale's famous *trompe l'oeil* wooden pelmets, simulating material, was much reduced. In a further act of insensitivity, these were painted blue to match the curtains.

Scarlett Davis's watercolour showed that in 1827 the pelmets were a deep shade of red and paint scrapes confirmed this, so, after the Victorian curtains were removed, Chippendale's pelmets were once again painted in crimson. This gave the key note of colour for the entire room. Since no pieces of Chippendale's wall paper could be discovered, a dark crimson flock with a very large design was made, a replica of a paper found only a few years before at Nostell Priory and contemporary with Chippendale's work there. Judging from the description of the Gallery paper in his Harewood account, the Nostell copy is an excellent choice.

Wooden pillars were inserted to replace the destroyed Ionic columns in the Venetian windows and painted by Edward Bulmer in imitation of verd antique marble, and the original glazing bars were replaced in the central western window. It is the restoration of the Venetian windows which has contributed most of all to the recreation of the Gallery as Carr and Adam envisaged it (plate 12).

The unremitting attention to detail is evident throughout. Shutters had already been made for the windows to counter the winds sweeping down Wharfedale and these were given a little extra gilded trim. Blinds were now provided for the three Venetian windows, painted with a design inspired by two Adam drawings in the Soane Collection, one of the panels in the Long Gallery of Syon House, the other a motif from a design for a Gentleman's Dressing Room at Harewood. The grilles of the central heating radiators below the windows — another 1990 concession to modern comfort — were cast from Chippendale's ornamental pieces on one of the Gallery mirrors. The fillet perhaps best of all indicates the skill and resource brought into play. None of Chippendale's fillet was in its correct place; some was found in store and the lengths required were matched up and supplemented by new sections where necessary (plate 15).

Two nineteenth-century marble statues have been introduced as terminal features. They stand on specially designed plinths and are strategically placed against the light of the north and south Venetian windows to control the vistas of the parkland beyond and the *enfilade* of the rooms leading to the Gallery. Psyche, besotted, gazes northwards at Cupid along the seventy-seven foot length of the room. They are a significant addition to the Gallery as an example of the patronage of the arts by the Lascelles family over the last two hundred years. This tradition continues. Since the 1960s a series of concerts has been held each winter season in the Gallery. The room is ideally suited from a musical point of view and the setting enriches the occasion. Adam would have approved of chamber music in the Gallery as the ceiling has no cove, a feature which he believed 'forms echoes, resoundings and unjust sounds'.[11]

On the other side of the house, a rather dark general-purposes room looks into John Carr's east court. There are sinks and a large cupboard, which was once lined with lead to store coal but is now a place where electric fuse boxes quietly brood. This is all that remains of the Circular Room, designed to be one of Adam's triumphant achievements in interior decoration. But the name, the Round Room, continues to be used and this exemplifies the unbroken tradition peculiar to a great house which has remained a family home. It is in the end Harewood's most distinctive asset.

For notes to this chapter see page 182.

Notes

ABBREVIATIONS
BDEA *A Biographical Dictionary of English Architects 1660-1840*, H. M. Colvin (ed) (1978)
DBS *Dictionary of British Sculptors 1660-1851*, R. Gunnis (ed) (1968)
DEF *Dictionary of English Furniture*, R. Edwards and P. Macquoid (revised R. Edwards 1954)
DNB *Dictionary of National Biography* (1885)
HA Harewood Archives
SC Soane Collection of Adam Drawings

NOTES TO CHAPTER 1

The spelling 'Gawthorpe' has been used as found in the relevant volume of the English Place-Name Society (A.H. Smith (ed), *The Place Names of the West Riding of Yorkshire*, Part 4, English Place-Name Society, vol 33, 180-1). 'Gawthorp', however, was commonly written in most of the eighteenth-century letters and those who lived in the locality seem to have omitted the terminal 'e'. The derivation given is 'cuckoo farmstead' (ibid).

Harewood House was at first always referred as the 'New House at Gawthorp(e)' or the New Hall and the name Harewood House was not accepted until the late 1760s: Adam's drawings are a useful guide to this. Both the village and the house are elsewhere often written as 'Harwood' and there is no doubt that this must have been the customary pronunciation in the eighteenth century. The Old English element in the name is taken to be either *haer* (a rock, heap of stones) or *hara* (a hare) (ibid).

1 H.J. Habakkuk, 'England', 3-4, in A. Goodwin (ed), *The European Nobility in the Eighteenth Century* (1953, 2nd edn 1967); G.E. Mingay, *English Landed Society in the Eighteenth Century* (1963, 3rd imp 1970), 209-13; J.H. Plumb, *Men and Places* (1963), 69-75.
2 James Lees-Milne, *Earls of Creation* (1962), 103-69; Frank Jenkins, *Architect and Patron* (1961), 71-5; Rudolf Wittkower, 'The Earl of Burlington and William Kent', *York Georgian Society Occasional Paper*

Number Five (1948); Rudolf Wittkower, 'Burlington and His Work in York' in W.A. Singleton (ed), *Studies in Architectural History*, vol 1 (1954), 47-66; Ian H. Goodall, 'Lord Burlington's York "Piazza" ', *York Georgian Society Annual Report* (1970), 23-38

3 Sir John Summerson, *Inigo Jones* (1966), 43-74, 113-20; James S. Ackerman, *Palladio* (1966), 50-4, 75, 78, 185; Hugh Honour, *Neo-classicism* (1968), 22.

4 Frank Jenkins, op cit, 76-80, 91-3.

5 Sir Lewis Namier and John Brooke, *History of Parliament, The House of Commons 1754-1790*, vol 3 (1964), 23.

6 Richard Pares, 'A London West India Merchant House, 1740-69', in R.A. and E. Humphreys (eds), *The Historian's Business and Other Essays* (Oxford, 1961), 198-226.

7 Habakkuk, op cit, 16; Mingay, op cit, 26-8.

8 'The Gascoigne Family', *Leeds Arts Calendar*, no 64 (1969), 4-5, initials A.W-C; C.V. Wedgwood, *Strafford 1593-1641* (1935), 192; John Jones, *History and Antiquities of Harewood* (1859), 265-6. Estate valuation by Carr 1739, £63,827.

9 Jones, op cit, 145-6, 290-1; G.E. Cokayne, *The Complete Peerage*, vol 7 (1929), 444-9.

10 Pares, op cit, 198, 224-5.

11 James A. Henretta, *'Salutary Neglect', Colonial Administration under the Duke of Newcastle* (Princeton, 1972), 45, 228-9, 230-1, 247-75.

12 A. Gooder (ed), 'The Parliamentary Representation of the County of York, 1258-1832', *Yorkshire Archaeological Record Series*, vol 2, XCVI (1938), 108-9, 146, 149; Namier and Brooke, op cit, 22-3; Mingay, op cit, 263-4.

13 Sir Lewis Namier, *England in the Age of the American Revolution* (2nd edn, 1961), 235-40; Namier and Brooke, op cit, 23.

14 Arthur Raistrick and John L. Illingworth, *The Face of North-West Yorkshire* (1959, repub 1965), 62-3.

15 Raymond Williams, *The Country and the City* (1973), 120-6; Kenneth Woodbridge, *Landscape and Antiquity* (Oxford, 1970), 25, 64-5.

16 Arthur Raistrick, *The West Riding of Yorkshire* (1970), 104-5; Raistrick and Illingworth, op cit, 22.

17 Sir Kenneth Clark, *The Gothic Revival* (1964), 34-7.

18 Calendar Patent Rolls, vol XIII, 1912, 335, 40 Edward III 27 December 1366.

19 John H. Harvey, *English Medieval Architects: a Biographical Dictionary down to 1550* (1984), 181-4.

20 John Jewell, *The Tourists' Companion or the History and Antiquities of Harewood in Yorkshire* (1819, 2nd edn 1822, Leeds), 19-2 (Guidebook to Harewood House).

21 John Jewell, ibid, 102.

22 David Black, 'Harewood Castle' in the *Archaeological Journal*, vol CXXV (1968), 339.

Forum, Council of British Archaeology, West Yorkshire Archaeological Society (1985), 10-15.

ibid, 1989, Steven Moorhouse, 4-7.

23 E. Hargrove, *History of the Castle, Town and Forest of Knaresborough with Harrogate* (4th ed 1789), 157.

24 William Brigg (ed), 'The Parish Registers of Harewood, Co. York', Part 1, *Yorkshire Archaeological Society, Parish Register Section*, vol 50 (1914), preface, 9 Oct 1748.

25 SC vol 50, 86.

26 For the restoration of these monuments, see Pauline Routh and Richard Knowles, *The Medieval Monuments of Harewood* (Wakefield, 1983), passim.

27 John Jones, *The History and Antiquities of Harewood* (1859), 97-8.

28 Tancred Borenius, *Catalogue of the Pictures and Drawings at Harewood House ...* (Oxford,1936), Intro V.

29 Raistrick and Illingworth, op cit, 22.

30 Tom Bradley, *The Old Coaching Days in Yorkshire* (Leeds, 1889; repub Wakefield, 1968), 11-12, 47, 59, 139-47.

31 *York Courant*, 12 March 1763.

32 For Lunardi's balloon *see* Elizabeth Burton, *The Georgians at Home* (1967), 304-5.

33 Baron Duckham, *The Yorkshire Ouse* (Newton Abbot, 1967), 78-81; *Bradshaw's Canals and Navigable Rivers of England and Wales* (1904; repub Newton Abbot, 1969), 439.

34 T.S. Ashton, *Economic Fluctuations in England 1700-1800* (Oxford, 1959), 21.

35 Ibid, 87-91, 96-103, appendix table 12.

36 W.G. East, 'England in the Eighteenth Century' in H.C. Darby (ed), *An Historical Geography of England before 1800* (Cambridge, 2nd edn 1967), 509.

37 E.W. Gilboy, *Wages in Eighteenth Century England* (1934), 176-9 and Appendix 2, Tables X and XI.

38 Ibid, 219-26; W.E. Minchinton (ed), *Wage Regulations in Pre-Industrial England* (1972), 116-19, 124-5.

39 Mingay, op cit, 81-3.

40 Sir J. Steven Watson, *The Reign of George III 1760-1815* (Oxford, 1960), 288, 375; Ashton, op cit, 90 note 12.

41 Nathaniel Lloyd, *A History of English Brickwork* (1925), 11.

42 C.F. Innocent, *The Development of English Building Construction* (1916; reprinted Newton Abbot, 1971), 270.

43 Ashton, op cit, 159.

44 Derek Linstrum, *West Yorkshire; Architects and Architecture* (1978), 32,

74 gives an earlier date for the stables; he quotes a perspective view of the 'Stables at Gawthorp built by Edwin Lascelles, Esq'r, 1748' (Wakefield Art Gallery and Museum, Drawings and Engravings).

45 Sir Richard Sykes, Bt, *Sledmere House* nd, 2-3.

46 Edwin Lascelles to Richard Sykes, 21 April 1755, Sykes Letters. See also, Edwin Lascelles to William Gossip of Thorp Arch, 18 October 1755 for advice on building, TA/23/3. I am grateful to Mr B.L. Harrison for letting me see his unpublished study on Thorp Arch.

47 Richard Sykes to Edwin Lascelles, 27 April 1755, op cit.

48 John Harris, *Sir William Chambers* (1970), plate 43.

49 Ibid, 210.

50 The death of Robert Carr in December 1760 led to the appointment of William Belwood of York as Clerk of the Works, BDEA, 106-7.

51 Sir Nikolaus Pevsner, *Yorkshire. The West Riding* (1959, 2nd edn 1967, revised Enid Ratcliffe), 221-2. Goldsborough was not definitely on the market until 1759 but Daniel Lascelles does seem to have been in possession by February 1762. He died in 1784 and the Hall remained in the family until the 1930s. He did not purchase Ribston Hall.

52 Norris had worked at Cusworth Hall near Doncaster and may have been one of a 'school' of building and decorative craftsmen in that area; several were later employed at Harewood House. See Chapter 3 note 24.

53 Horatio F. Brown, *Inglesi e Scozzesi all' Universita di Padova dell' anno 1618 sino al 1765* (Venezia, 1921), 211, 1986, 1 Oct 1738. My thanks are due to Dr Derek Linstrum for this reference and to Dr Terry Friedman for making his copy of the Register available to me.

54 James Hall, *A History of Ideas and Images in Italian Art* (1983), 247. Christopher Hibbert, *The Grand Tour* (1987), 118-9. J. G. Links, *Canaletto and His Patrons* (1977), 25, 36.

55 James S. Ackerman, op cit, 61, 80, 168-70; Sir John Summerson, 'The Classical Country House in Eighteenth Century England', *Journal of the Royal Society of Arts*, vol 107 (1958), 539-86.

56 Mingay, op cit, 160-61, 219-20.

57 Sir John Summerson, *Architecture in Britain 1530-1830* (1953), 247-8; see also J.W. Johnson, *The Formation of English Neo-classical Thought* (Princeton, 1967), 84-90, 94-5.

58 Summerson, op cit, 248-50; Harris, op cit, 20, 25-9; Honour, op cit, 18-25.

59 Harris, op cit, 1-4 and Chapter 2 passim.

60 J. Arthur Cash, *Laurence Sterne, the Early and Middle Years* (1975), 53-9, 182-5, 188, 193. (Note that Edwin Lascelles did not marry Anne Chaloner, 58.)

61 Ibid, 185, n2

62 Harris, op cit, 20, 209; Chambers Letters, RIBA, John Hall Stevenson to

William Chambers 3 November 1755 (CHA/2/4).

63 Ibid, Edwin Lascelles to William Chambers, 20 June 1756 (CHA/2/4).

64 Lees-Milne, op cit, 221-63.

65 As note 48.

66 Harris, op cit, plates 44 and 45, 40 and 209.

67 Chambers's plan for the base storey is HA Portfolio Misc; Plumb, op cit, 151.

68 Harris, op cit, 43; also quoted in BDEA 204-9.

69 Dorothy Stroud, *Capability Brown* (Country Life, 1950; revised edn, 1975), 105-6.

70 R.G. Wilson, *Gentlemen Merchants, the Merchant Community of Leeds 1700-1830* (Manchester, 1971), 70.

71 BDEA 189-96; Paul Breman and Denise Addis, *Guide to Vitruvius Britannicus* (New York, 1972), 25-7; R.B. Wragg, 'John Carr of York', *Journal of the West Yorkshire Society of Architects (Leeds)*, vol 17 (December 1957 and March 1958); Mr Wragg discusses the presumed relationship between Carr and Edwin Lascelles for which there is no definitive evidence. The extract from the College of Arms (929.1 York Reference Library) shows that John Carr's mother, Rose Lascelles, was the daughter of John Lascelles Gentleman of Norton-in-the-Clay, a village about twenty-five miles north-west of York; but a search of the relevant parish registers has failed to give me any evidence that she belonged to the Harewood branch of the family. The name is widespread throughout the area; R.B. Wragg, 'John Carr: Gothic Revivalist', in W.A. Singleton (ed), *Studies in Architectural History*, vol II (1964), 14-15, refers to Carr's designs in a gothic style for landscaped features at Plompton and Harewood and it seems that an elevation for the 'Castle Idea' submitted for the new house at Gawthorpe is Carr's work; I. Hall, 'John Carr: A New Approach', *York Georgian Society Annual Report* (1972), 18-28, puts forward a means of identifying Carr's building which is consistent with the attribution of both the stable block and the above-mentioned design for Harewood House to Carr, see note 38; 'The Works of Architecture, John Carr', a list prepared by the *York Georgian Society* (1973).

72 This architect remains unidentified. The name does not recur in the Harewood building papers after 1756.

73 John Fleming, *Robert Adam and His Circle in Edinburgh and Rome* (1962), 249, 257.

74 Robert Adam to James Adam, 17 June 1758, Clerk of Penicuik Muniment vol II, Adam Papers, Scottish Record Office, GD 18/4848.

75 James Adam to Robert Adam, 25 June 1758; ibid, GD 18/4849.

76 Robert Adam to James Adam, 5 September 1758; ibid, GD 18/4852.

77 Adam's elevations for the North and South Fronts, SC vol 35, nos 5, 6; his plans for the three storeys, SC vol 35, nos 7, 8, 9 of which that for

the principal floor is here reproduced as fig 5; three plans exist to illustrate the intermediate stages in finding a compromise between the designs of Carr and Adam, two in the Harewood Archives and a third printed and discussed in A.T. Bolton, *The Architecture of Robert and James Adam*, vol I (1922), 161 and 168-9, and then in the possession of Mr Walter Brierley, the York architect.

78 The plan probably accepted by Lascelles is reproduced as fig 6.

79 R. Adam and J. Adam, *The Works in Architecture of Robert and James Adam* (1768; reprinted and published by Thézard Fils, Dourdain, 1900), vol I, no I, plate V; see Bolton, op cit, 246 and 247 (footnote).

80 R. and J. Adam, op cit, 8-9.

Notes to Chapter 2

1 Sir John Summerson, *Georgian London* (1945; revised edn 1962), 65-6.

2 Isaac Ware, *A Complete Body of Architecture ...* (1756), 108, 274-88, plate 30.

3 Ibid, 95.

4 J.H. Plumb, op cit, 78, writes 'one lavatory was thought sufficient for the huge house at Harewood'.

5 Ware, op cit, 328.

6 For the making and use of bricks see Lloyds, op cit, especially 29, 22-37, 51-6, 65; Innocent, op cit, Chapter 10, especially 152-4; Alec Clifton-Taylor, *The Pattern of English Building* (1962), 205-41.

7 Ibid, 22.

8 Nehemiah Curnock (ed), *The Journal of the Rev John Wesley*, vol 6 (1909), 232.

9 William Brigg (ed), 'The Parish Registers of Harewood Co. York', op cit, passim.

10 Clifton-Taylor, op cit, 73, 78, 144, 145.

11 H C Portfolio Misc.

12 The staircase was reconstructed by Sir Charles Barry during the nineteenth-century alterations — see Chapter 6; Bolton, op cit, 169, 173, comments on Adam's plan for a similar staircase of a central flight branching into returns.

13 Ware, op cit, 333.

14 Eileen Harris, *The Furniture of Robert Adam* (1963) 20-1, 63-4, and plates 3, 4. Adam's design for the 'new' Dining Room, SC vol 35 no12; ceiling vol 11 no134. See figs 17, 18.

15 See Sir J. Steven Watson, op cit, 20-2, 84-7 for the threat to British West Indian trade during the negotiations which preceded the Peace of Paris, 1763; P. Breman and D. Addis, op cit, 24, for the house as finally planned by Carr after 1762.

16 Clifton-Taylor, op cit, 29; Gordon Jackson, *Hull in the Eighteenth Century* (Oxford, 1972), 39-41.

17 Charles Hadfield, *The Canals of Yorkshire and North-East England* (Newton Abbot, 1972), vol I, 100-1; F. Lewis Hinckley, *Directory of the Historic Cabinet Woods 1460-1900* (New York, 1966), 118-33.
18 Ashton, op cit, 89-90 and Table no 12, 189; Clifton-Taylor, op cit, 332-3; Innocent, op cit, 279.
19 Clifton-Taylor, op cit, 333; Margaret Whinney, *Wren* (1971), 149-50.
20 W. Wheater, *Some Historic Mansions of Yorkshire* (Leeds, 1888), 103.
21 Ware, op cit, 87-9.
22 Clifton-Taylor, op cit, 315-18.
23 Geoffrey Beard, *Georgian Craftsmen and Their Work* (1966), 182.
24 This is the case for instance at Cusworth Hall, near Doncaster.
25 Geoffrey Beard, op cit, 70 and 188-9, where the Rose's account for their plasterwork at Harewood House is printed in full; see also Geoffrey Beard, 'The Rose Family of Plasterers', *Leeds Arts Calendar*, no 54 (1964); for Henderson and Rothwell see Beard, *Georgian Craftsmen*, 167, 170; R.B. Wragg, 'Some Notes on Eighteenth Century Craftsmen', *York Georgian Society Annual Report (1955-6)*, 58-60.
26 Jackson, op cit, 39-41.
27 Sir William Chambers, *A Treatise on the Decorative Part of Civil Architecture* (3rd ed 1791), ii.

NOTES TO CHAPTER 3
1 Sir William Chambers, op cit, i.
2 J. Woolfe and J. Gandon (eds), *Vitruvius Britannicus* (1771), vol V, 4-5.
3 SC vol 21, no 148.
4 Robert Adam to James Adam, 24 July 1760; Clerk of Penicuik Papers, GD18/4866, op cit.
5 J.H. Jesse (ed), *George Selwyn and his Contemporaries* (1901), vol I, 396-8.
6 Honour, op cit, 27-8.
7 Lees-Milne, op cit, 123; Hall, op cit, 21-2.
8 James Lees-Milne, *The Age of Adam* (1947), 55; Sir John Summerson, *Architecture in Britain 1530-1830* (1953), 270.
9 Ibid, 261-4.
10 SC vol 35, nos 11 and 15.
11 SC vol II, nos 135-7.
12 SC vol 23, no 256.
13 Gervase Jackson-Stops and James Pipkin, *The English Country House: A Grand Tour* (1985), 201, 204-6. Malise Forbes Adam has identified the subjects of these paintings and questions their attribution to Rebecca. She has most generously discussed her findings with me.
14 E. Hargrove, op cit, 155, quoted by Jewell, op cit, 25.
15 Nicholas Penny ed. *Reynolds*, Catalogue of Exhibition (1986), 229, no 61.

16 Edward Croft-Murray, *Decorative Painting in England*, 1537-1837, vol 2 (1970), 52.

17 Ibid, 296-7. The decorative painting on the ceiling is here ascribed to Rebecca, on the evidence of Jewell, op cit 35. Damie Stillman, *The Decorative Work of Robert Adam* (1966), 70 no32 gives Zucchi for the larger paintings and possibly for the insets also. Notably, E. Hargrove op cit 152 states that all the decorative painting in the Music Room is by Zucchi. Geoffrey Beard, *The Work of Robert Adam* (1978), 60 quotes Jewell and mentions attribution to Kauffman, but stylistically favours Zucchi. By comparison with Zucchi's known work, therefore, the ceiling of Harewood House may with some confidence be attributed to Antonio Zucchi.

18 A. Stephenson, 'Chippendale Furniture at Harewood House', *Furniture History*, vol 4, 64.

19 SC vol 22, nos 177 (1766), 178 (1769), 179 (1769), 180 (1770).

20 Beard, op cit, 68, 83; J. Harris, op cit, 217-8.

21 SC vol 11, no 168 (1765).

22 SC vol 11, no 169 (1765).

23 SC vol 11, nos 170, 171 (1769); John Jewell, op cit, 28.

24 Beard, op cit, 188-9.

25 Clifford Musgrave, *Adam and Hepplewhite Furniture* (1966), 92; Jewell, op cit, 28.

26 Ivan Hall, 'The Engravings of Thomas Chippendale Jnr 1779' in *Furniture History*, vol XI (1975), 57.

27 SC vol 22, nos 199 (1774), 201 and 202 (11 June 1771), 203 and 204 (13 June 1771); other designs for this chimney-piece are nos 200, 205 and 206.

28 Wragg, op cit, 61; for Richardson only see DBS, 319; Beard, op cit, 61 (note 2). Richardson worked on the external carving (see page 55).

29 Beard, op cit, 94; Wragg, op cit, 61.

30 Ibid, DBS, 384.

31 Jewell, op cit, 27; Bolton, op cit, 175 quotes the source as Anon, *Tour of the Western Highlands*, 1787.

32 Jill I. Low, 'William Belwood, Architect and Surveyor' in *Yorkshire Archaeological Journal*, vol 56 (1984), passim, but especially 132.

33 SC, vols 35, 53, 11, 22.

34 SC, vol 11, nos 158-161; no 161 shows the colouring indicated in pencil as areas A, B, C. For the importance of these indications, see Chapter 8, on the restoration of the Yellow Drawing Room.

35 Robert Morris, *Select Architecture* ... (1755), preface. Plate 23 resembles Harewood House; John Carr's copy in Sir John Soane's Museum is marked with his own sketches on certain pages.

36 SC vol, 50 nos 87, 88.

37 SC vol 11, nos 120, 149.

38 SC vol 14, no 121, vol 11, no 148, dated 1767. Two designs for the
 Painted Breakfasting Room at Kedleston Hall are very similar, both
 dated 1768, see L. Harris (ed) *Robert Adam at Kedleston* (1987) 56-7.
39 For the influence of James 'Athenian' Stuart on Adam's painted
 rooms, see E. Harris, op cit, 15-16; Musgrave, op cit, 31.
40 SC vol 20, nos 71 and 72 (for the Circular Room) and nos 73 and 74. This
 room has been referred to throughout as 'the Circular Room', but it
 was also the Round Room and the Octangular Room. This last name
 refers correctly to the shape of the room (see figs 6, 7); Bolton, op cit,
 162, shows the room as the Lady's Dressing Room, a circular apart-
 ment, but both the use of the term 'octangular' on occasion in the
 building accounts, and the plan as published in 1771 (fig 7) leave no
 doubt that the room as built was not circular.
41 See Bolton, op cit, 168 for illustration of an Adam drawing for the
 balustrade, Richardson Collection, Victoria & Albert Museum.
42 Beard, op cit, 174.
43 Lees-Milne, op cit, 172; Musgrave, op cit, 166.
44 For John Brown see Chapter 4 note 27.

NOTES TO CHAPTER 4
1 Anthony Coleridge, *Chippendale Furniture* (1968), 73-83.
2 Ibid, 91-3 and Appendix B.
3 Christopher Gilbert, *The Life and Work of Thomas Chippendale*, 2 vols
 (1978), vol 1, 195-220, vol 2 passim. This is the definitive work on
 Chippendale furniture at Harewood House. See also C. Gilbert, 'Chip-
 pendale's Harewood Commission', *Furniture History*, vol IX (1973), 1-
 32. The furniture has also been illustrated and described in numerous
 other works, eg DEF; M. Jourdain and F. Rose, *English Furniture, the
 Georgian Period 1750-1830* (1953); R.W. Symonds, 'Adam and Chippen-
 dale: A Myth Exploded', *Country Life Annual (1958)*, 53-6, suggested
 that although Adam influenced Chippendale, he did not work in
 partnership with him, a theory further examined notably by Dr Eileen
 Harris, *The Furniture of Robert Adam* (1963) and accepted in principle
 since this publication. Coleridge, op cit and Musgrave, op cit, offer a
 comprehensive survey of Chippendale's furniture at Harewood.
4 Ivan Hall, 'Neo-Classical Elements in Chippendale's Design for the
 Director of 1762', *Leeds Arts Calendar*, no 65 (1969), 18; 'Newly Discov-
 ered Chippendale Drawings Relating to Harewood', ibid no 69 (1971)
 5-17; Anthea Mullins, 'Local Furniture Makers at Harewood House',
 Furniture History, vol I (1965), 32-8; Anthea Stephenson, 'Chippendale
 Furniture at Harewood', ibid vol IV (1968), 62-9. Geoffrey Beard (ed),
 'The Harewood Chippendale Account 1772-7', ibid, 70-80.
5 E. Harris, op cit, 27.
6 Musgrave, op cit, 78-82; Coleridge op cit, 121-3.

7 E. Harris, op cit, 102, no 141. SC vol 49, no 55, Vase for Entrance Hall, 1778.

8 L. Boynton and N. Goodison give the full text of this letter 'Thomas Chippendale at Nostell Priory', *Furniture History*, vol 4 (1968), 16.

9 E.A. Entwisle, *The Book of Wallpaper* (1954; reprinted Kingsmead, Bath 1970), 31-41, 61-2.

10 Damie Stillman, op cit 25; Robert Adam to James Adam in Rome 8 Feb 1762 concerning painted ceilings at Herculaneum and Zucchi's copies of these. Clerk of Penicuik Papers, op cit, GD18/4926.
 James Adam in Rome to Robert Adam, 4 December 1762, ibid GD18/4949.
 Robert Adam in London to James Adam, ibid GD18/4853.
 James Adam in Venice to Robert Adam, 25 June 1760, ibid, GD18/4861.

11 Compare Coleridge op cit, 142, 143. It was quite usual for a patron to supply some of his own materials especially where these luxury articles carried heavy import duty.

12 Anon, *A Tour from Cambridge* ... (c1796), op cit, 29.

13 DEF vol 2, 325, 350-3; C. Gilbert, op cit, vol 1, 197; Jewell, op cit, 29.

14 DBS, 111-12.

15 J.H. Plumb, op cit, 76; see note 10, Chapter 6.

16 L. Boynton, 'The Bed-bug and the Age of Elegance', *Furniture History*, vol I (1965), 15-31.

17 This D-shaped stool was acquired by the Chippendale Society, 1988, see Christie's catalogue of the Harewood House Sale, 3 October 1988, lot 172, no 477. cf Gilbert, op cit 41, vol 1, 210.

18 The Travel Journals of Elizabeth, 1st Duchess of Northumberland, September 1771. Victoria and Albert Museum transcript, ref 121/26. I am indebted to Mr Christopher Gilbert for this valuable source.

19 Letter of Francis F Foljambe of Aldwark to his father-in-law, John Hewett, 28 Jan 1799, in Bulletin No 21 (1981) of the Local History Study Section of the Yorkshire Archaeological Society, by permission of J.B.T. Foljambe and Nottinghamshire County Record Office. Research by Barbara Nuttall.

20 Wheater, op cit, 105; Tate Wilkinson, *The Wandering Patentee* (York, 1795), vol I, 187.

21 Travel Journals, 1771, op cit. See also Lady Victoria Percy and Gervase Jackson-Stopes, *Country Life*, CLV, 31 Jan, 7 and 14 Feb 1974.

22 Ibid. Mary Hewit was paid £8 8s a year with board.

23 R. Rowe, 'A Neo-Classical Masterpiece' *Leeds Arts Calendar*, no 58 (1966), 6-12.

24 DEF vol 3, 360; see note 10, Chapter 6.

25 C. Gilbert op cit vol 1, 198-9. In private ownership, exhibited Leeds Art Gallery, Temple Newsam House, Thomas Chippendale Bi-centenary

Exhibition, Nov 1979, Catalogue No 38.

26 For billiard tables, see DEF vol 3, 190; Gillow and Son of Lancaster and London specialised in this branch of cabinet-making; the local carrier Brumfit delivered the table to Harewood House in February 1772 (HA).

27 C. Gilbert, op cit, vol 1, 203. Brown the gilder is possibly Richard Brown, who valued the gilding done for Sir Lawrence Dundas; see A. Coeridge, op cit, 144.

28 R. Campbell, *The London Tradesman* (1747; reprinted 1969), 170-1.

29 Jenkins, op cit, 131-5.

30 Gilboy, op cit, 283, Table XI, Appendix 2.

31 Robert Adam to James Adam, 8 February 1762. Clerk of Penicuik Papers, op cit, GD18/4926.

32 For Zucchi, see Croft-Murray op cit 53-4, 296-7; Rebecca, ibid 54, 258-60; Borganis, ibid 54 and Damie Stillman op cit, 46; Chapter 2, 20.

33 Sir Henry Steuart Bt, *The Planter's Guide* (Edinburgh and London, 2nd edn, 1828), 8.

34 John H. Harvey, 'The Family of Telford, Nurserymen of York', *Yorkshire Archaeological Journal*, 42 (1969), 352-7; John H. Harvey, *Early Gardening Catalogues* (1972), 30-4.

35 Travel Journals, 1771, op cit.

36 Jewell, 1819, op cit, 42.

37 Jackson, op cit, 256-7. For Thomas White, see Steuart, op cit, 223-4, 487-8.

38 Stroud, op cit, 98, 147, 164, 213, plates p179.

39 Wheater, op cit, 105-6. A balanced contemporary appreciation is given in Forrest's Tours, BM Add Mss, 42, 232.

NOTES TO CHAPTER 5

1 *The Gentleman's Magazine* (1795), 172.

1 *Leeds Intelligencer*, 2 February, 1795.

3 Jones, op cit, 296-7; Namier and Brooke, op cit, 22.

4 Cust Archive ZBM 168, North Yorkshire County Record Office. Edwin Lascelles writing from Harewood House, 23 August 1785.

5 Will of Edwin Lascelles, Lord Harewood, 17 March 1790 proved 12 February 1795. His estimated annual income was about £46,000 of which £30,000 came from landed property (HA): Cockayne vol 6, 310-14, landed estate in 1883 valued at about £38,000. See below, note 15.

6 Rev. Richard Warner, *A Tour through the Northern Counties of England and the Borders of Scotland*, vol I (Bath, 1802), 241-2.

7 Grove, Sir George, *Dictionary of Music and Musicians*, Eric Blom (ed) vol 7 (5th ed, 1954), 23; vol I. 373.

8 Ibid vol 2, 294. None of this family is however mentioned as a singer.

9 Tate Wilkinson, *Memoirs of His Own Life*, vol I (York, 1790), 198; *Leeds*

Intelligencer, 28 June 1774 and 18 July 1775.

10 Ellis Waterhouse, *Painting in Britain 1530-1790* (1953; 3rd ed, 1969), 159-60, 215, 222. See DNB, vol 9, 1237 John Hoppner, for the portrait of Henrietta 2nd Countess of Harewood now in the Cinnamon Drawing Room of Harewood House.

11 John Steegman, *Victorian Taste* (1950, republished 1970), 62-4 for discussion of the roles of patron, connoisseur and collector.

12 James Greig (ed), Joseph Farington, *The Farington Diary* (1923-8), vol I, 137-8.

13 Messrs Christie, Manson and Woods have been unable to trace Lord Harewood's purchases or to identify his references to the Nagel Sale.

14 Hugh Tait, 'Sèvres Porcelain in the collection of the Earl of Harewood' in *Apollo Magazine* (June 1966), 437-8, 440-1

15 Farington, op cit, vol I (Nov 1795), 100-1.

16 Tancred Borenius, op cit, Introduction V-VII: Andrew Wilton, *Turner and the Sublime* (1980), 23-4, David Hill, *In Turner's Footsteps: Through the Hills and Dales of Northern England*, (1984), 13-14, 120; see Martin Hardie, *Water Colour Painting in Britain*, vol 2, *The Romantic Period* (1967), 1, 7, 26 for Viscount Lascelles's perceptive appreciation of Girtin's work in preference to Turner's; for John Varley at Harewood, see ibid, 99; also T. Borenius, op cit, 189, no 475 and Introduction V-VII.

17 Dorothy Stroud, *Humphry Repton* (Country Life, 1962), 99-100; see also Bryan E. Coates, 'Park Landscapes in the East and West Ridings in the Time of Humphry Repton', *Yorkshire Archaeological Journal*, part 63 (1965), 465-80.

18 Stroud, op cit, 100-1. Possibly Adam's former entrance was adapted to the new site.

19 Mrs Edwin Gray, *Papers and Diaries of a York Family 1764-1839* (1927), 164-5.

20 Jones, op cit, 188-90.

21 Christopher Hibbert (ed), Louis Simond, *An American in Regency England: the Journal of a Tour in 1810-1811* (1968), 111.

22 Ibid, 113.

23 Ralph Edwards and Margaret Jourdain, *Georgian Cabinet-makers* (Country Life, 1944), 63.

24 See DBS, op cit, 145-6; Wragg, op cit, 62-5; Jewell, op cit, 26.

25 Robert Rowe, op cit, Chapter 4, note 17. The desk is now at Temple Newsam House, Leeds.

26 Ward Jackson, op cit, 21-30, nos 17, 220, 331; Jewell, op cit, 21; Anthea Mullins, *The Building and Furnishing of Harewood House, 1755-1853* (University of Leeds MA Thesis, unpub 1966) 152-68. This deals fully with Regency furniture at Harewood.

27 For the political career of Henry Lascelles, 2nd Earl of Harewood, see Gooder (ed), op cit, 112-14, 153-4; Wilson, op cit, 103-4, 169-70, 173, 177.

28 Jones, op cit, 190-1.
29 Borenius, op cit, no 365, plate LI. This portrait is in the Dining Room
 of Harewood House. Both Turner and Girtin lent water colours of the
 house to Lawrence, who apparently relied on Girtin's 'Harewood
 House from the South West' for the background, see Borenius, op cit,
 no 307, plate XLI. This watercolour by Girtin now hangs in the Princess
 Royal's Sitting Room.

NOTES TO CHAPTER 6

1 Derek Linstrum, *Sir Jeffry Wyatville* (Oxford, 1972), 53-60; BDEA, 136-
 40.
2 Mark Girouard, *The Victorian Country House* (Oxford, 1971), 1-29.
3 P.W. Kingsford, *Builders and Building Workers* (1973), 13-20.
4 Rev Alfred Barry, *The Life and Times of Sir Charles Barry RA* (1867), 117;
 Girouard, op cit, 31-2; for conditions in the building industry, see
 Kingsford, op cit, 63, 67.
5 Sir Nikolaus Pevsner, *Some Architectural Writers of the Nineteenth
 Century* (Oxford, 1972), 70-1, 77.
6 The sculptor was John Thomas who was responsible for the stone
 carving in the new Houses of Parliament; DBS, 388-90.
7 SC vol 11, no 167.
8 Kenneth R. Towndrow, *Alfred Stevens* (1939), 113.
9 Richard Buckle, *Harewood, a New Guide to the Yorkshire Seat of the Earls
 of Harewood* (Derby, 1972), 25.
10 These eighteen chairs are now in the Music Room (see plate 18) with
 the two sofas and the pair of bergères, similarly covered in Beauvais
 tapestry.
11 An example of the way in which Chippendale's ornamental work has
 been so re-used and taken out of its original context as almost to defy
 recognition. See Chapter 8, The Cinnamon Room.
12 Pevsner, op cit, *Yorkshire. The West Riding*, 259.
13 *Leeds Directories*, 1839, 1861.
14 Borenius, op cit, 163, no 402.

NOTES TO CHAPTER 7

1 See DNB, vol 1941-50 (OUP, 1958), 483-4 for short biography of Henry
 Lascelles, 6th Earl of Harewood.
2 James Pope-Hennessy, *Queen Mary 1867-1953* (1959), 519-21, gives an
 interesting account of their engagement and marriage.
3 Ibid, 333, footnote and 408.
4 Maurice Craig, 'Portumna Castle' in *The Country Seat, Studies in the
 History of the British Country House* no 6 presented to Sir John Summerson
 on his sixty-fifth birthday (1970), 36-41. Viscount Lascelles was, how-
 ever, the grand-nephew not the grandson of the Earl of Clanricarde.

5 Tancred Borenius, op cit, passim.
6 See DEF, vol I, 66 for the preference of George III and Queen Charlotte for a portable tent-bed.
7 SC vol 11, no 138 (1766), ceiling design for Edwin Lascelles's Study; SC vol 53, no 32 (a) design for friezes for Dressing Room.
8 Arthur Young, *A Six Month's Tour through the North of England*, vol I (1770), 143, has a description of Lady Strafford's Bird Closet in Wentworth Castle.
9 Richard Gill, *Happy Rural Seat: The English Country House and Literary Imagination* (New Haven, 1972), gives in the introduction to his main theme enlightened comment on the historical and contemporary significance of the English Country seat, 3-18.

NOTES TO CHAPTER 8
1 Geoffrey Beard, ibid, 10, and *Georgian Craftsmen* (1966), 76.
2 L.O.J. Boynton, 'Sir Richard Worsley's Furniture at Appuldurcombe Park' in *Furniture History*, vol I (1965), 42.
3 Desmond Shawe-Taylor, *The Georgians; Eighteenth-Century Society and Portraiture* (1990), 156-60.
4 Ibid 156. The portrait of Lady Harrington is in the Henry E. Huntingdon Library and Art Gallery, San Marino, USA.
5 Fanny Burney, *Diary and Letters of Madame D'Arblay*, edited Charlotte Barrett, with preface and notes by Austin Dobson, 1904: Journal from Bath, 1 Nov 1782, 112.
6 Sir Richard Worsley, *DNB*, vol 63, 36-7.
7 Penny, Reynolds Catalogue op cit, 389, no 203; for the portrait of Mrs Edward Lascelles and her infant daughter, ibid..
8 David Hume, *Treaties on Human Nature II*, 1739, quoted in Bernard Denvir, *The Eighteenth-Century: Art Design and Society*, 1689-1789 (1983), 75.
9 Joseph Nollekens: DBS 276-70. His name as 'Nolekins' is written across the drawing, Soane Collection vol 22, 198. He also sculpted a relief of Psyche and Cupid (for Harewood House) given as his Diploma work for the Royal Academy, 1773 (Council Minutes, vol 1, 153). The tondo is in the Royal Academy.
10 Horace Walpole to Sir Horace Mann, 22 April 1775, *The Letters of Horace Walpole*, ed Mrs Paget Toynbee (Oxford, 1903-5), vol IX, 186, quoted Damie Stillman, op cit 17.
11 Robert Adam to Miss Nelly Adam, Leghorn, 23 Jan 1755, Clerk of Penicuik Papers, op cit, GD18/4761.

Select Bibliography

MANUSCRIPT SOURCES

Unless specifically mentioned in the text, all the sources quoted are from the Harewood Collection in the Archives Department of Leeds City Libraries at Sheepscar, Leeds. Lists of these references have been deposited with the Archives Department and the Reference Library of Leeds Central Library. Some of the Collection may be on exhibition at Harewood House, but no indication has been given where a particular item has been selected for this purpose.

The Adam drawings for Harewood House in the Adam Collection, Sir John Soane's Museum, London, are a major primary source.

Other documentary sources used in this study include

Clerk of Penicuik Papers, Scottish Record Office, Edinburgh

Cust Archive, North Riding Record Office

Letters of Sir William Chambers, RIBA Manuscripts

Letters and Papers of the Sykes family of Sledmere House, East Yorkshire.

PRINTED PRIMARY SOURCES

Adam, R. and J. *The Works in Architecture of Robert and James Adam, Esquires* (1778; reprinted & published Thézard E. Fils, Dourdain 1900; R. Oresko (ed) 1975).

Campbell, A. *The London Tradesman* (1747: reprint Newton Abbot, 1969).

Chambers, Sir William. *A Treatise on the Decorative Part of Civil Architecture* (3rd edn, 1791).

Chippendale, Thomas. *The Gentleman and Cabinet-Maker's Directory* (3rd edn, 1762: reprint New York, 1966).

Farington, J. in Grieg, J. (ed), *The Farington Diary*, vol I (1923-8).

Gray, Mrs E. *Papers and Diaries of a York Family 1764-1839* (1927).

Hargrove, E. *History of ... Knaresborough with Harrogate* (Knaresborough, 4th edition 1789).

Ismay, J. 'A Visit to Chapel Allerton at Harewood in 1767', *Thoresby Society Publications*, vol 37 (Leeds, 1945).

Jesse, J.H. (ed), *George Selwyn and His Contemporaries*, vol I (1882, 1901).

Jewell, J. *The Tourist's Companion or the History and Antiquities of Harewood in Yorkshire* (Leeds 1819, 1822).

Jones, J. *The History and Antiquities of Harewood* (1859).

Morris, Robert. *Select Architecture … Designs of Plans Well-suited to both Town and Country* (1755).

Simond, L. in Hibbert, C. (ed), *An American in Regency England. Journal of a Tour 1810-11* (1968).

Steuart, Sir Henry. *The Planter's Guide* (2nd edn, 1828).

Ware, Isaac. *A Complete Body of Architecture …* (1756).

Warner, Rev R. *A Tour through the Northern Counties of England and the Borders of Scotland*, vol I (1802).

Wesley, Rev J. in Curnock, N. (ed), *Journals*, vol 6 (1840-2).

Wheater, W. *Some Historic Mansions of Yorkshire* (Leeds, 1888).

Wilkinson, T. *Memoirs of his Own Life*, vol I (York, 1790).

— *The Wandering Patentee*, vol I (York, 1795).

Woolfe, J. and Gandon, J. (eds), *Vitruvius Britannicus*, vol V (1771).

Young, A. *A Six Month's Tour through the North of England*, vol I (1770).

Newspapers: *Leeds Intelligencer; Leeds Mercury; York Courant.*

Directories: Leeds, *Directories* for 1839, 1861; York, *Directories* for 1781, 1784, 1798, 1805, 1816-7; *The Gentleman's Magazine* (1795).

The Travel Journals of Elizabeth, 1st Duchess of Northumberland, Victoria and Albert Transcript, 1771, ref 121/26.

SPECIALIST ARTICLES AND PUBLICATIONS

Beard, G. 'The Rose Family of Plasterers', *Leeds Arts Calendar*, no 54 (1964).

— 'The Harewood Chippendale Account', *Furniture History*, vol 4 (1968).

Black, D. 'Harewood Castle', *Archaeological Journal*, vol CXXV (1968).

Borenius, T. *A Catalogue of the Pictures and Drawings at Harewood House and Elsewhere in the Collection of the Earl of Harewood …* (Oxford, 1936).

Boynton, L. O. J 'The Bed-bug and the Age of Elegance', *Furniture History*, vol I (1965).

— 'Sir Richard Worsley's Furniture at Appuldurcombe Park', *Furniture History*, vol I (1965), 42.

Brigg, W. (ed), 'The Parish Registers of Harewood, Co. York', pt I, *Yorkshire Archaeological Society, Parish Register Section*, vol 50 (1914).

Brown, H. F. *Inglesi e Scozzesi all' Universita di Padova dell' anno 1618 sino al 1765*. Venezia (1921).

Brown, P. *Secrets in Stucco, an Interpretation of the Decorative Plasterwork at the House of Dun* (1989, unpublished).

Buckle, R. *Harewood. A New Guide Book to the Yorkshire Seat of the Earls of Harewood* (1972).

Burney, F. *Diary and Letters of Madame D'Arblay*, ed Charlotte Barrett (1904).

Coates, B. E. 'Park Landscapes in the East and West Ridings in the Time of Humphry Repton', *Yorkshire Archaeological Journal*, vol 41 (1965).

Council of British Archaeology, *Forum* (1985, 1989).

Gilbert, C. 'Chippendale's Harewood Commission', *Furniture History*, vol 9 (1973).

Gooder, A. (ed). 'The Parliamentary Representation in the County of York', *Yorkshire Archaeological Society Record Series*, vol 2, XCVI (1938).

Hall, I. 'John Carr: A New Approach', *York Georgian Society Annual Report* (1972).

— 'Neoclassical Elements in Chippendale's Designs for the *Director* of 1762', *Leeds Arts Calendar*, no 65 (1969).

— 'Newly Discovered Chippendale Drawings Relating to Harewood', *Leeds Arts Calendar*, no 69 (1971).

— 'The Engravings of Thomas Chippendale, Jnr. 1779' *Furniture History*, vol XI (1975).

Harvey, J.H. 'The Family of Telford, Nurserymen of York', *Yorkshire Archaeological Journal*, vol 42 (1969).

Hayward, H. 'The Schedule of the Clients of John Linnell', *Furniture History*, vol 5 (1969).

Low, J. I. 'William Belwood, Architect and Surveyor', *Yorkshire Archaeological Journal*, vol 56 (1984).

Mullins, A. 'Local Furniture Makers at Harewood House', *Furniture History*, vol I (1965).

— 'The Building and Furnishing of Harewood House 1755-1855', MA thesis, University of Leeds (unpublished, 1966).

Penny, N. ed. *Reynolds*, Catalogue of the Exhibition (1986).

Routh, P. and Knowles, R. *The Medieval Monuments of Harewood* (1983).

Rowe, R. 'A Neo-Classical Masterpiece', *Leeds Arts Calendar*, no 58 (1966).

Stephenson, A. 'Chippendale at Harewood House', *Furniture History*, vol 4 (1968).

Summerson, Sir J. 'The Classical Country House in the Eighteenth Century', *Royal Society of Arts Journal*, vol 107 (1959).

Symonds, R.W. 'Adam and Chippendale: A Myth Exploded', *Country Life Annual* (1958).

Tait, H. 'Sèvres Porcelain in the Collection of the Earl of Harewood', *Apollo Magazine* (June 1964, Jan 1965, June 1966).

W-C, A. 'The Gascoigne Family', *Leeds Arts Calendar*, no 64 (1969).

Wragg, R. B.

— 'Some Notes on Eighteenth Century Craftsmen', *York Georgian Society Annual Report* (1955-6).

— 'John Carr of York', *Journal of the West Yorkshire Society of Architects*, vol 17 (Dec 1957; Mar 1958).

York Georgian Society. *The Works in Architecture of John Carr* (1973).

SECONDARY SOURCES

Ackerman, J. S. *Palladio* (1966).

Aslin, E. *Nineteenth Century English Furniture* (1962).

Ashton, T. S. *Economic Fluctuations in England 1700-1800* (Oxford, 1959).

Barrett, F.A. and Thorpe, A.L. *Derby Porcelain* (1971).

Barry, Rev A. *The Life and Works of Sir Charles Barry, R.A.* (1867).

Baughan, P. E. *The Railways of Wharfedale* (Newton Abbot, 1969).

Beard, G. *Georgian Craftsmen and Their Work* (1966).

— *The Work of Robert Adam* (1978).

Bolton, A. T. *The Architecture of Robert and James Adam*, 2 vols (1922).

Brackett, O. *Thomas Chippendale* (1924).

Bradley, T. *The Old Coaching Days in Yorkshire* (Leeds, 1889; reprinted Wakefield, 1968).

Bradshaw. *Canals and Navigable Rivers of England and Wales* (1904: reprinted Newton Abbot, 1969).

Burton, E. *The Georgians at Home* (1967).

Clark, Sir Kenneth. *The Gothic Revival* (1964).

Clifton-Taylor, A. *The Pattern of English Building* (1962; 4th edition 1987).

Cokayne, G. E. *The Complete Peerage*, VI (1926), VII (1929).

Coleridge, A. *Chippendale Furniture* (1968).

Colvin, H. M. (ed). *A Biographical Dictionary of English Architects 1660-1840* (1978).

Craig, M. 'Portumna Castle' in *The Country Seat: Studies in the History of the British Country House*, no 6, presented to Sir John Summerson, Colvin, H.M. and Harris, J. (eds) (1970).

Croft-Murray, E. *Decorative Painting in England, 1553-1837* 2 vols (1970).

Denvir, B. *The Eighteenth Century: Art, design and society, 1689-1789* (1983).

Duckham, B. *The Yorkshire Ouse* (Newton Abbot, 1967).

East, W.G. 'England in the Eighteenth Century', in Darby, H.C. (ed), *An Historical Geography of England before AD 1800* (Cambridge, 1936: 2nd edn, 1967).

Edward, R. and Jourdain, M. *Georgian Cabinet-makers* (Country Life, revised edn, 1955).

Edwards, R. and Macquoid, P. *The Dictionary of English Furniture*, 3 vols (revised edn, R. Edwards 1954).

Entwisle, E.A. *The Book of Wallpaper* (reprinted Bath, 1970).

Fastnedge, R. *English Furniture Styles* (1961).

Fleming, J. *Robert Adam and His Circle in Edinburgh and Rome* (1962).

Fulford, R. *Glyn's 1753-1953* (1953).

Gilbert, C. *The Life and Work of Thomas Chippendale*, 2 vols (1978).

Gilboy, E. W. *Wages in Eighteenth Century England* (Cambridge, 1934).

Gill. R. *Happy Rural Seat: The English Country House and the Literary Imagination* (New Haven, 1972).

Girouard, M. *The Victorian Country House* (Oxford, 1971).

Girtin, T. and Loshak, D. *The Art of Thomas Girtin* (1954).

Grove, Sir G. Blom, E. (ed). *Grove's Dictionary of Music and Musicians* (5th edn, 1954).

Gunnis, R. (ed). *Dictionary of British Sculptors 1660-1851* (1968).

Habakkuk, H. J. 'England', in Goodwin, E. (ed), *The European Nobility in the Eighteenth Century* (1967).

— 'Daniel Finch, 2nd Earl of Nottingham: His House and Estate', in Plumb, J.H. (ed), *Studies in Social History. A Tribute to G.M. Trevelyan* (1955).

Hadfield, C. *The Canals of Yorkshire and North-East England*, vol 1 (Newton Abbot, 1972).

Hall, J. *A History of Ideas and Images in Italian Art*, 1983.

Harris, Eileen *The Furniture of Robert Adam* (1963).

Harris, L. (ed) *Robert Adam and Kedleston: the Making of a Neo-Classical Masterpiece* (1987).

Harvey, J. H. *A Biographical Dictionary of English Medieval Architects, A Biographical Dictionary down to 1500* (1984).

Hecht, J. J. *The Domestic Servant Class in Eighteenth-Century England* (1956).

Henretta, J. A. *'Salutary Neglect', Colonial Administration under the Duke of Newcastle* (Princeton 1972).

Hibbert, C. *The Grand Tour* (1987).

Hill, D. *In Turner's Footsteps* (1984).

Hinckley, F. L. *A Directory of the Historic Cabinet Woods 1460-1900* (New York, 1960).

Honour, H. *Neo-Classicism* (1968).

Hughes, E. 'The Eighteenth Century Estate Agent', in Cronne. H.A., Moody, T. W., Quinn, D.B. (eds), *Essays in British and Irish History in Honour of James Eadie Todd* (1949).

Innocent, C. F. *The Development of English Building Construction* (Oxford, 1916: reprint Newton Abbot, 1971).

Jackson, G. *Hull in the Eighteenth Century* (1972).

Jackson-Stops, G. and Pipkin, J. *The English Country House, A Grand Tour* (1985).

Jenkins, F. *Architect and Patron* (1961).

Jourdain, M. and Rose, F. *English Furniture: The Georgian Period 1750-1830* (1953).

Kingsford, P. W. *Builders and Building Workers* (1973).

Lees-Milne, J. *The Age of Adam* (1947).

— *Earls of Creation* (1962).

Links, J. G. *Canaletto and his Patrons* (1977).

Linstrum, D. *Sir Jeffry Wyatville* (Oxford, 1972).

— *West Yorkshire; Architects and Architecture* (1978).

Lloyd, N. *A History of English Brickwork* (1925).

Malins, E. *English Landscaping and Literature 1600-1840* (1966).

Minchinton, W. E. *Wage Regulation in Pre-Industrial England* (Newton Abbot, 1972).

Mingay, G. E. *English Landed Society in the Eighteenth Century* (3rd impression, 1970).

Murray, P. and L. *A Dictionary of Art and Artists* (1965: revised edn, 1969).

Musgrave, C. *Adam and Hepplewhite and Other Neo-Classical Furniture* (1966).

Namier, Sir Lewis. *England in the Age of the American Revolution* (2nd edn, 1961).

Namier, Sir L. and Brooke, J. *History of Parliament: The House of Commons 1754-1790*, vol III (1964).

Pares, R. 'A London West India Merchant House', in Humphreys, R. A. and E. (eds), *The Historian's Business and Other Essays* (Oxford, 1961).

Pinto, E. H. *The Craftsman in Wood* (1962).

Pope-Hennessy, J. *Queen Mary 1867-1953* (1959).

Raistrick, A. *West Riding of Yorkshire* (1970).

Raistrick, A. and Illingworth, J. I. *The Face of North-West Yorkshire* (Clapham, Yorkshire, 1959).

Reynolds, G. *Turner* (1969).

Shawe-Taylor, D. *The Georgians: Eighteenth-Century Society and Portraiture* (1990).

Steegman, J. *Victorian Taste* (1970).

Stillman, D. *The Decorative Work of Robert Adam* (1966)

Stroud, D. *Capability Brown* (1957; revised edition 1975).

— *Humphry Repton* (1962).

Summerson, Sir J. *Georgian London* (revised edn, 1962).

— *Architecture in Britain, 1530-1830* (1953).

— *Inigo Jones* (1966).

Thompson, F.M.L. *English Landed Society in the Nineteenth Century* (1963).

Tillott, P.M. (ed). Victoria County History, *A History of Yorkshire. The City of York* (1961).

Towndrow, K.R. *Alfred Stevens* (1939).

Ward-Jackson, P. *English Furniture Designs of the Eighteenth Century* (1958).

Waterhouse, E. *Painting in Britain, 1530-1790* (1969).

Watson, Sir J. Steven. *The Reign of George III 1760-1815* (Oxford, 1960).

Wedgwood, Dame C.V. *Strafford 1593-1641* (1935).

Wilson, R.G. *Gentlemen Merchants: The Merchant Community in Leeds, 1700-1830* (Manchester, 1971).

Wilton, A. *Turner and the Sublime* (1980).

Woodbridge, K. *Landscape and Antiquity: Aspects of English Culture at Stourhead 1718-1838* (Oxford, 1970).

Young, G.M. (ed). *Early Victorian England, 1830-1865*, 2 vols (1934).

Acknowledgements

This fully revised edition of *Harewood House* has been prompted by the restoration of three of the State Rooms, including the Gallery. I am most grateful to the Earl of Harewood for suggesting a second edition and for actively promoting its publication. He and the Countess of Harewood have given the additional section detailed scrutiny and expert comment, without which it would have been impossible to record the work of restoration with accuracy and confidence.

Alec Cobbe and Edward Bulmer, who were responsible for the planning and implementation of the decorative programme, shared their knowledge and enthusiasm with me. I much enjoyed these tutorials among the plaster and the paint-pots. The interest, the helpfulness and the goodwill of the staff of the Estate Office and the House made it, as always, a pleasure to work at Harewood.

Apart from the final chapter on the restoration, new material has been included mainly from the two basic sources for research, the Harewood Archive deposited with the West Yorkshire Archive Service, Leeds, and the Collection of Adam Drawings in Sir John Soane's Museum in London. A third source, equally important if less prolific, is the Adam Correspondence in the Clerk of Penicuik Papers, owned by Sir John Clerk of Penicuik and deposited in the Scottish Record Office in Edinburgh. I am, therefore, deeply indebted to W. E. Connor and his staff of the Leeds City Archives Department, to Christine Scull, Librarian of the Soane Museum, and to the Keeper of the Records of Scotland and his staff. Sir John Clerk very kindly gave me permission to publish extracts from the Adam letters.

It is, unfortunately, not possible to thank individually all those who have contributed to the preparation of this second edition, among them Geoffrey Beard, Anthea Bickley, Peter Brown, Richard Buckle, R. M. Butler, Judith Close, J. M. Collinson, Malise Forbes Adam, Terry F. Friedman, Christopher Gilbert, Derek Linstrum, James Lomax, Kate Oldfield, Helen Valentine, John Weaver, whose information on the architectural history of Harewood Castle was invaluable, and Caroline Rigg, who re-processed my scripts with admirable equanimity.

I have appreciated beyond measure the ready assistance of the librarians and staff of the Libraries of the City of Leeds Art Gallery and Temple Newsam House, the University College of Ripon and York St John, the Yorkshire Archaeological Society, the City of York and especially the North Yorkshire County Libraries of Harrogate and Ripon.

Lastly, I remember with gratitude the scholarly guidance and stimulating encouragement of the late Dr Eric Gee of York, who first persuaded me to write about Harewood House.

Index